PRESERVING YOUR FAMILY PHOTOGRAPHS

MAUREEN A. TAYLOR

ISBN: 978-0-578-04800-0

Cover design by Cecilia Sortino, C Design Lab

Book design and layout by Angel Editing www.angelediting.com

Published by Picture Perfect Press www.pictureperfectpress.com

Printing in the United States

TABLE OF CONTENTS

PREFACE

In all the years I've worked with photographs, as a professional curator and researcher, the number of titles on the history of photography has increased, but there arc still topics that need research and publication. One of the under explored areas in the last 150 years plus of photography is the importance of the medium in family history. I hope this book helps explain why family historians and genealogists need to be interested in their photographic heritage. I believe every family collection has a unique story to tell. Each photograph has a fascinating history including how and why it survived multiple generations. Let's try to take care of these valuable pieces of our history so that others can appreciate them.

This book would not have been possible without the support and encouragement of the many friends and colleagues who responded to a call for their unanswered photography questions. Through them, I learned a great deal. Parts of this book were a challenge to write because the technology kept changing. Several individuals shared their expertise and experience to help explain technical terminology and procedures including David Mishkin, of Just Black and White, Paul Messier, www.paulmessier.com, Brenda Bernier, Paul M. and Harriet L. Weissman Senior Photograph Conservator for Harvard University and Lorie Zirbes of Retouching by Lorie www.retouchingbylorie.com. Many other patient individuals felt family photographs were important enough to take the time to talk with me.

There are people who nudged me during the course of this book. When writing a book, you need friends you can turn to for opinions and suggestions. I am very lucky to know a number of individuals who let me do that, including: Kathy Hinckley, (www.familydetective.com) and Jane Schwerdtfeger. I also must thank all the folks who've offered suggestions during my workshops on photo preservation. Once again, I need to thank my husband for his encouragement and my children, James and Sarah, for their unending curiosity about the world. They ask questions about everything and encourage me to look at life in a new way.

I fell in love with photography and historical images as a young child and my fascination with the topic has never wavered. It is my hope to pass on this interest to others, through the topics covered in this volume. Try to find time to enjoy your photographic heritage. It's a great way to spend some relaxing moments.

INTRODUCTION: PRESERVING OUR PAST FOR THE FUTURE

Several years ago, a woman at one of my lectures stood up and announced that she had a solution for organizing all the photographs she had collected. "Put them on your computer and throw away the originals, that way you don't have the clutter." Needless to say, I spent the next half hour explaining why transferring your family photographs to a digital format was a temporary solution that could lead to future retrieval problems and the loss of the originals. The woman's comment made me aware of the amount of misinformation available to the public regarding photo preservation. Others in the class asked questions regarding organization of their photographs. I was supposed to give an introductory lecture on family history, but instead spent two hours answering inquiries about family photographs. This group of people taught me that there is a changing notion of what constitutes a photograph.

In each generation since the daguerreotype, the definition of a photograph changed as the medium and technique for producing an image evolved. For individuals living at the inception of commercially successful photography in 1839, a daguerreotype was produced on metal and had black and white and reflective properties, while for someone living in 1939, the most common images were snapshots produced on paper. A photograph can be created on almost any material coated with light-sensitive chemicals—leather, glass, china, or fabric, for instance. Each of these materials presents a preservation dilemma. In the late twentieth century, our family photographs came in a variety of mediums ranging from a traditional color photograph processed at a lab or an instant color photograph to the now more prevalent digital image. The diversity of images in family collections leads to uncertainty over how to organize and care for both the historical images and those that are being created today.

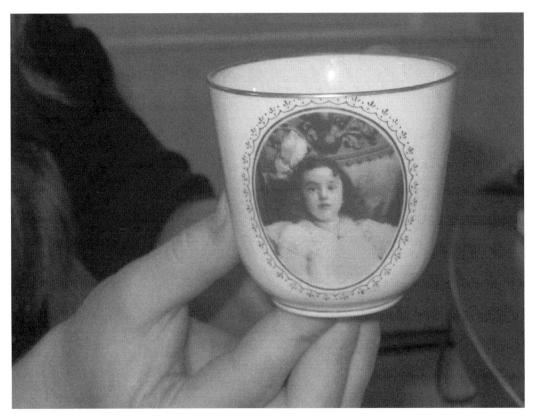

A photograph can be created on almost any material coated with light-sensitive chemicals—leather, glass, china, or fabric, for instance. Unidentified child, c. 1900 – *Collection of the author.*

Add to that confusion, advertising that sells supplies and materials under the heading of acid-free and archival, and it isn't surprising that our family photograph collections are in a state of disrepair. Acid-free means that the substance is actually free of acid while archival suggests that it is not harmful. However, since there are no standards to judge an archival process, it is best to be specific when talking about terminology relating to photographic conservation, preservation and restoration. Manufacturers are often caught in the mix-up by proclaiming their products are archival when, in fact, they are not suitable for long-term storage. The history of preservation methods illustrates that until storage materials are properly tested, no products should be sold to consumers who might not fully understand the technical terms and product components.

So what does archival really mean and why is it important? Archival means used in an archive. Don't depend on the staff in most stores to advise you on which products to purchase. Even though the label says archival, it is best to check with the manufacturer to see if the product conservation professionals have approved the product. Be sure the product has passed standards that

indicate it is safe to use with photographs. You need to be familiar with the preservation methods used in most archives and libraries to keep your pictures safe. Since we all want our photograph collections to outlive us, it can be difficult to know the right approach to caring for our images.

If you were to ask a group of people where they store their family photographs, most would reply that they are in boxes in the closet, the attic or the basement. They will follow your question with an apologetic statement about not knowing what else to do with them.

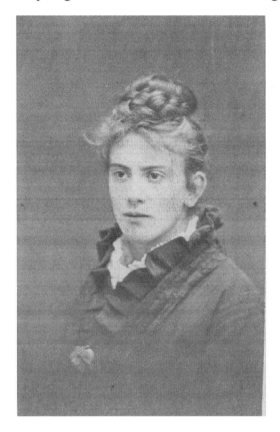

Our ancestors loved photography as much as we do today. Unidentified woman, c. 1900 – *Collection of the author*

While genealogists are more aware than ever of the value of their photographs, the next step is gaining an understanding of how to care for their valuable images. Every picture tells a story of the lives and experiences of our ancestors. Why not pay attention to what we have so that future generations can understand their ancestors and their lives?

There are several reasons our pictures remain in shoeboxes.

WE PRODUCE ENORMOUS NUMBERS OF IMAGES

Few of us now use film, but just a few years ago, getting film developed meant being overwhelmed by choices. Do I want multiple prints? What size prints? Do I want them on CD or

would I rather look at them on the web? So many choices and yet each one generates a storage or preservation problem. Today, digital photography means that we take even more photos than in the past.

A few years ago, even before the current digital boom, the Photo Marketing Association reported that Americans took 55 million pictures a day or more than 20 billion a year. Compare that to film habits. If you were to take 100 rolls of film (36 exposures) in a given year and ask for double prints you would be generating 7,200 pictures! That doesn't include all the pictures you've taken in other years or the negatives. What are you going to do with them all? Granted you probably send copies to friends and relatives, but what do you do with the rest?

If you use an online service, you choose the images you want printed or you may print them out at home on special paper. Unfortunately, the rest of your images may only remain online for a short period of time unless you elect to pay for digital storage. There are free storage options available such as Yahoo's Flickr www.flickr.com. Users can upload 100 megabytes of images a month and display 200 of their most recent images for free. Pro accounts cost $24.95 US and have no limits.

By producing a CD you think you have solved the space problem. After all, how much space does a single CD occupy? However, several years later you discover that you can no longer look at the CD because the technology has changed or suffers from preservation problems.

WE LACK THE TIME TO IDENTIFY THE IMAGES WE PRODUCE

If you are like most people, you probably have boxes full of photographs of past generations waiting for identification. Extremely lucky individuals have ancestors who actually placed their pictures in albums and wrote captions on the backs or underneath the pictures. However, the majority of us have produced so many pictures that we are overwhelmed by the amount of time it would take to identify all the images we have taken, never mind the ones we inherited from other family members. This problem can be overcome by selecting a small group of images to identify. Then you can move on to the rest.

HOW DO WE KNOW THAT OUR SOLUTIONS WON'T DAMAGE OUR PICTURES?

Magazines present us with decorating suggestions on how to use our family pictures in scenarios ranging from framing arrangements to Christmas ornaments. But these decorating solutions may destroy our pictures. And, how many of us have photographs in those magnetic albums from the

1970s that have caused irreparable damage to our photographs? My mother placed our graduation pictures in frames on a living room table. In just a few years, sunlight had caused significant color changes in the images.

CAN ANY DAMAGE BE REVERSED?

If you have the time to identify and organize your pictures, you may still have the problem of damaged photographs. Did a relative place an X over the head of your ancestor in a group portrait and then use ink to write a name across the face of the neighboring person? Do mold, dirt or chemicals obscure the face of an ancestor? Has an image faded? Before you attempt to clean any image, remember that the first rule of conservation and preservation is to proceed cautiously so that you don't do more damage. A few basic pieces of equipment such as a scanner, a computer, and special software, can help you enhance even the most damaged photographs in your collection. If you require professional conservation or restoration help, do you know how to find the right person?

IT'S TOO EXPENSIVE

Purchasing a magnetic album is less expensive than buying one from an archival supplier, but consider the future. I have several albums from the 1970s and I can vouch for the damage they have caused to my irreplaceable images. Isn't it worth the additional expense to invest in albums manufactured by reputable archival suppliers? You don't have to put all your family photographs in a preservation-quality album. But if you don't, are you prepared to lose them? This book outlines some inexpensive solutions for limited budgets.

IS IT OKAY TO THROW AWAY IMAGES?

You bet it is. I don't discard photos of individuals, but endless scenes of landscapes or pictures that are excessively blurry may not be worth keeping. Brenda Bernier, Paul M. and Harriet L. Weissman Senior Photograph Conservator for Harvard University suggested that instead of actually throwing away your discarded images you donate them to a conservation lab or graduate program. The popularity of digital photography means that there are fewer traditional prints to use as teaching tools.

Given the number of pictures we take, our confusion over definitions, and the ever-changing technology, is it any wonder that many of us put off working with our family photographs. What

is needed is encouragement and education.

This book is the companion volume to my first Family Tree Books publication, *Uncovering Your Ancestry Through Family Photographs* revised edition (2005) that helped you identify your family images. This volume continues the process of working with your photographs by answering the questions listed in this introduction. It also provides a basic understanding of how to care for and organize your family photograph collection. This book outlines in easy steps, how to add value to your home collection by applying the concepts that conservators and photo curators use every day. Each chapter ends with a series of commonly asked questions and answers. This book also:

- Provides a set of safe scrapbooking guidelines.

- Furnishes a list of basic conservation supplies.

- Teaches you how to select a conservator.

- Helps you identify the type of damage to the photographs in your collection.

- Explains the legal aspects of family photography.

- Presents some low-cost alternatives.

CHAPTER ONE: STORIES WORTH SAVING

Every family photograph collection has a story to tell and is worth saving. In 1986, the Photo Marketing Association surveyed camera owners to find out why they took pictures. It's not surprising that 95% of them responded that they use photography to "preserve memorable scenes."[1] That is primarily still true today, although many of us tend to capture spontaneous moments via cell phones and digital cameras. For most of us, the stories present in our family photographs document important moments. They offer clues about the roles of individuals in the family as well as providing their own version of your family history.

Look carefully at your photographs. The information contained in the images and their captions is not necessarily the same data you found in other types of documents used for genealogical research. The photographic narrative needs to be interpreted. What do your images say about your family? For instance, can you tell from looking at a picture of a couple what type of relationship they have? If you are looking at a family group, can you determine the dominant member of the family? This type of background is often lacking from other material.

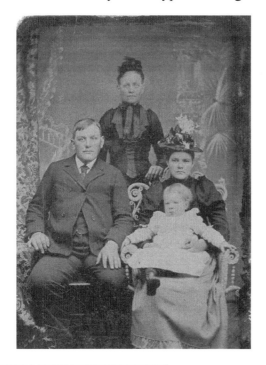

Family group photos often depict relationships like this young couple with a baby and a grandmother. Unidentified family, c. 1898 – *Collection of the author.*

[1] Brad Edmondson, "Polaroid snaps the customer," *American Demographics*. 9 (February 1987): 23.

A group of photographs is the collective story of the family. Think about who is not depicted in your family collection or in individual images, and what images are missing from your collection. The people included in or missing from the photographs add to your understanding of family dynamics. My mother doesn't have any of her baby pictures because her sister who was seventeen years older had the images in her collection. My aunt gave them to her daughter who in turn gave them to one of her sons. My mother still doesn't have copies of her own baby pictures.

Everything about your family photographs adds to your understanding of their place in the family. Where are they stored? Are they precious enough to be kept in a location that allows for easy retrieval or are they buried in the attic? Now consider how you obtained the photographs in your possession. Did a particular relative give them to you or did you go out and find them? Your collection may contain a few photographs that depict your special relationship with that relative.

It is a rare collection of images that stays intact over several generations. Various family members usually ask to have a few images to remember deceased individuals or to replace images. One relative recently requested a copy of childhood photographs because a fire destroyed his home. You can tell a lot about the history of photographs in your family by discovering the earliest photograph in your collection. This photograph tells a story beyond what and who is depicted. It can enlighten you as you trace it to previous owners. If you only own twentieth century images, ask "Why are there no photographs before that point?"

The answers to each of these questions inform you of the place of photography holds in your family. You may not think that answering these inquiries is important to learning how to organize, preserve, and restore individual family pictures. In fact, in each step of the process, you will make determinations about the sentimental value of the images you are going to organize. The answers to each of these questions will ultimately lead you to additional information and even more images.

Step back from the individual pictures and view your collection as a whole. What types of photographs are included? Who took them and when? What do you really know about the individuals depicted? All of these questions become important when you begin to organize your collection. As you answer these questions you will know which photographs to place in the family album.

While there are basic preservation needs for all types of images, some images require special considerations. For instance, preserving a photo on cloth may require consulting with a textile conservator. Conservation and preservation are ways to prevent future damage. Images in cases or frames must be stored differently than negatives. Each step in the preservation and

conservation process asks you to define the parameters of your family collection. Are you going to purchase supplies for all your images or only those that have special significance? It is advisable to place all of your images in storage, but you may only be able to take extra precautions with a precious few.

You may decide that some of your images require restoration, the process of reconstructing their original appearance. However, professional restoration is a time consuming and expensive process. By determining the familial importance of certain images, you create a priority list of items to be professionally restored. If you chose to try enhancing your photographs using a software package, you are still determining which photographs are worthy of your time and energy.

The very act of creating an album, scrapbook or family web page with images requires that you make additional decisions about your photographs. Why do you include some and not others? You may want to include a statement of your intent as a preface to your final product.

So how do you reconcile the desire to use all of your pictures with the reality of working with a few at a time? You do this by asking yourself a series of questions about what photographs are most important to you.

- Who are the important people in your life?

- Which images depict events that you want to remember?

- Is there a series of photographs that tell the story of your family?

- Are there photographs of family friends that have special significance?

These are just a few questions. When you look at your collection, whether or not you are aware of it, you are making decisions regarding their future care. You are probably not going to include images of family friends or distant relatives in your albums or pay for expensive conservation unless they played a significant role in your family life.

In order to organize your family photographs, there are several steps to follow as you create a record useful to future generations. Whether you choose to arrange your photographs in PAT-approved albums or store them in boxes, you still need to caption each image. This can feel like an overwhelming process, especially if you don't know where to start, so in the beginning you may only want to try to identify small numbers of images.

There are few supplies that you need to begin the process. Since these photographs are in part members of your family tree, keep your genealogical research close by for reference

purposes. When handling the images, wash and dry your hands thoroughly or wear disposable examination gloves available in pharmacies. It's best to buy the non-latex type since so many people are now allergic to latex. Discard them after use. White gloves used to be recommended, but they can be clumsy to use. It's possible to cause inadvertent damage. Wearing gloves will prevent any substances on your hands from further damaging the images. No matter how clean we think our hands are, we can still transfer oil and fingerprints to the surface of the pictures. Years later, you may find that you've left a perfect set of fingerprints on the image you touched with bare hands. A scanner, good magnifying glass, or a photographer's loupe will help you examine each picture for additional details. As you conduct your genealogical or photo research, be sure to carry duplicates or photocopies of your images on research trips rather than originals. This precaution will prevent originals from becoming lost or damaged. Lastly, a camera can be used to document the original condition and arrangement of each part of your collection. The proximity and context of other photographs can help you identify images in your collection.

RETAINING THE ORIGINAL ORDER

Are your photographs in the same boxes in which you received them? If so, one of the first steps towards organizing your images is to document what they look like before you disturb the order. One member of the Smith family kept papers and photographs relating to different generations of the family in different boxes. Each box is labeled with the male head of the household's name. This system allows the family to use these boxes and their genealogical information to recreate a history of each generation depending on the materials that still exist. Their first step is to photograph the

What is the PAT?

The Photographic Activity Test (PAT) measures the reactivity of products and their components to photographs. The International Standards Organization (ISO) issues the standards used in the test. Manufacturers voluntarily submit their products for testing. In the United States, one of the facilities that tests materials is the Image Permanence Institute in Rochester, N.Y. If you have a question regarding a certain product, call the manufacturer or supplier to see if it passed the PAT. The Image Permanence Institute (IPI) www.imagepermanenceinstitute.org/ a non-profit research lab sponsored by the Rochester Institute of Technology and the Society for Imaging Science and Technology, tests paper and plastic as well as "adhesives, inks, paints, labels, and tapes" for four to six weeks. The PAT is used internationally, so look for evidence that products have passed this rigorous standard before buying.

collection as is by laying out selections of material. This documentation process can become important later when the Smiths are unable to recall which box the photographs came from. In addition, each photograph should be labeled with the original box number. Place the photograph face down on a clean dry surface and write the box number in the upper right corner lightly in pencil. Alternately you can write your identification in the lower corner. Just be consistent. It is preferable to use a soft graphite pencil which can be purchased at art supply stores. Pen should never be used on photographs because the ink can run and ruin the image. Resin coated papers require a special pen that is quick drying, light fast, and safe for pictures, such as a ZIG marker or an artist's pencil no. 6B. A Stabilo pencil also works, but can rub off. These pencils and pens are available in most art and scrapbook stores.

Try to document the original order of the photographs in order to retain any identifying information – *Lynn Betlock*

PHOTO IDENTIFICATION TECHNIQUES

In order to tell a story, you need to answer the who, what, when, where and why of the picture. Each image is a photographic mystery waiting to be solved. If you know the identity of the individuals in the picture, they should be captioned. A basic label should include the names of the individuals in the

picture, when it was taken, the geographic location and an explanation of why it was taken. Examine the photographs in your possession and see if you can answer all of the above questions. Most individuals are missing key pieces of information. With a few easy steps, however, you can add to your knowledge about an image.

Ask other family members if they recognize the photograph. Can they remember why it was taken and when? Do they know the names of the people in the image? Do you know when the image was taken? The clothing clues and photographer's imprint can help you assign an approximate date. Costume encyclopedias can lead you to a time frame. If the photographer's name is present, you can locate a span of dates by researching their business in local city directories. Where are the people in the image standing? By examining the photograph for artifacts or signage, you can find additional clues that will help you date the image.

In one collection, a pair of wedding portraits was rediscovered. The owners knew the identity of the individuals. A date was established based on clothing and the photographer, and then it became clear that these were wedding portraits. In this case, the bride was not attired in the traditional wedding dress and veil. Each photograph in your collection should have a label displaying, at minimum, a name and date so that they can be understood in the future.

This identifying information will be written in pencil on either the album page or outside the storage materials. Until you decide how you are going to organize your collection, it is helpful to use a worksheet to keep track of your research and the caption. For additional tips on identifying your pictures see *Uncovering Your Ancestry Through Family Photographs.*

ADDING TO YOUR COLLECTION

As you lay out your photographs to begin working with them

Basic Caption

- Person/persons:
 Name(s), Life Dates, Date of the Photograph (if known)

- Event:
 Family Name, Occasion, Identity of Individuals, Date of the Photograph

- Who labeled the image and when

Basic Kit

- Genealogical Research

- Worksheets for additional information

- Photocopies of the photographs

- Magnifying glass

- Disposable examination gloves for handling the pictures

- Camera

- Zig marker, Stabilo pencil or a soft lead artist's pencil (6B)

- Microspatula

and answer the above questions, it may become apparent that your collection only represents a small portion of the photographs that were created throughout the history of your family. Each collection of images has been brought together by a seemingly random set of circumstances. Their very survival depended on their value to other members of the family. At each juncture of a family tree, photographs are either lost due to disinterest, damage, or passed on to future generations. Think about the images that are currently part of your family photograph archive and try to imagine what your collection would be like if you had a pictorial representation for each individual. In the Emison family for instance, there are few images prior to the beginning of the twentieth century. Is this because only these few images survived, or because the family was disinterested in photography until a certain point? The likelihood is that there are other, perhaps earlier, photographs in the collections of distant relatives on other branches of the family tree.

Once you have documented the arrangement of your images and tried to identify some of your photographs, you may want to look for other photographs to enhance what you already have. For instance, the Bessette family collection is divided between several siblings. They are primarily images of the siblings as children. Only a couple of group portraits exist of their mother and her siblings. Since both sides of the family, the Bessettes and the McDuffs, had large numbers of children, it is reasonable to assume that other family members may have images to fill in the gaps. In fact, one of the cousins had images relating to his father who was of the same generation as the mother of the Bessette children. If there are photographic gaps in the family record, you might want to try to locate other family pictures. This process might be as simple as contacting all of your known relatives or it might involve library research.

As part of an estate, photograph collections are rarely mentioned and so their dispersal is not part of public record. If you ask various family members, you will find that most have collections of ancestral photographs, ones they were given after the death of various family members. It is worth the time and effort to track down these missing images and copy them so that they become part of your genealogical documentation.

There are additional sources of photographs that can be added to the family archive. Passports, visas, driver's licenses, and work identification cards can yield additional or new photographs. You might even find an image of a relative in a newspaper or magazine article.

A FAMILY COLLECTION THROUGH THE GENERATIONS

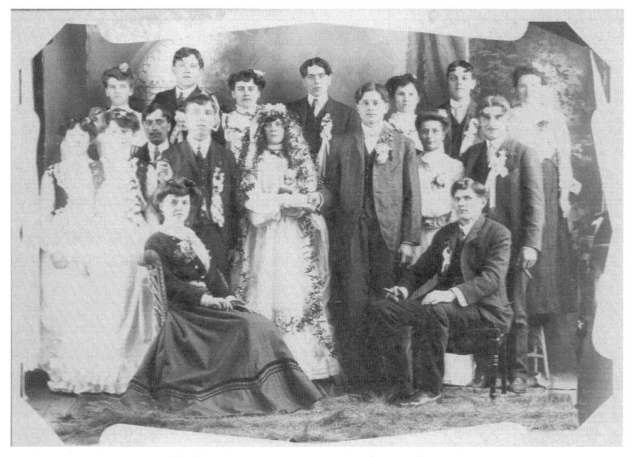

Photographs are usually inherited by women in the family. Who inherited the photos in your family? Unidentified wedding group, c. 1920 – *Collection of the author*

Once you've surveyed the photographs in your possession, tried to identify them, and attempted to find new ones, you are ready to learn some basic conservation and preservation techniques. Let's consider what happens to a fictional photograph collection from its beginning to the present. The Smith Family, intrigued by the new invention called the daguerreotype in 1839, sits for individual family portraits. Since these are one-of-a-kind pictures, it is necessary to pose for additional images to have copies for family members. The oldest daughter gives her portrait to her future husband. The father sends his to his elderly mother who he hasn't seen in several years. The mother and son hold onto to their images. The family becomes fascinated with having portraits taken every few years as children are born and people marry. Soon their collection has expanded to include a variety of mid-nineteenth century images such as daguerreotypes, ambrotypes and cartes

de visite. The son not only sends a tintype of himself from a Civil War battlefield taken by an itinerant photographer, he sends along a few pictures of his friends. The daughter, a young married woman, begins to collect small paper photographs called cartes de visite of famous nineteenth century people. She places them in an album alongside her family photographs.

Several years pass. The son and daughter are raising their own families. They take their children to the photo studio for formal portraits, both as a family and individually. Since they no longer live in the same town, they send each other copies of the pictures. Their parents' daguerreotypes are now part of their individual collections. Since each wants a copy, they go to their local photo studio and have prints made. The family photograph archive is now divided between at least two different family groups. Upon the deaths of the parents, the children further divvy up the images to create still more photograph collections. This happens for several successive generations until there are boxes of photographs stored in the attics, basements, and closets of many homes. The original daguerreotype cases are either broken or have disappeared to be used for other purposes. The images stored in damp and humid conditions are damaged by mold. Chemical stains from improper washing mar the surface of several, by now, unidentified family members. No one took the time to write captions on the images. A relative attempts to caption the images based on his or her own knowledge and places some erroneous names on the backs of the photographs.

Heritage versus Contemporary Photographs

For the purposes of this book, the word photograph refers to both historical and contemporary photographs. Photographic family history is created with each new snapshot. All photographs should be treated with respect and consideration regardless of when they were taken.

Flash forward to the present. You have been helping your parents clean out their attic. You discover several boxes of photographs, some identified and some not. When you ask your parents, they tell you they know some of the people. The photographs have continued to be damaged by environmental humidity and temperature fluctuations. Your family has moved several times and some of the mounted and framed photographs are broken or cracked. Another well-meaning relative has taken a pen, placed an X above the one person in the school portrait they knew, and proceeded to write their name in ink on the front of the photograph. Having an interest in family history, you decide to tackle the various issues relating to this collection: identification, restoration, and organization.

This is a fairly typical scenario. The inheritance patterns for the images and the damage they are subjected to happens in most families. What is unique is the composition of individual family photograph collections because photography played a different role in each family.

You must take several steps to stop the collection from disappearing completely. The first step is learning how to care for the various types of images in your possession. In the course of caring for them, it is necessary to learn a little photographic history as well.

SENTIMENTAL VERSUS MARKET VALUE

Every time you look at your images, the sentimental value of the photographs probably comes to mind. You may be holding the only picture of a great aunt you fondly remember or your baby's first steps. It is easy to take these photographs for granted because they are part of our family history. But you may not be aware of the market value of some of the images in your collection.

Twenty years ago, you could buy a historical photograph for a few dollars, but today, those very same images are being sold for larger sums than you can imagine. Take a look at the photographs being offered for sale in online auction houses and you'll gain a new appreciation for your family photographs. In 1998, Swann Galleries sold a family photograph album containing fourteen tintypes of Calamity Jane, her parents and siblings for $21,850. Rare images are being rediscovered and sold for amazing amounts. Sotheby's sold a previously unknown collection of daguerreotypes by Boston photographers Southworth & Hawes for a record

> **What is a Photograph Collection?**
>
> According to Webster's Dictionary, a collection is a "group of objects or works kept together" (p. 281). A photograph collection is therefore the images kept together by a particular family. There is no differentiation between historical images and those currently being created. All are part of your collection.

$3,304,497. The daguerreotypes were discovered in the basement of a home. Before you think that preserving your family photographs is an unnecessary expense, consider the market value of the images.

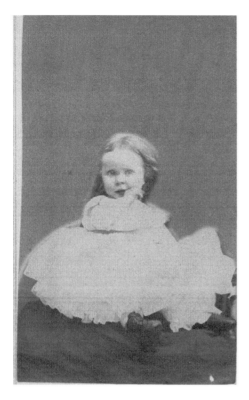

What is the sentimental vs. historical value of your photographs?
Collection of the author

Several factors determine the market value of individual images and collections, including the condition of the photograph. When you look through your photographs, evaluate their sentimental value and historical worth in terms of the following:

FAMOUS PERSON

Can you identify the people in your pictures? Does oral tradition allude to a famous person in your family? Who knows, it might be true! Once you have a name, consult either online or print versions of biographical encyclopedias for information. You may discover a notable person in your family whose history was lost over the years. Sometimes family stories about an ancestor's exploits are true. Keep in mind that photographs of famous individuals unrelated to your family can also be found in albums and collections. It was quite popular in the nineteenth century to collect photographs of famous individuals.

UNUSUAL IMAGES

You may also own an image that has significant historical value. If any of your photographs are unusual depictions of events, landscapes or even medical anomalies, they may be valuable. For instance, a photograph of a particular town may be the only known image of that location.

IDENTIFIED PHOTOGRAPHS

The monetary value of a photograph increases if the person is identified. There are boxes of unidentified photographs sitting in antique shops, but images with an identification attached are less common and therefore worth more.

WELL-KNOWN PHOTOGRAPHER

Photographs taken by famous photographers may be mixed in with your family snapshots. For instance, the collection auctioned by Sotheby's sold for a high sum because the images were in good condition, the poses were unusual and they were the work of one of the first daguerreotype studios in the United States. Researching photographers is explained in *Uncovering Your Ancestry Through Family Photographs*.

UNUSUAL PHOTOGRAPHIC PROCESS

Occasionally, a photograph is valuable because of the process that created it or its format. Photographic Jewelry is uncommon and sells for more than paper portraits. Nineteenth century photographers sometimes used innovative techniques or unusual photographic processes to lure customers into their studios. If you don't recognize the name of the process listed on the back of a photograph, consult one of the glossaries of photographic terminology mentioned in the bibliography.

Not every collection of photographs is going to contain images that fall into these categories, but it is worth considering the monetary value of your collection in addition to its significance to your family history. Spending a few extra dollars on a special storage box seems worth the investment for images important both historically and sentimentally. If you think an image should be appraised for its significance, find a professional by using the online search form for the Appraisers Association of America (www.appraisersassoc.org).

By the time you're done working with your photographs, you'll have learned basic photo history, used them to uncover unknown information about members of your family, contacted relatives who have other pictures, restored some of damaged images to their original lustre and organized them so that future generations can appreciate them. It is a long process, but not a daunting one. It takes time, patience and a little capital, but in the end it is a worthwhile project. You'll find that it is also fun. Your photographs are like a puzzle or a good mystery that you need to solve. You can't wait to discover the ending. The final result of your efforts will be a well-organized story of your family in words and pictures.

CHAPTER TWO: THE PRESERVATION FACTS

The fictional Smith Family photographs incurred damage in the same way that your photographs do. Some damage may be the result of a single incident such as a broken photograph, while other damage happens slowly such as the fading that is present in color images. Most of the injuries our photographs suffer over time are the direct result of three factors: chemical, physical and biological. Chemical damage is characterized by fading, yellowing and staining. Physical damage consists of tears, cracks, warping, and creases. Biological deterioration is a result of insects, animals and mold. Improper storage materials and environmental conditions such as excess moisture, temperature fluctuations, pests, chemicals, and light influence the rate at which those factors deteriorate the images.

Physical damage can occur every time you look at your photographs. The surface of this unidentified portrait is covered with small scratches. Unidentified wedding, c. 1900 – *Collection of the author*

PHYSICAL

Every time you touch your images with bare hands or shuffle through them, you damage the pictures. Moving photographs against each other while looking at them is abrasive and causes small scratches in the surface. In some pictures, abrasion removes part of the image. Gloves are a necessity when looking at pictures. Handling images without gloves can leave fingerprints on the surface. While your fingerprints won't be immediately visible, they eventually will be. You probably have the fingerprints of several relatives on your pictures. The oils and dirt on your hands cause deterioration of the image. The best precaution is to handle photographs by the edges while wearing disposable exam gloves. They are available at pharmacies.

BIOLOGICAL

There are two major types of biological factors that many photographs are exposed to--pests and mold. In both cases, the amount of exposure influences the degree of damage done to the image area. Proper storage containers and conditions can prevent this type of decay. Mold is discussed in the section on environment.

PESTS

Photographs and albums offer animals and insects food and nesting materials. For instance, wood frames can attract insects such as termites. If you want to frame your images, see the list of precautions in Chapter 11. The paper backing on photographs and the adhesive used to mount the picture can encourage Silverfish. If you are storing your photographs in an attic or basement, you may not be aware of the mice or other animals that live there. Your pictures provide warmth and supplies for building nests. Finding small animals and insects in your picture collection is an unpleasant surprise. If these pests decide to nest in your storage boxes, their excrement will stain the images. Proper storage conditions and containers can stop the problem before it starts.

CHEMICAL

Other types of damage are not as apparent. The very containers that we use for storage may seem safe, when in fact they may exude gases that will eventually stain the image. Wood, plastic, cardboard and other types of materials used to manufacture boxes can produce off-gases. For these reasons, take precautions with storage containers. Professional librarians and archivists use boxes produced by the suppliers listed in the Appendix.

One common cause of chemical stains is acid from mounting boards and glassine envelopes. Most paper contains acids from the manufacturing process. To prevent damage minimize the contact between your photographs and acids. This is accomplished by placing photographs in storage enclosures that are approved for this specific purpose.

Some damage happens due to substances our images come into contact with. The blotches in the background near her head are stains from the adhesive used to adhere it to an album page. Unidentified woman, 1880s – *Collection of the author*

Some of the damage incurred by our images is inadvertent. Every time a photo lab processes your film, it is subjected to chemicals. If the chemicals are not completely rinsed off during development, they may cause staining. If you have brown stains on your black and white images, they may be the result of the chemicals used to develop the pictures. Improper processing marred one couple's wedding photographs. The photographer did not spend enough time washing the prints before drying. The result is an album full of brown-stained photographs.

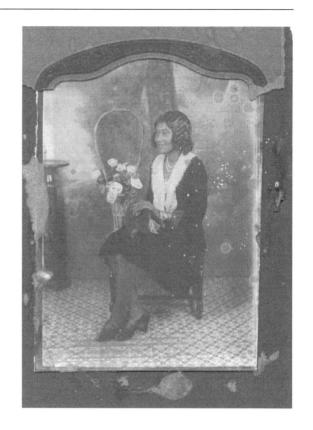

This unidentified photograph was found hiding behind a fireplace during a household remodeling project. It is covered with mold and scratches. Unidentified woman, c. 1930 – *Collection of the author*

ENVIRONMENT

Where you store your photographs can determine how long they will last. The amount of exposure to fluctuating humidity, temperature, light and pollutant levels has a direct effect on photo longevity. Any of these environmental issues can encourage chemical, biological or physical deterioration. Selecting the right storage area for your photographs is an important decision. Rather than placing your photographs in danger, take some time to consider your storage options.

HUMIDITY

High humidity and dampness allow mold and mildew to grow on images. This can destroy the photograph. Mold and mildew grow on most photographic surfaces but low humidity levels can stop the process. Professional archives maintain their collections between 30-50 percent relative humidity. In one library, the rear wall of the brick building was in need of re-pointing. Unbeknownst to the librarians, the rare books stored in closed glass cabinets on that wall were being subjected to dampness in each rainstorm. They were not periodically checked for damage

because the building had a temperature and humidity system. As soon as the staff became aware of the problem, the books were removed to special storage cabinets. Unfortunately, some of books sustained substantial mold damage. This is a rather extreme case, but it illustrates the importance of storage conditions. Even if you think your photographs are safe from humidity or other damage, it is wise to examine them at least once a year to make sure.

TEMPERATURE

High temperature and wide temperature fluctuations harm pictures by accelerating various deterioration factors. Ideally, photographs should be stored at a constant temperature of approximately 70 degrees. The chapter on color discusses the special temperature requirements for all types of images.

Most photographs consist of several layers. The emulsion, the layer that contains the image, is particularly susceptible to damage. Your pictures expand and contract in the summer and winter, just like the roadway in front of your house does in reaction to temperature changes. Temperature and humidity changes can cause your pictures to stick together. If this happens, do not pull them apart

It is fairly inexpensive to monitor the temperature and humidity in the areas where you store your images. Libraries and archives use devices such as a hygrothermograph or a wide range of electronic data loggers. There are also humidity indicators that don't record information, but can be checked periodically. These cards are available in hardware stores. The devices can be expensive sophisticated models or ones that can be mounted on a wall or placed on a table. Separate readings for temperature and humidity are provided.

LIGHT

Displaying our pictures is such an automatic action that few of us stops to considers what happens when we hang them on a wall or place them on a mantel. Having photographs of family events in frames for visitors to see is an illustration of our family pride. The bad news is this practice exposes photographs to light and in some cases, temperature fluctuations. Color is especially susceptible to fading. Light can change color and cause nineteenth century images to fade as well. The lovely blue cyanotypes can fade rapidly when placed on display. With some precautions, you can still exhibit those favorite photographs. Some guidelines appear in Chapter 11.

Librarians and photo curators are now aware that photocopying your pictures should be kept

to a minimum. While you will want to bring copies of your photographs with you to visit relatives or on research trips, be sure to limit photocopying. The combination of three types of hazards, heat, light and ozone, are inherent in the photocopying process.

POLLUTION

Don't underestimate the problems caused by exposure to chemical pollutants in our environments. This includes not only the dirt and soot present in air pollution, but the materials present in common household cleansers and tobacco. Exposure to these substances can corrode the surface of the images or leave deposits. If you spray air freshener repeatedly near a photograph, you are depositing chemicals on it. You will start to see gradual changes in the picture quality. Just as tobacco leaves nicotine stains on walls and furniture, it will affect the images in your possession. You can prevent damage caused by pollutants by using an air purifier and regularly cleaning the storage area. If you have a substantial family photograph collection, an air purifier can be a worthwhile investment.

Types of Damage	Results
Humidity	Mold, mildew, discoloration and warping, photographs stick together
Gases from Storage Containers	Staining, acid migration
Improper Photo Processing	Staining
Temperature Fluctuations	Cracking, warping
Photocopying	Light and heat. Keep to a minimum.
Handling	Deposits oil, dirt and fingerprints, leads to staining, marks, creases, bent corners and tears.
Animals/Insects	Staining and holes from feeding and excrement
Dust and dirt	Hard to remove from surface without damaging it.

SHOULD YOU CLEAN YOUR PICTURES?

As you begin going through your images, you will be tempted to clean off the surface dirt and grime that has collected over time. STOP! There are ways to safely dust off some of the material on the surface of the photographic materials, but it must be done with care or you will abrade the surface. The basic tools can be purchased at a hardware store and an art supply shop. You can also

purchase them from the suppliers listed in the Appendix. Remove surface dust and dirt with a soft bristle brush and gently sweep it across the image in even strokes. Some of what appears to be grime may actually be mold or staining. If it doesn't come off with gentle brushing, leave it alone. Dirt on the card surrounding the image can be cleaned with either a dry cleaning pad for use on documents (available from archival suppliers) or an eraser approved for conservation work. In 1997, an article suggested using Magic Rub and the Mars Plastic erasers.[2] Both are product names. They leave little residue on the surface. Manufacturers constantly change chemical formulations of their products, so before purchasing any product, verify that it hasn't been reformulated by calling the manufacturer. Do not try to erase the surface of the image because you might end up removing loose pieces of emulsion.

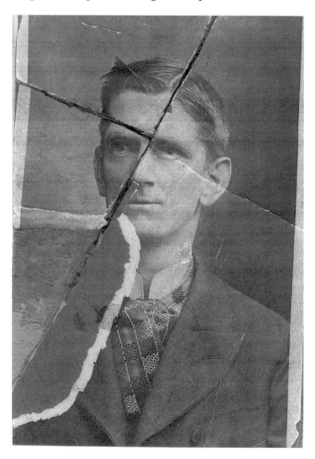

Photographs can break during handling. This portrait of a member of the Wilson family has been pieced back together and glued to a shoebox lid! Harry Mansfield Wilson, c. 1900 – *Collection of the author*

[2] Brenda M. Bernier, "A Study of Poly (Vinyl Chloride) Erasers Used in the Surface Cleaning of Photographs". *Topics in Photographic Preservation.* 7 (1997): 10-18.

STORAGE CONSIDERATIONS

By now, you are completely discouraged. Is any place safe for your family photographic heirlooms? The answer is yes! By adhering to a few rules of storage and materials, you can extend the life of your family photographs. If you want to display and frame a few special pictures, go right ahead. Just be sure to follow the guidelines. As you look at your photographs, handle them carefully by the edges and wear special gloves whenever possible.

Each type of photographic process has special storage requirements depending on the format and the materials. There are several general tips for all photographs starting with storage environment and types of containers.

STORAGE ENVIRONMENT

Of primary importance is where you store the collection. Can you think of any place in your house that meets the criteria of constant temperature, low humidity, is dark, and is out of the way of the hazards mentioned above? In most homes, the best place to store pictures is on a shelf in a windowless closet. The worst places to store images are basements and attics. Attics experience often extreme seasonal temperature variations and roofs can leak. Basements can be damp, but also periodically flood. One woman lost all of her family photographs when she left them on the basement floor during a recent move. An unusually strong rainstorm combined with an open window caused the problem. Any attempt to preserve the damaged photos usually requires consultation with professional conservators. They are trained to handle this type of damage. It may be possible to save photographs exposed to water damage.

Attics, basements and garages are not good storage places

AVOID THESE STORAGE AREAS

1. Basements: There is too much humidity and the possibility of a flood. A woman placed all her boxes of photographs in the basement when they were renovating their house. Unfortunately for her, when a major rainstorm hit the area her basement flooded. Instead of calling a conservator for advice, she lost all of those pictures.

2. Attics: They experience extreme temperature fluctuations: Cold in the winter and hot in the summer.

3. Garages: They expose your photographs to humidity, temperature fluctuations and toxic fumes.

CONTAINERS

Many suppliers offer special boxes, sleeves and envelopes, but how do you know which ones are best for your images? You will want to select materials that are guaranteed to protect your images. Many suppliers and manufacturers will highlight certain items by saying they passed the PAT. This means that manufacturers have tested the reactivity of the components of various types of paper and plastic to photographs. You want to look for this designation whenever purchasing supplies.

> **List of supplies for a home preservation kit**
> - Storage containers
> - Soft bristle brush
> - Disposable examination gloves
> - Hygrothermograph, data loggers or humidity indicators. The latter don't record but can be checked periodically and are available at hardware stores.
> - Graphite Pencil (for labeling boxes)

Plastics can cause a whole array of problems for photographic materials. When purchasing clear sleeves, make sure that you buy inert plastics such as polyester or polypropylene. Either is fine, but polyester is more expensive. Not all suppliers carry Polypropylene or Polyester sleeves. You should also verify the materials in the sleeves before purchase by calling the supplier directly. Suppliers that are accustomed to working with libraries and museums will readily address your concerns.

Since plastic, wood and cardboard give off gases that cause a variety of problems don't use containers made out of these substances to store your images. The best materials are boxes with reinforced corners available from archival suppliers. Museums and libraries also use baked enamel metal cabinets for storage. Make sure the box tops fit snugly so that dirt and dust do not settle on your prints.

The Basics All supplies must pass the PAT.	
Boxes	Reinforced corners or baked enamel cabinets, sized appropriately. Too big and your pictures slide around but too small and they get damaged from being cramped.
Paper	Lignin Free
Plastic	Polypropylene or inert polyester

WHAT TO AVOID

Unrefined plastic or cardboard boxes.

If the storage container gives off an odor, gases are being emitted and will damage the images over time. Additionally, the acids in the glue in the cardboard may stain them.

Acid paper folders or envelopes.

This category includes brown kraft paper and glassine. These materials pose several dangers. The chemicals used to bleach papers may cause the photographs to fade.[3] Lignin is a component of poor quality paper and will stain your images. If you place photographs in gummed envelopes, the glue can cause stains. The acid papers will, over time, stain the images as well.

Do not use rubber bands, paper clips, or other objects to keep your images together.

Rubber bands deteriorate and adhere to the surface of the photograph while paper clips rust and cause indentations in the images. Rubber bands can also cause tears in the images.

HOW TO SELECT STORAGE MATERIALS

1. Deal with a reputable supplier. See the list in the Appendix.

2. Purchase materials that have passed the PAT.

3. If buying plastic sleeves, make sure they are polypropylene or another type of inert polyester.

[3] Pete Kolonia, "How to Preserve Your Prints," *Popular Photography* (October 93): 47.

4. The ISO standard 18902 recommends filing enclosures should be buffered. While buffered enclosures can cause problems with a small number of pictures, the benefits outweigh the risks.

WHAT YOU CAN DO TO KEEP THE PICTURES YOU SHOOT NOW

- Print your significant digital images using a photo printer and high quality paper and inks.

- Buy storage materials that passed the PAT. (See Appendix for suppliers)

- Store photos and film at the proper temperature and humidity.

- Remember to label them.

- Back up your digital images.

By following these guidelines for all the pictures in your collection, you are guaranteeing that future family members can enjoy them. The basic requirements of temperature, humidity, and PAT-tested materials are easy to obtain and maintain.

HOW CAN I CARE FOR MY COLLECTION ON A LIMITED BUDGET?

Money is always an issue in caring for a family collection. There are a few ways to save.

- Compare prices

Ask the suppliers listed in the Appendix to send you their free catalog or search their websites and then comparison shop. Custom-size boxes and folders will cost more than those available in standard sizes. Many items are offered in a variety of styles. You can start small and add special items later.

- Buy in bulk by sharing orders.

Ask a friend or archive manager if they are interested in saving money by purchasing in bulk. Most suppliers offer volume discounts on popular items.

- Companies sometimes offer discounts.

Inquire about discounts. For instance, Light Impressions has offered me a discount in their last several catalogs. Find out if you qualify by calling their toll-free number.

If this still doesn't help, incrementally preserve your images by sorting them into PAT-approved storage containers.

- Try alternative suppliers. Art supply houses carry a wide variety of materials. In my experience, this is not true for office supply stores.

WHEN MAILING PHOTOGRAPHS

Scanners and electronic images make it easier than ever to share images with family members, but if you need to send an original image through the mail, take precautions.

1. Place each individual image in a protective polypropylene sleeve to protect against abrasion.

2. Sandwich the images in their sleeves between two pieces of stiff cardboard or foam core (available in art and office supply stores) and appropriately sized for the image. The photographs should be flat against the surface of the cardboard in their protective sleeves. If the photo is framed, then create tape from corner to corner diagonally across it multiple times. It should look like the union jack design in a flag. If the glass breaks this will prevent the glass from falling out and damaging your picture.

3. Select an envelope that will protect the images from bending, and from the elements.

4. Write in large letters across the envelope: DO NOT BEND PHOTOGRAPHS.

5. Mail the package using a method such as UPS Air, Registered Mail or FedEx that provides you with a return receipt and tracking information. If the package is lost, there may be a way to locate it. If you send it regular mail and it doesn't arrive at its destination, it may be lost forever.

> **Proper Packaging**
>
> If you are sending photographs, always include at the very least one piece, or better yet, two pieces, of corrugated cardboard or foam core board. Even securing a photo on mount board will not provide adequate protection. If you are sending a package containing glass, tape the glass and wrap it horizontally with bubble packing and then another layer vertically. Then place the package in a box filled with plastic peanuts. This method will offer maximum protection without adding much to the weight.

6. Don't worry about insurance. You can never replace a family photograph and most insurance will only reimburse for the actual cost of an image.

David Mishkin, of *Just Black and White*, a company that specializes in historic copying and duplication of images, advises his clients to take the following precautions when shipping images.

CHOOSING A STORAGE FACILITY

Is your collection too large to store at home or do you lack the right environment? In this case, you might want to consider renting space at an archival storage facility. Many museums and archives store at least part of their collections off-site. You can find one in your local area by contacting a library, museum or conservation lab in your area. Since your collection has sentimental, if not monetary value, you use a set of criteria to evaluate the facility. Ask the same kinds of questions that institutions ask before entrusting their collections.

Call ahead for an Appointment

In order to properly evaluate storage conditions, visit the facility. Your visit will provide an opportunity to see how other collections are stored. An integral part of a visit is a tour of the storage areas. If your request for a tour is denied, find another facility.

On the Visit

Bring a checklist of questions with you. This helps you remember to address the selection criteria. For example, estimate how many boxes of material you are planning to keep in storage and for how long.

Cleanliness

Are the storage areas neat and clean? You have the right to ask how often an area is cleaned and by what method. At one facility, when I inquired about pest control, the marketing person looked at me oddly and claimed they didn't have any. Since most collections, even those from your home, are exposed to insects and rodents, this was an overstatement on his part. An entire warehouse of collections needs to be regularly inspected for vermin. Ask about their inspection schedule. Be sure to ask about how they manage pest control. Many storage facilities only spray when necessary to avoid the toxic and damaging effects of the chemicals.

Security

Observe how the facility handles your visit. Do you have to sign a visitor log? You want your collections to be safe from theft, so find out how you gain access to your material when it is

in their hands. Any facility that allows general access without supervision is not very secure. Professional record storage involves formal procedures for retrieval of items from storage.

Disaster Preparation

What is the facility's plan in case of a natural disaster or fire? You can ask to see a copy of their plan for these events. Well-managed companies update these plans on a regular basis. Does the space have a fire detection and suppression system? Natural disasters usually occur when we least expect them, so it is important to ask questions about the facility's proximity to flood zones. The best storage facilities are constructed using inflammable materials and are not located in areas prone to floods.

Environmental Controls

Remember that you will be paying to store your collections at this facility so you want better storage conditions than you are able to supply at home. Of primary concern is the existence and stability of the temperature and humidity system. Air conditioning and heat are not necessarily adequate for storage unless environmental controls are maintained. It is a good idea to inquire about temperature variation during extreme hot and cold weather. True museum-quality storage facilities record temperature and humidity levels.

Retrieval

Accessibility is more than just being able to retrieve items from your collection. Well-organized facilities use inventory systems to manage the material in their care. These systems enable the staff to quickly find items for customers. While you probably won't need to access your material in the middle of the night, you will want to know if there are specific hours for retrieval or if you can stop by anytime. Most facilities ask that clients call in advance of a visit to give them time to locate the material.

Costs

These services are expensive. When you call to set up a tour, ask the representative how they charge for space and other services. Depending on the cost, you may want to compromise on certain features like retrieval in order to lower your costs. Before you sign the contract make sure the paperwork doesn't transfer ownership of stored materials to the facility after a certain amount of time.

As you are about to end your tour, ask for a list of references. You can always benefit from the opinion of a museum or library professional who uses the facility for storage. I've seen all kinds of so-called archival storage facilities. If the staff doesn't understand how to manage a facility with good environmental conditions, pest control and security, then it probably isn't the right place for your collection. The worst space I've ever seen was a 100 year-old warehouse that had wooden floors and walls, no temperature and humidity control, and was very dirty. They considered themselves an archival record management facility. Over the telephone, they sounded perfect, until I made an on-site visit.

Low Cost Storage Solution from David Miskin of Just Black and White www.justblackandwhite.com

If you can't find appropriate space in your home, consider renting a safe deposit box. Banks maintain these storage areas at the same environment as their offices, usually at a fairly stable temperature and humidity. Safe deposit boxes can be rented for a yearly fee, provide dark storage and security.

CHAPTER THREE: CASED IMAGES: DAGUERREOTYPES, AMBROTYPES AND TINTYPES

At almost every lecture, someone approaches me with a question about a small box or book-like item they found in with the family photographs. Some people arrive with the item in hand and are unsure how to open it. Others know it is a photograph, but wonder what kind. Paper photographs are familiar while the images in these small cases are not necessarily part of every family photograph collection. Their images and the beauty of the presentation are valuable family artifacts. If you have one or two in your collection, treat them with care and respect. They are the earliest types of photographs and provide you with a glimpse into life in the mid-nineteenth century.

Typically three types of images were placed in cases: daguerrotypes, ambrotypes and tintypes. They have several parts-- the case, the image, the cover glass, and a mat that creates a frame around the image. These items also contain a preserver, a thin strip of metal with a paper seal that creates an airtight fit of the various pieces. While the glass protects the surface of the image from abrasion, the preserver prevents environmental pollutants from contaminating these images. Unfortunately, this was not always successful. Some seals lost their airtight qualities as the tape aged. While you can find a daguerreotype, ambrotype or tintype in their cases, locating one in mint condition is difficult. Cased images are subject to various types of damage.

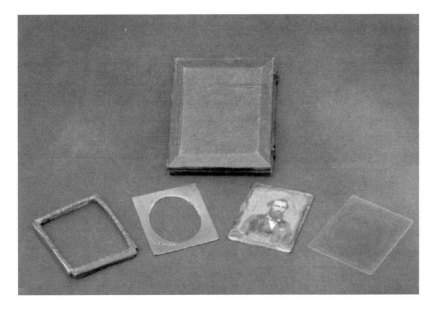

Cased images have several parts – the case, the image, the cover glass, and a mat that creates a frame around the image. *Collection of the author*

DAGUERREOTYPES

In 1840 Francois Gouraud, a contemporary of the, Louis Daguerre arrived in the United States with daguerreotypes. He traveled throughout the country giving demonstrations on how to create a daguerreotype, a photographic image on a silver plate.

A daguerreotype is a sheet of polished silver covered in light-sensitive chemicals and exposed to light. The resulting portraits were initially crude and miraculous. Never before had individuals seen such a clear and unflattering portrait of themselves. The final product was a realistic portrait of an individual that could be obtained in a short period of time. Unfortunately, the first cameras had long exposure times. This meant holding a particular pose and expression for a length of time. One move resulted in a blurry image.

These images were one of kind. The technology did not exist to make multiple copies. Daguerreotypists learned to make duplicates of the image by having an individual sit for additional portraits or by making copies of the original. Mass-production of daguerreotypes often became the responsibility of an engraver who made prints based on the image.

> If you want to know more about the fascinating history of the daguerreotype read Beaumont Newhall's *The Daguerreotype in America* (New York: Dover Publications, third printing 1976)

Even with these limitations, the daguerreotype became an instant success. Whole industries developed to produce the metal plates, chemicals, and cases necessary for this new process. Many individuals with the technical knowledge and the financial resources to purchase equipment and supplies established themselves as daguerreian artists. Enterprising individuals attracted customers to their regular businesses by offering to take their picture while they were in the store. Itinerant daguerreotypists set up portable studios in more rural areas. America's love of the photograph was insatiable.

Daguerreotype Sizes (in inches)

Imperial/Mammoth plate	Larger than 61/2 x 81/2
Whole Plate	61/2 x 81/2
Half Plate	41/2 x 51/2
Quarter Plate	31/4 x 41/4
Sixth Plate	2 ¾ x 31/4
Ninth Plate	2 x 21/2

Daguerreotypes came in variety of sizes from a mammoth plate (8 $^{1/2}$ inches in height) to the small ninth plates (2 $^{1/2}$ inches in height). The most popular sizes for portraits were the quarter, sixth and ninth plates. You can easily determine the size of the daguerreotypes in your collection by measuring them with a ruler or measuring tape.

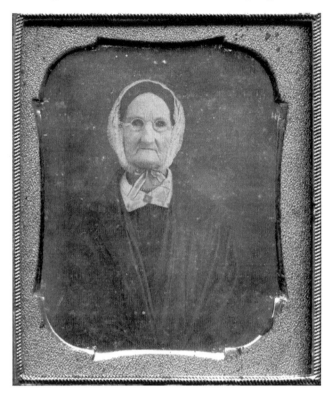

Example of a daguerreotype. Unidentified woman 1850s. *Collection of the author*

Individuals not familiar with the different types of cased images often confuse daguerreotypes, ambrotypes, and tintypes. If you have not seen one before, it can be difficult to determine what type of image is in the case. Recently, at a bank function, the manager held up a printing plate of the institution's founder and declared it an ambrotype. Since a printing plate has an engraved surface and an ambrotype is glass, it was obvious that the manager lacked familiarity with various types of cased images. Fortunately, daguerreotypes have a distinctive appearance. Their reflective mirror-like surface is easy to identify once you know what to look for. Another clue is that the preservers did not always keep out pollutants and moisture so the plates are usually tarnished and in need of conservation. If you have a cased image that is unreadable, it may be a daguerreotype. A professional conservator may be able to chemically reverse this tarnishing. You can identify a daguerreotype using the following criteria:

HOW TO IDENTIFY DAGUERREOTYPES

1. **Shiny, reflective surface.**

 Mirror-like appearance, you will be able to see yourself reflected in the plate.

2. **Must be held at a particular angle to see the image.**

 A daguerreotype can only be seen when it is held at an angle under indirect light.

3. **By tilting them at a different angle, the image will change from a negative to a positive.**

 If at first you can't see the image, try viewing it from different angles.

4. **Usually in a case, although not always.**

 Daguerreotypists placed the images in the case to protect the surface, but they are often found without cases. As the images tarnished, they were removed from the cases and either discarded or mistreated. The later cases with their intricate designs became collector's items.

5. **Sometimes colored or tinted.**

 Customers wanted the images to look more realistic with the addition of tints applied to the surface. You can often see pink cheeks and gold jewelry.

6. **Can be confused with cased ambrotypes and tintypes.**

 Even after applying these identification criteria, you may be unsure whether you have a daguerreotype without taking it out of the case. Do not attempt this unless you have professional assistance. You can inadvertently damage the image.

SPECIAL CONCERNS

Conservators can stabilize a daguerreotype either by stabilizing all the parts separately and then reassembling them. There are certain conditions that warrant conservation work.

Tarnishing

This daguerreotype has a halo pattern of tarnishing. Mrs. Stevens Everett, ca 1850 – *Library of Congress*

Metal tarnishes when exposed to air and the chemicals in it. A daguerreotype consists of a coated silver plate that reacts to sulfur in the air. Therefore, most daguerreotypes have some degree of tarnishing. In the worst cases, it will completely obscure the image. Conservators may be able to reverse this tarnish.

A particular type of tarnishing looks like a halo around the image. A Halo of Corrosion on the metal plate forms from exposure to air pollution or high humidity. Depending on the amount of exposure to pollutants and the quality of the airtight seal, the color can range from light yellow to darker shades that totally obscure the image.

Conservators use water-based solutions to clean a daguerreotype. The chemical cleaning of a daguerreotype is considered a major invasive treatment that is not without risk. In most cases, conservators will opt for dusting the surface with a gentle jet of air or through a rinse of deionized water. Most conservators consider using chemical cleaning methods only when heavy disfiguring corrosion is present.

Weeping

Another type of damage commonly seen is the glass decomposition or "corrosion." Dust

particles trapped on the glass also add to the problem. In these instances, the damaged glass is replaced or dirty glass is cleaned. When the daguerreotype is put back together, the paper seal is replaced and secured.

Abrasion

The chemicals that create the image rest on the surface of the metal plate. Rubbing, brushing or exposure to abrasive substances will remove the image and scratch the plate. In fact, photographers could re-use the plates by polishing and thus eroding the image.

Loose Preserver

If you are lucky enough to have a daguerreotype with its original parts, the preserver may be loose. You can gently press the preserver back in place. A better choice is to have a conservator restore your image to its original lustre by cleaning the glass and adjusting the preserver.

Scratches

Separate from abrasion, scratches can occur on the plate through mishandling and neglect. These scratches in the surface of the metal plate cannot be removed through conservation. Digital restoration can eliminate them.

AMBROTYPES

Another type of cased image is called an ambrotype. Popular in the mid-1850s, they consist of a piece of glass coated with a photo chemical known as collodion, a mixture of gun cotton and ether. The end result is a negative image until backed with a dark piece of cloth or fabric. The image is then viewed as a positive. The rest of the image includes the cover glass, mat, case and preserver. Just like the daguerreotype, ambrotypes were a one of a kind image. They were available in the same sizes as a daguerreotype.

Identification

It is very difficult to tell if the cased image you possess is an ambrotype or a tintype because the colors are similar. The best way to identify an ambrotype without taking it apart is to look for missing pieces or holes in the backing material. These dark areas will appear transparent. The light areas are the collodion. If you can't take the image apart, use a magnet. Tintypes are magnetic and ambrotypes are not.

For a background history of the ambrotype, consult William Crawford's *Keepers of Light, History and Working Guide to Early Photographic Processes*

47

SPECIAL CONCERNS

The backing has flaked off the back of this ambrotype. 1850s. *Chris Foran*

A professional conservator should be the only one to clean or tamper with a cased ambrotype. The image only exists as a coating on the surface of the glass. Once again, unless you have extensive experience with ambrotypes, leave it in the hands of a professional conservator. Several types of damage can afflict an ambrotype and other glass negatives.

Missing Backing

When the ambrotype was ready to be placed in a case, the surface could be backed with either a dark fabric or paper. It could also be coated with a layer of dark varnish. This made the positive image visible to the viewer. As the ambrotype aged, pieces of backing separated from the image causing transparent areas where you can see clear through the glass to the backing. If you attempt to replace this backing you could pull away any emulsion that has adhered to it.

Broken Glass

Both the covering glass and image glass can break. If the image glass is in the case, and the pieces are intact, take it to a professional conservator. If the image class is not in a case, treat it as a glass negative by sandwiching it between two pieces of glass to hold the pieces together. See instructions in Chapter 6.

Emulsion lifting from the glass

Since the collodion emulsion is brushed onto the glass surface to create the image, it can lift off the glass as the surface is exposed to abrasion and fluctuations in temperature and humidity. You can stabilize this damage by sandwiching the glass between two clean pieces of similarly-sized glass.

TINTYPES

The third type of cased photograph resembles a daguerreotype only because it is an image on metal. Unlike the daguerreotype and ambrotype, multiple tintypes could be made at a sitting. A tintype was inexpensive to produce, and it took less than a minute to walk out of a photographer's studio with one in hand. Some photographers used special multi-lens cameras to produce additional individual exposures. Tintypes, like daguerreotypes and ambrotypes, were not made using a negative.

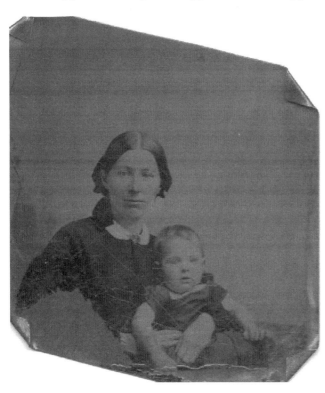

This is photographer's proof. Note the bent corners. Unidentified woman, 1860s. *Collection of the author*

History

Tintypes or Ferrotypes have a fascinating history. It was the first photographic process invented in the United States and its longevity is only surpassed by the paper print. A chemistry professor in Ohio patented the process in 1856 and it survived

> To find out more information on tintypes read, Floyd Rinhart, Marion Rinhart and Robert W. Wagner's *The American Tintype*

until the middle of the twentieth century. While the name suggests the metal was tin, it was actually iron sheets cut into standard sizes. The sizes initially corresponded to ambrotypes and daguerreotypes so that in the early period they could be placed in cases. Other sizes were introduced later such as the "thumbnail" tintype made to fit into a specially-created album. These tintypes were literally no larger than a thumbnail, thus their nickname. Tintypes are usually found in either a case, a paper sleeve with a cut-out for the image, or lack their protective covering.

Tintype Sizes

These are primarily the sizes for cased images. Tintype sizes varied for paper sleeves and mimicked the size and format of card photographs.

Whole plate	$6^{1/2}$ x $8^{1/2}$ inches
Half plate	$4^{1/2}$ x $5^{1/2}$ inches
Quarter plate	$3^{1/2}$ x $4^{1/2}$ inches
Sixth plate	2 ¾ x $3^{1/4}$ inches
Bon-Ton with paper sleeve	$2^{3/8}$ x $3^{1/2}$ inches (could be as large as 4 x 5 inches)
Ninth plate	2 x $2^{1/2}$ inches
Sixteenth plate	$1^{5/8}$ x $2^{1/8}$ inches
Gem or thumbnail	1 x 1 inch (or smaller)

If you have a Civil War relative, then it is likely that you have a few tintypes in your collection. Itinerant photographers traveled with the troops and set up to take pictures whenever there was an opportunity. Soldiers often sent these durable images home via the mail without the

fear that they would break like an ambrotype.

These images were replaced in standard photography studios by paper prints, but retained their popularity at tourist resorts until the early part of the twentieth century. If you have a tintype, don't assume that the image dates from the mid to late nineteenth century. Always rely on the photographic identification techniques explained in *Uncovering Your Ancestry Through Family Photographs.*

Identification

Unfortunately, the process of identifying a tintype still in its case is done using the process of elimination. If the image is not reflective or is missing pieces of backing, then it is may be a tintype. However, ambrotypes in pristine condition have a similar appearance.

DAGUERREOTYPES, AMBROTYPES AND TINTYPES: HOW TO TELL THEM APART

In cases where the primary identifying characteristics are not apparent, the only way to discern the type of cased image is to take it out of the case. In those instances, a professional conservator should be consulted. Be very careful not to damage the case or the image in the process. Removing images from their cases can expose them to deterioration factors in the environment.

Major Characteristics

Daguerreotype	Ambrotype	Tintypes
Mirror-like surface	Negative on glass; appears as a positive image	Negative on iron; appears as a positive image
Must be held at an angle to be seen	Backed with a dark background	Fixed on a black metal background
Usually cased	Usually cased	Paper mat or case
Image is reversed*	Not reversed*	Image is reversed*
1839	1854	1856

- There were reversing lens so this characteristic also depends on the type of lens used to capture the image.

IDENTIFYING INFORMATION IN A CASED IMAGE

Occasionally, there is a surprise waiting for you when the conservator removes the image from the case--the name of the photographer or other identifying information. Silas Brown, of Providence, included an advertising card as part of the backing in the ambrotypes he created. Other individuals report finding the names of the person represented in the portrait written on the backing. In other instances, the owner of the image inserted a small slip of paper in the case so that you could see the name when you opened the case to view the portrait. However, the identifying information for the vast majority of cased images has been lost.

SPECIAL CONCERNS

Tintypes or ferreotypes are more durable than ambrotypes and daguerreotypes, but are still susceptible to damage. The primary types of damage occur through exposure to moisture, mishandling and abrasion.

Rust

Since the major component of a tintype is iron, exposure to moisture causes damage. Think about what happens to metal that is left out in the rain. It eventually corrodes. The same corrosion happens to a tintype if it comes into contact with water or is repeatedly exposed to high humidity. A professional conservator can stabilize rust.

Bent Plates

A tintype is created on a thin piece of iron that can be bent if submitted to pressure and mishandled. Bending can crack the surface of the black coating, exposing the iron plate to corrosive elements.

Abrasion

The image formed by the coating of collodion on the surface of the metal sustains the most damage from abrasion. This damage can occur when two plates rub against each other and when stored improperly. The image will become scratched, and in the worst cases, the emulsion will flake off. Digital restoration techniques can repair some of the damage.

The surface of a tintype can flake off when exposed to rough handling. Unidentified man, c. 1870. *Collection of the author*

Cracking of the varnish and emulsion

Each tintype was coated with a layer of varnish before being handed to the customer. The varnish helps to protect the picture, but also leads to another type of damage. The varnish and emulsion will crack when mishandled or stored in an area with fluctuating temperatures and humidity. Thin sheets of metal expand and contract in hot and cold conditions. These changes crack the emulsion and you can lose pieces of the image. In cases where large areas of the picture are missing, photographic restoration on a copy can recreate detail if the majority of the image is still intact.

The surface of a tintype is susceptible to many types of damage and should be handled carefully. Unidentified family 1890s. *Collection of the author*

Handling suggestions: *Don't clean them yourself!*

It is so tempting. The dust on the glass of the ambrotype or daguerreotype just seems to be sitting on the surface. It looks easy enough to take it apart and even simpler to clean. Don't! Individuals often attempt to clean a cased image with disastrous results. They inadvertently cause irreparable damage to the image and lose it forever. What looks like dirt on the glass could be a sign of major deterioration. The fragile surface of all types of cased images makes it difficult to assess the extent of the damage. Contact a professional conservator before attempting any restoration work yourself.

With these cautions in mind, the best rule to follow is:

***Leave all restoration to a professional*.**

CASES

An amazing variety of case designs existed in the mid-nineteenth century. Cases refer to any type of unit manufactured to hold ambrotypes, daguerreotypes and sometimes tintypes. Cases ranged from specially-designed photographic jewelry to others available in standard sizes. The earliest cases in the 1840s were relatively simple compared to the later more elaborate "union cases" of the late 1850s and 1860s.

In the 1840s, cases consisted of wooden frames and leather embossed with a design. A simple hook and eye served as the clasp. When opened, the side facing the image was velvet in a rich color such as red, purple or green. These cases can still be found in good shape. The leather is often worn from use, but it is usually the hinges that fail to hold the case together.

More fragile cases were made of paper-mache. Manufacturers tried to make these cases waterproof by adding chemicals. They also experimented with making them fireproof. Unfortunately, these chemicals also helped the paper-mache deteriorate with age. The combination of the acid and lignin content of the paper with the chemical additives created cases that have rarely survived intact into this century.

The most durable case and the one most likely to survive intact was the "union case". Patented by Samuel Peck in 1852, the case consisted of gum, shellac, and fiber (wood and other types). At first appearance, these cases appear to be made of plastic. They are beautiful in appearance. The materials used to manufacture the cases could be molded into any shape. This led to elaborate surface designs. As cased images became less common, the cases themselves became collectible and usable for other purposes. For this reason, many individuals removed the

daguerreotypes, ambrotypes and tintypes from these cases, thus losing a vital part of the image.

Chart of Standard Case Sizes

Style	Average size in inches
Whole	7 x 9
Half	5 x 6
Quarter	4 x 5
Sixth	3½ x 3¾
Ninth	2½ x 3
Sixteenth	2 x 2

SPECIAL CONCERNS

Broken or Damaged Cases

Since photographers employed cases for protection and presentation of the images they took, the cases sustained most of the damage when an image was dropped or mishandled. While you can find examples of cases in perfect condition, the vast majority was damaged. The most repairable cases are the "union cases" whose hinges

> The best overview of the development of cases is Floyd and Marion Rinhart's *American Miniature Case Art*.

need replacing. Papier-mâché usually crumbles and cracks when handled. Unless you consider the case an important family artifact, you probably want to spend time and money on proper storage rather than conservation.

Storage Considerations for Cased Images

Unlike ambrotypes that break, and tintypes with emulsion sensitivity, the daguerreotype plates are fairly sturdy but the images or not. The primary concern with all photographic materials is that the storage environment maintains a certain level of temperature and humidity. However, you can take other precautions to lengthen the life span of stored cases.

Images in cases should be stored in individual boxes with reinforced corners. These boxes can be purchased ready-made from suppliers (see Appendix) or created from sheets of PAT

heavyweight paper. This four-fold system (see diagram) works well to protect both images in the case and those that lack them. Cased images don't actually need the covering, but since the case is also considered an artifact and identifier, use boxes whenever possible. Boxes give you the added advantage of a surface on which to write a caption. Placing the caption on the box exterior means you will have to look at the image less and can thus reduce wear and tear.

Images that are no longer in cases also need additional protection. A four-fold paper covering will protect the materials from abrasion and the ambrotype from breaking. After covering, place the object in an acid and lignin-free envelope. Ambrotypes not in cases, should be treated like glass negatives.

FREQUENTLY ASKED QUESTIONS

How can I permanently attach a label to a cased image?

Once you have spent time researching and establishing identifying information on a previously unidentified image, you desperately want to retain it. There are two ways to handle this with a cased image. You can enclose a slip of acid and Lignin-free paper in the case so that it shows when opened. But, unless you have a way to slide part of the slip into the left-side housing, this paper will fall out each time the image is opened. Another option is to write the data on the storage box or sleeve exterior. This method has a few benefits. You keep the image in the storage envelope that protects it from damage. You can see the information without having to handle the image. As long as you don't separate the image from its storage enclosure, the information won't be lost.

CHAPTER FOUR: PHOTOGRAPHIC PRINTS

All of us are familiar with paper prints. Every year we produce them by the thousands, documenting our family milestones and vacations. The paper prints of our ancestors and the ones we take today are similar, but the chemicals and processes that create the images are different. Lay all your prints side by side and you will create a rainbow of colors since each photographic process employed different techniques to produce a result. Each of these prints has a couple of things in common. They were all produced with a negative and are susceptible to particular types of damage. By following the basic preservation guidelines presented in Chapter 2, you can extend the life span of these images.

The negatives used to produce these prints ranged from paper to glass to contemporary film materials. Just like prints, these negatives require protection from damage. Understanding the different types of photographic materials in your collection will help you take steps to care for them.

Paper prints fall into several categories. In the nineteenth century, two types of paper prints existed: Printing-out papers and developing-out papers. In the first instance, light sensitive chemicals applied to paper allowed the image to appear during exposure to light. Developing-out papers required chemical processing to bring out the image. There is a revival of nineteenth century printing out processes. Photographers experimenting with these photographic processes are causing a renewed interest in the photographic community. If you want to try to duplicate the methods that created your ancestral portraits, you can find directions in *Historic Photographic Processes* by Richard Farber.

THE NINETEENTH CENTURY

Capturing images on paper is one of the oldest photographic processes, but it took a couple of decades for it to become popular. At about the same time that Daguerre developed his images on metal in 1839, an inventor in England, William Fox Talbot, experimented with paper photographs. His very rare prints, called photogenic drawings, used ordinary table salt (sodium chloride). Eventually, he discovered a way to make paper negatives called calotypes. This is essentially the same system, negative and paper print, used today.

Egg white, another commonly available household substance, played an important role in

the development of paper prints. Albumen prints created from paper coated with egg white and light-sensitive silver nitrate became popular from 1850 until almost the turn of the twentieth century. The photographer, immediately prior to use, made this type of paper print on site. Factory-made paper did not become available until the 1870s.

All prints were contact prints, meaning they were the same size as the negative. When you are looking at an 11 x 14 inch print from the 1870s, the negative was also 11 x 14 inches. Since artificial light was not available until the late nineteenth century, sunlight was a key ingredient of the photographic process. The right set of environmental circumstances, including adequate sunlight and good weather, became necessary for a good print. Most printing occurred outdoors. Cold temperatures negatively affected the photographic process.

The first twenty years of the photography utilized silver compounds to create the image. After this initial period, photographers experimented with the light sensitive qualities of other chemicals. The platinum print, created with metallic platinum, had the advantage of resisting fading. The lovely blueprint photograph, the cyanotype, consists of iron salts. These photos fade when exposed to sunlight. Collodion, the same substance used to create ambrotypes, became synonymous with photography. The light sensitivity of the silver halide in the collodion made it useful for prints and when creating glass plate negatives. The composition of photographic papers and techniques employs chemical processes that most of us are unfamiliar with. For that reason, it can be difficult to identify a particular photographic process.

By the end of the nineteenth century, card photographs came in a variety of shapes and sizes. *Collection of the author*

IDENTIFYING THE PROCESS

Conservators and photographic historians invest time learning to identify the various types of paper prints available in the nineteenth century. For most genealogists, this knowledge only becomes important when trying to establish a date for an image. However, as illustrated in examples in *Uncovering Your Ancestry Through Family Photographs,* it is other details in the images that often confirm the date. Correct identification of the photographic method is essential when attempting conservation, but is not an integral part of deciding how to store most of these images.

In some cases, identification can be done on the basis of print color. The brilliant blue of a cyanotype is unmistakable. It is not simple to identify prints that have changed appearance due to the addition of toning chemicals. Toning can modify the color of the final print by depositing chemicals on the print. Professional conservation workshops teach students to identify the processes by explaining the composition of the prints. A small hand-held microscope can be purchased from the suppliers listed in the Appendix. Only with experience in looking at a magnified section of a print can one be likely to make identification. At one of these workshops, a conservator, when asked how he was able to correctly identify photographic processes, replied that it requires time, patience and experience. For this reason, only a professional with the proper background should do conservation work.

Type of Photograph	Date Introduced	Characteristics
Salted Paper Print	1840-1855	Yellow-brown, red-brown Fades
Cyanotype	1880	Blue
Platinotype	1880	No fading
Albumen Print	1850 - 1895	Fades Tiny cracks in the image Colors same as Salted paper print Paper fibers visible
Carbon Print	1860	No fading Large cracks in dark areas

Woodburytype	1866	No fading Some cracking in dark areas
Gelatin Printing Out Paper or Collodion	1885	Purple image No paper fibers visible
Matte Collodion	1894	No fading Some paper fibers visible
Gelatin Developing Out	1885	No paper fibers Reflective dark areas resemble a silver color
Woodburytype	1866	No fading Some cracking in dark areas
Gelatin Printing Out Paper or Collodion	1885	Purple image No paper fibers visible
Matte Collodion	1894	No fading Some paper fibers visible
Gelatin Developing Out	1885	No paper fibers Reflective dark areas resemble a silver color

CARD PHOTOGRAPHS

Probably the most common type of nineteenth century photograph in your collection is known as a card photograph. The thin paper used to produce the majority of nineteenth and early twentieth century prints necessitated mounting them to heavy card stock or cardboard to help support the print. These images, regardless of the type of photographic process, came in standard sizes. The cartes de visite cards are the smallest. They resemble in shape and size, the nineteenth century visiting cards from which they derive their name. Individuals of a certain economic status carried small cards engraved with their name as a means of introduction. The Duke of Parma decided to use photographic cards and started the trend of the cartes de visite. Introduced into the United States

> James M. Reilly's *Care and Identification of 19ᵗʰ Century Photographic Prints* offers a succinct description of the different processes and a color identification chart.

William C. Darrah's *Cartes De Visite in the Nineteenth Century* presents examples of the various subjects covered by photographers.

in 1860, they became wildly popular setting off a craze referred to at the time as "Cartomania". Our ancestors not only rushed to photographers' studios to have their picture taken, they began collecting images of friends, relatives, and notables. Photographers began filling the demand for images by creating sets on various topics. The social ritual of visiting included adding a photograph of yourself to the family album on display as well as spending time looking at the collection.

Photography became more than a way to document family members, it evolved into entertainment. A particular type of card photograph, the stereograph was part of that transformation. Developed in the 1850s, the term refers to two almost identical images mounted side by side. When viewed through a special lens, the image appeared three-dimensional. Photographers created sets on topics ranging from fictional stories to travel. My mother recalls that during the Depression, her family owned an extensive set of stereographs. She and her siblings played with the stereographs on a regular basis. Unfortunately, they disappeared. The reverse side of these cards usually contained a description of the image. The cards remained in existence until the early to mid years of the twentieth century.

Carte de visite photos were very popular in the 1860s. Unidentified woman, early 1860s. *Collection of the author*

Some types of card photographs and sizes in inches

Cartes-de-visite	4 ¼ x 2 ½	Process introduced in U.S. 1859
Cabinet Card	4 ½ x 6 ½	1866
Victoria	3 ¼ x 5	1870
Promenade	4 x 7	1875
Boudoir	5 ¼ x 8 ½	Not known
Imperial (life-size)	$6^{7/8}$ x $9^{7/8}$	Not known
Panel	8 ¼ x 4	Not known
Stereograph	Either 3 x7 or 4 x 7	Smaller 1859 Larger 1870

CANDID PHOTOGRAPHIC PRINTS

Until the late 1880s, there were two ways to have your portrait taken. You could visit a professional studio or use the services of the amateur photographer in your family. These portraits lack spontaneity because it was an involved process. Remember that the size of the print was the size of the glass negative. Show a group of children a few nineteenth century images and they will mimic the stiff pose and lack of facial expression. They will want to know why it wasn't fun to have your picture taken.

The number of photographs in family collections increased with the advent of the snapshot. Eliza Jane Taylor and her brother in law, 1950s. *Collection of the author.*

Kodak changed all that when George Eastman introduced our ancestors to candid photography with his "you push the button, we do the rest" slogan. He eliminated the need for technical knowledge from the picture taking process. Each camera came loaded with negatives on a film that was sent back to the factory when the roll was full. The pictures appeared in the mail along with the camera loaded with a new roll of film. Our ancestors now had the freedom to depict and play with photography. Anyone could use the box camera and it changed the way our families thought of photography. This changeover is apparent in your family collection. The increased number of pictures and the style of the images reflect how photography became a leisure activity for adult and children. Kodak marketed Brownie cameras directly to children.

Kodak print size related to the type and size of the camera used. As long as film remained available, the camera stayed in use. For instance, the 101 camera wasn't discontinued until sixty years after its introduction in 1895. A complete list of Kodak camera and print sizes appears in Brian Coe's *Kodak Cameras: The First 100 Years*.

Amateur cameras manufactured by Kodak and other companies allowed our ancestors to photograph their daily lives. *Collection of the author*

SPECIAL CONCERNS

Different types of nineteenth century and early twentieth century prints develop problems based on the chemical processes used in their creation. Each photograph is a combination of

photographic chemicals and paper. Both elements can affect the longevity of the print as much as conditions under which they've been stored since their creation.

Certain types of damage occur to all paper prints as a result of improper environmental conditions and handling. There are also specific types of damage to which different types of prints are susceptible. Then, there is damage that occurs under extraordinary circumstances like floods.

Tape can damage photographs. Unidentified woman, c. 1930. *Collection of the autho*r

Most of these prints consist of an image, a paper support and adhesive that fixes the print to the support. Each element affects the stability and permanence of the image.

Improper Washing

My parents' wedding pictures developed horrible brown stains about a decade after they were taken. These stains stemmed from the photographer's failure to rinse the pictures long enough to remove the chemicals. Archival processing includes washing the prints for at least fifteen minutes in clean water to ensure the chemicals won't cause stains. A professional conservator can possibly remove these stains.

High Humidity

Many prints experience various types of damage, including curling, from exposure to humidity. In some instances, the highlight areas of the pictures fade and turn yellow. The loss of

detail can be significant and the whole picture will gradually fade from view. Albumen prints are very sensitive to humidity.

Silver Mirroring or Silvering

If your black and white photos have a blue-silver cast when held at certain angles, silvering is present. In the worst examples, the entire image disappears beneath this mirroring. This damage occurs when the silver in the photo rises to the surface. Conservators can reduce silvering especially in areas where it obscures details.

Cracked Emulsion

The emulsions of several different types of prints, including those with a gelatin or collodion image, develop cracks in the surface due to fluctuations of temperature and humidity. This process can cause pieces of the image to flake off. Gelatin prints swell with moisture and become brittle. The image on an albumen print can crack in environmental conditions. Collodion is also very sensitive to moisture and has a tendency to become brittle and crack.

Abrasion

All photographs experience damage when shuffled against one another or against other types of items. Prints stressed by humidity and temperature variations are more sensitive to abrasion. Gelatin prints and those with a collodion surface can actually lose pieces of the image area in these conditions. Proper storage with polypropylene sleeves, acid and lignin-free paper and in boxes can protect images from abrasion.

Curling

Photographs printed on thin paper will curl when exposed to humidity or during the drying process. For this reason, most prints were mounted on heavy card stock. Some photos, especially panoramas were rolled intentionally for storage. This requires a photo conservator.

Transference

Platinum prints or platinum toned prints can transfer their image. Examine the backs of the images in your collection. Do you see the ghost of the image there? This transfer also occurs when prints are placed face to face and can interfere with your ability to view the image.

This is not a photograph. It's the ghost of the image that was resting against the back of this cardboard. *Collection of the author*

Fading

Light can also contribute to the fading of prints. Cyanotypes are particularly sensitive to light fading. These images should be stored in darkness rather than exhibited.

Foxing

Small reddish brown spots on the surface of the print indicate foxing damage. This is a result of chemical interaction with high humidity, not mold damage. Albumen prints usually show signs of foxing.

Mold and Mildew

Leave your prints in a damp environment long enough and they will develop mold and mildew. In order to kill the mold, have a professional conservator treat the picture. You can retard mold growth by storing your images at constant temperature and low humidity. Mold and mildew will stain the images.

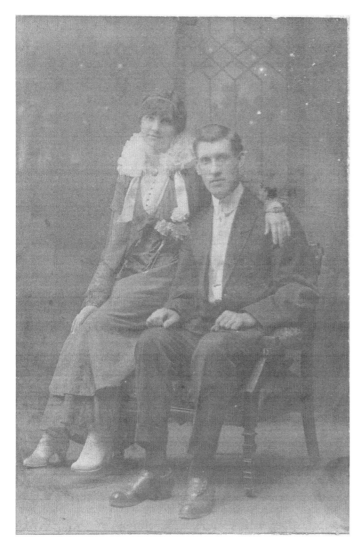

The white dots on this photo are mold. Unidentified couple, c. 1930. *Collection of the author*

Fingerprints on images

Closely examine your prints and negatives. You may see fingerprint evidence of the individuals who previously handled these images. Handling prints and negatives without gloves allows a thin layer of oils to build up on the surface. This moisture attracts dust and adheres to the surface leaving a lasting impression of friends and relatives. If your contemporary prints have been handled without gloves, gently clean off the surface using a lint free soft cloth. [4]

[4] Klaus B. Hendriks and Rudiger Krall, "Fingerprints on Photographs" *Topics in Photographic Preservation* (5): 8-13.

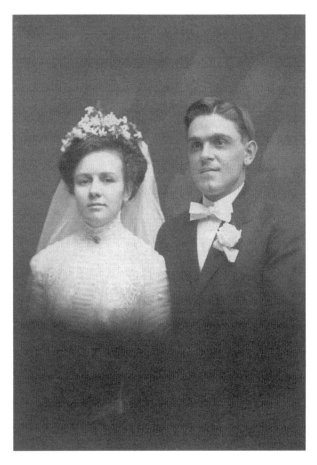

The photographer inadvertently left his hand print visible in this early twentieth century wedding portrait. *Collection of the author*

Paper Supports

Around 1865-70, wood pulp became the predominant form of paper and paper board available for use with prints. The material was used to prevent prints from curling after processing. The sizes of the images and the mounting boards varied from the small card photographs such as cartes de visite to oversize prints suitable for framing.

The primary print damage caused by mounting board and framing mats is exposure to materials containing acid and lignin. Both will discolor the image. In addition, the lignin makes the print brittle. Broken photographs are as much a result of the board composition as mishandling. When acid and lignin mats are used in framing, it will leave a similarly-shaped stain on the print.

Surface Treatments

The third component of the photographic prints is the substances applied to them or the surface treatments used to improve the print quality. Photographers added gelatin, waxes and varnish to the surface of salted paper prints to give them a glossy appearance. Albumen prints

naturally have a glossy appearance but burnishing enhances it. During processing, albumen prints passed through a machine. Turpentine and castile soap was sometimes applied to the machine rollers to prevent the prints from sticking. These chemicals ended up as deposits on the prints.[5]

Handcoloring

This girls dress is a lovely blue, her sash a rainbow of colors and the floor and drape are fuchsia. Unidentified woman, c. 1865. *Collection of the author.*

In the absence of color photography, photographers began to use artistic techniques to add detail and color to their images. The types of coloring evolved with time and experience from simple charcoal outlining to the use of oil and watercolor paints, crayons and colored powders. Additional substances such as gum arabic and varnish sealed the color on the prints. These materials can darken or crack with age.

Larger studios employed artists to produce a colorized portrait. Outlining enhanced the image in case of fading. The most common additions were gold jewelry and pink cheeks. In men's portraits, collars and shirts were colored white. In some albumen prints the image has faded while the color retains its original tones.

[5] James M. Reilly. *Care and Identification of 19th Century Prints.* (Rochester, NY: Eastman Kodak Co., 1986): 31.

Toning

Images on printing-out papers were often toned with a solution of gold or platinum to improve the image color and increase permanence. For instance, images treated with gold toning changed color from a brick-red to a deeper color like brown or purple. A combination of gold and platinum toning resulted in a neutral color. The majority of nineteenth century photographs on printing-out paper were toned. [6]

Adhesives

Photographers needed a substance to fasten a picture securely to its backing. Choices included animal glues, gum arabic, gelatin, and starch paste. The best substance on the list is starch paste. This substance is still used by conservators today. Starch paste causes the least amount of damage to the print. The moisture in any adhesive can cause ripples in prints, and some of those substances also damaged the appearance of the prints.

BASIC CHARACTERISTICS OF PRINTS

Type of photograph	Problems
Albumen Prints	Brittle, fading, yellowing, cracking, curling, foxing
Cyanotypes	Light fading, curling
Salted Paper Prints	Fading
Platinum Prints	Transference
Collodion	Especially susceptible to abrasion

RESIN COATED PAPERS (RC)

In the 1960s, a new type of paper that saved processing time and didn't curl when drying was introduced. These new resin coated (RC) papers only required about a minute to move from the processing to the drying stage.[7] Kodak was unaware of the deterioration problems of this paper when it was introduced and advertised the product as permanent. It is only recently that preservation became an issue for commercial manufacturers of photographic materials.

[6] Reilly, p. 23.

Contemporary RC paper still experiences deterioration, but Kodak has found ways to increase the longevity of these papers. Unless you print your own photographs or request (at extra charge) fiber-based paper from a photography studio, your prints will be resin coated. The coating protects the print surface from abrasion, but causes several problems. Fiber-based papers do not have a coating and can be processed for museum quality storage.

SPECIAL CONCERNS

Labeling

Place the image face down on a clean hard surface like a piece of glass or a table. I prefer to use a piece of glass the same size as the print. Gently write on the back. Otherwise, you risk embossing the print with your writing. If the top of the image depicts a light area such as a sky, write your labeling information along the bottom edge to keep it from showing through. Use a soft lead artist's pencil, number 6B, or a waterproof pen such as a ZIG marker. Be careful. A 6B pencil can smudge. When using a marker, make sure the ink is dry before placing the image against other items.

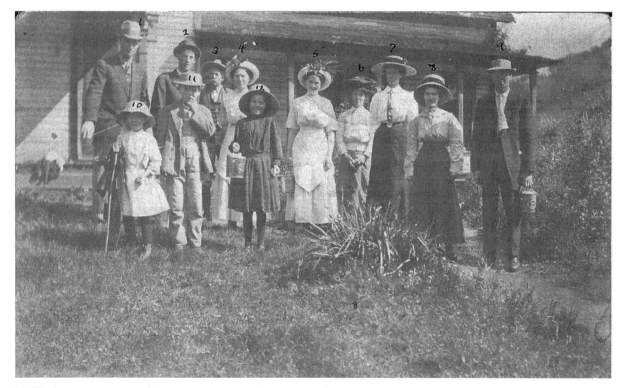

While it was a great idea to name each person for posterity, the numbers are written on the front of the photo in India ink. On the back was the following:

[7] Wilhelm, p. 589

no.1 Is my feller
" 2 Nans feller
" 3 Papa
" 4 Nan
" 5 me
" 6 Mamma
" 7 Mrs. Ashcroft (a neighbor)
" 8 Miss Smith (the school teacher)
" 9 is Miss Smiths feller
" 10 Lucile
" 11 Pleasant
" 12 Mabel
Taken c. 1900
Courtesy of Leanne M. Baraban

> **Basic Caption**
>
> - Person/persons:
> Name(s), Life Dates, Date of the Photograph (if known)
>
> - Event:
> Family Name, Occasion, Identity of Individuals, Date of the Photograph
>
> - Who labeled the image and when

Bronzing

In his book, *Permanence and Care of Color Photographs*, Henry Wilhem explains that black and white RC prints developed in the 1970s and early 1980s suffer orange, gold or yellow discoloration after only a few years. This discoloration sometimes takes the form of spots on the surface of the print.

Cracking

RC prints can develop stress cracks from handling and environmental conditions. Fluctuations in humidity combined with poor display conditions contribute to the problem. You can view the cracking by holding the print at an angle or under a magnifying glass.

Framing Concerns

According to Wilhelm, RC prints give off gases that deteriorate the image. Sealing a print in a frame increases the rate of deterioration. RC prints need frames that allow for airflow instead of being sealed on all sides. However, if the print will be exposed to pollutants in the environment, a sealed frame might be best. Most framing establishments should be familiar with the technique. If in doubt about what type of frame to use, consult a conservator.

Storage Considerations for Prints

There are several ways to inexpensively protect the paper prints in your possession. While providing a stable environment free from fluctuating temperature and humidity is at the top of conservators' lists, this atmosphere is not always possible to achieve in the home environment.

A simple way to protect your prints from breakage is to store same size prints together, either when you organize them, or when they are waiting to be filed. This storage method enables the prints to support each other.

Invest in polypropylene sleeves or pages to stop abrasion. The most common form of abrasive damage results from stacking and shuffling through unprotected images. Think about what happens to the surface and edges of ordinary playing cards when they are used repeatedly. The same sort of wear and tear happens to your images.

Store your images in individual polypropylene (inert polyester) sleeves in an acid and lignin-free box. Creative Memories sells a photo storage system made from inert plastic suitable for long-term storage. The Sort It! System is compact, efficient and safe for picture collections.

FREQUENTLY ASKED QUESTIONS ABOUT PRINTS

The following questions are often asked at lectures and workshops.

I have a large framed image that appears to be a drawing of a photograph?

It is most likely a crayon portrait. These are enlargements that were colored using charcoal pencil, chalk or pastel. Photographers either hired artists to add detail to the images or did the work themselves. Certain parts of the portraits especially the eyes, eyelashes and eyebrows were enhanced. The hair and background needed even more detail. The practice was popular from the mid nineteenth to the early twentieth century. These portraits were intended for display in the family home and came in a variety of sizes.

Mostly likely, the portrait in your possession is on brittle paper backed with a lightweight fabric. It may have pieces of the paper missing and is probably discolored.

In order to stabilize the print, send it to a professional conservator for treatment. If this is cost prohibitive, store the unframed picture, wrapped in acid and lignin-free materials, in a box.

What can I do about Rolled Photographs?[8]

The only way to permanently unroll these images is through the use of a humidification chamber. Then the image can be flattened. This re-introduction of moisture reverses the curling of lightweight paper. Humidification does not involve immersing the image in water, it merely creates an extremely humid environment that encourages the curling to relax. This conservation treatment should not be attempted by a non-professional.

Generally, these images are oversize or panoramic views of groups or landscapes. The rolling occurred because the print was produced on a lightweight paper that reacts to humidity by curling. It is also possible that someone deliberately rolled the photograph for storage purposes.

These images suffer damage through repeated rolling and unrolling. The emulsion will crack and the image can break. Therefore, do not unroll these images. Let a professional conservator help you flatten the image. Exposing the image to humidity makes the surface tacky and susceptible to damage. Forcing a curled photograph to unroll may cause the image to break into pieces.

[8] Sarah S. Wagner. "Some Recent Photographic Preservation Activities at the Library of Congress. *Topics in Photographic Preservation* (4):140-142.

CHAPTER FIVE: PHOTOGRAPHIC ALBUMS

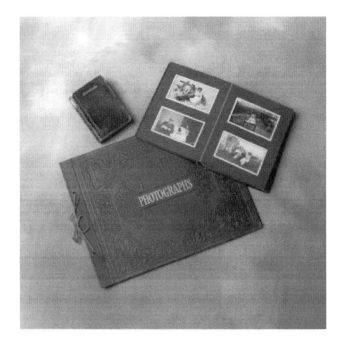

Collection of the author

It would be almost impossible to find a family photograph collection that doesn't have at least one album. My contemporary photographs are arranged in albums in chronological order. These albums in our collections are intrinsically valuable. The photographs themselves have sentimental value, but don't discount the informational content of the albums. Examine the albums in your collection in terms of your family history and see what you can learn from them.

1. Who created the album?

Check the inside front cover of the album to see if the original owner wrote their name inside. If they didn't, can you determine who created the album based on the captions of the images? Are there any captions that specifically identify a mother or display a full name? There may be clues to the identity of the owner throughout the album so keep track of any significant facts.

2. Who is included?

When you look at the album, make a list of not only who is included, but also who is left out. Omissions can provide clues and add to your understanding of family history. For instance, if

one particular family member doesn't appear in any of the photographs, your research may suggest that the relative wasn't living in the area.

3. What events are depicted?

By looking at the album in its entirety, you can develop a feel for the types of events that are included. There may be wedding photographs of couples followed by images of their children. Or, the album may be topical. In one family, a series of albums depicted various relatives holding the same baby. These albums were eventually given to both sets of grandparents and other relatives. This was the only baby in that generation of the family and thus, was a very important person.

4. What does your family history tell you about these individuals?

What do you know about each individual depicted in the album? This knowledge might help you determine the purpose of the album or help you identify when the album was created.

5. Re-examine these images as a total collection.

Now step back from the individual images and think about the album. You might discover some surprising facts about the relationships of the various people in the album. Sometimes relatives that fall out of favor are removed from albums. Did you notice any missing images?

6. Whose photos are in the initial pages?

In my experience the person on page one of an album is very important to the creator. Look for a relationship between the way the first page and the rest of the album is laid out. There are often identification clues. Figure out who one person is, and the rest may fall into place.

Captions are helpful when deciphering the content of the album and vice versa. Sometimes, the images provide identification clues to assist you in the process of completing the captions.

HISTORY

Our ancestors initially used plain paper albums to arrange their photographs with captions written underneath until commercially manufactured albums became available. These albums figured prominently in the decorating scheme of nineteenth century parlors and were displayed beside the family bible for visitors to view. Often, the albums contain the name of the owner.

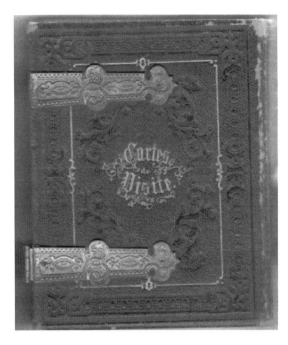

Mid-nineteenth century photo albums often resembled bibles. *Collection of the author*

These nineteenth century albums evolved from scrapbook pages to pre-cut albums back to scrapbooks. At first glance, the card photograph albums don't have the same personality of the blank pages because the arrangement of the page is dictated by the shape of the album. But at a closer glance, you'll notice that the images on those pages were put into a particular order by the owner. People important to the owner, the circle of family members and friends, appear in an album as a reflection of the owner's life.

As albums lost their formality and amateur photography became popular, albums became a form of personal expression. These albums portrayed family unity and revealed a personal identity. Albums, with their imaginative arrangements, decorative cutouts, and artifacts, are the predecessors of the contemporary scrapbook.

Throughout the history of photography, parallel innovations developed to allow our ancestors to present images. These developments ranged from cases for early photographic images to contemporary photographic albums. The introduction of each new type of image enabled booksellers and bookbinders to develop a side industry that eventually burgeoned into mass production of a variety of albums and coincided with the demand for images.

Cartes-de-visite Albums

The first albums designed specifically to hold photographs were imported into the United States in 1860. A year later, an American produced an album that provided a space for a carte-de-visite and a space for the portrait subject's autograph. Most albums manufactured and patented in

the decade after 1862 were of a similar design. Each album leaf contained windows in which to place the card photographs. These albums typically had leather or cloth covers and brass clasps with decorative tooling. Pages held two photographs back to back in a pre-cut heavy card stock. The bottom of the window was initially sealed which made it difficult to insert the card. Later improvements included leaving the bottom open so that cards could be slid in. These albums could be purchased in a variety of sizes.

Album Sizes[9]

Size	Number of images
Octavo	50-100
Quarto	Up to 400 cards. Most held 120-160.
Pocket albums	6-12

In his 1981 book, *Cartes de visite in Nineteenth Century Photography*, William Darrah writes that four common types of albums existed. Family albums obviously held portraits of family members, houses and perhaps even cemetery monuments. Celebrity albums concentrated on a particular subject such as statesmen. The contents of these albums reflected the interest of the creator. Travel albums were also popular. You could purchase ready-made photographs of popular tourist spots and place them in an album. Shops sold them individually or in sets. Darrah also identified, the subject album, such as a class book, as another popular category. Subject albums were the precursors to the contemporary yearbook and held images of all the members of a particular graduating class. Other subject books focused on wars, art, or another favor topic of the creator. [10] Matthew Brady, a famous Civil War photographer, sold Brady's Album Gallery that allowed individuals to purchase prints of his war scenes and arrange them in an album.

[9] William C. Darrah. *Cartes de Visite in Nineteenth Century Photography* (By the Author, 1981): 8, 9.
[10] Darrah. *Cartes de Visite in Nineteenth Century Photography* (By the Author, 1981): 8, 9.

Cartes-de-visite Albums[11]

Type	Dates Popular
Family Albums	1862-1905
Celebrity Albums	1862-1880
Travel Albums	1862-1885
Subject Albums	1862 -?

Tintype Albums

The standard sizes of tintypes made it easy to display them in cartes-de-visite albums. One exception is the albums created especially for the thumbnail or gem tintypes. They were very popular in the mid-1860s because of the cost. At mid-decade, thumbnails sold for $.25 a dozen and albums for a $1.00. [12] This was a fraction of the cost of paper prints and albums. When placed in a paper mount, these "gems" fit into a standard cartes-de-visite album.

Cabinet Card Albums

These albums resembled cartes-de-visite albums in layout and format. The larger size accommodated the different size prints. These albums resembled in presentation a family bible. In most homes, the album was displayed alongside the bible, a statement of its importance to the family.

Scrapbooks

Families that chose to make their own family photograph album could do so using ready-made journals or by creating one by stitching together sheets of paper or cloth between two covers. Photographs were either glued or sewn onto the pages. These albums were the forerunners of the present-day scrapbooks.

SPECIAL CONCERNS

One of the most often asked questions at my presentations on family photographs is what to do with images that are in albums. The first suggestion is to follow the basic rules for extending the longevity of any photographs by placing them in an area that does not experience variable

[11] Darrah. *Cartes de Visite in Nineteenth Century Photography* (By the Author, 1981): 8, 9.
[12] Floyd Rinhart, Marion Rinhart, and Robert W. Wagner, *The American Tintype* (Columbus: Ohio State University Press, 1999): 74.

temperature and humidity. You want to maintain the integrity of the album as a total package because of its value as a family artifact. If your albums were created befor the 1950s, it's likely that the most significant deterioration has already happened. Therefore, conservators suggest keeping the album in its original state unless it is extremely damaged. In cases of extreme damage, you may be able to restore the album to its original condition by:

- Having a professional bookbinder or book conservator repair the damage to the binding or individual pages.

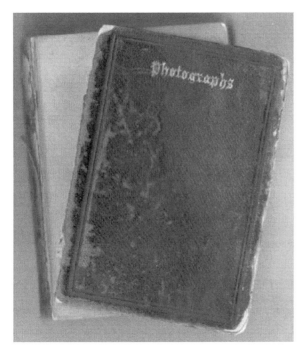

A professional bookbinder or a conservator can repair broken album bindings. *Collection of the author*

- Consulting a photographic conservator about encapsulating individual pages. Duplicating the arrangement of the old album in a new one. If the photographs are stuck to the pages, have a photographer make copies of the images for the new album or scan them yourself. Transfer the captions by rewriting them.

There are specific types of problems that result from storing photographs in an album. Some problems result from handling and others from the techniques used to create the album. Then, of course, problems also result from the products used to manufacture the albums.

Abrasion

Every time you look at an album page of photographs that is unprotected by a polypropylene cover, the prints facing each other are subject to abrasion. These prints rub against each other during viewing or storage of the album.

Acid Paper

Unless your photographs are stored in albums constructed of acid and lignin-free papers, there will be acid migration from the paper to the images. This migration results in discoloration and staining of the photographs in the album. Another common source of acid in albums are the ephemeral pieces of our lives that we place beside our images such as cards, tickets and documents.

Adhesives

Until the invention of the magnetic album or plastic sleeves, most people used adhesives to mount photographs to the pages. Glue was either applied to the back of the image or to photo corners. When damp glue comes into contact with an image it has the potential to cause discoloration or buckling. This also depends of the type of glue used and how it was applied. The adhesive also increases the difficulty of removing the photographs from the albums.

Magnetic Albums

These dreadful albums are still being sold in photo stores and departments. The magnetic material destroys family photographs by exposing them to glue and the gases given off by the plastic sheet protectors. Your photographs will become stuck to these album pages. But many people purchase magnetic albums because they are inexpensive. A friend's daughter recently purchased new magnetic albums because of the high cost of PAT-approved albums, despite being warned of the danger to her images.

STORAGE CONSIDERATIONS

It is easy to take precautions with the images you have in albums.

1. Ensure that all the new albums you purchase are safe for use with photographs. Choose papers that have passed the PAT and follow the guidelines outlined in the Scrapbooking section of this book to create safe and preservation-quality albums.

2. To save money, purchase albums without slipcovers. You can create your own, by wrapping the albums in a clean material such as unbleached muslin. This step protects the images from dust and environmental pollutants.

3. Interleave the pages with a thin acid and lignin-free tissue paper to protect older albums from acid migration and abrasion.

What can I do about photographs in black paper albums?

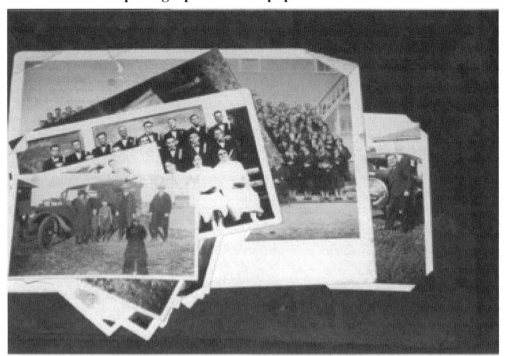

Don't rush to take apart your black paper albums. *Collection of the author*

According to the National Archives, not all albums should be taken apart. The problem is that the paper gets brittle not that it damages the picture. There is no need to panic and start taking those albums apart. There is a simpler solution. You can interleave the pages with paper or tissue that passes the PAT test. The only danger is that you are doubling the size of the album and can break the spine. Tissue available from the suppliers listed in the Appendix will reduce the bulk. If you're worried about loose photographs falling out of the album, wrap it in a clean piece of unbleached muslin. Wash and dry the fabric before using it in this manner.

Can I safely remove photographs from magnetic albums?

Speakers at a conservation workshop suggested using unwaxed dental floss to remove photographs from the pages of a magnetic album. Be very careful not to cut the photographs during this process. You can also use a microspatula to gently separate the images from a page.

I noticed that advertising now promotes magnetic albums as "Archival Safe". Are they safe to use?

Absolutely not! Unless an album meets the PAT standards, you shouldn't use it for your

photographs. More companies are using the word archival in their advertising copy, but don't be fooled. There is no industry standard for the term archival. Unfortunately, this wording appeals to preservation-conscious consumers who unknowingly purchase products that do not meet the standards.

CHAPTER SIX: NEGATIVES

The history of prints corresponds to the development and history of the negatives used to produce them. After prints, negatives make up a significant part of our family photograph collection. But how many people know about the negatives in their possession? The majority of this material in our homes dates from the era of the Kodak candid pictures to the present day. Negatives consist of a base layer and a coating of emulsion. The base layer contains either glass or a plastic material. The emulsion is the negative of the print in our possession.

The following chart displays the major characteristics of commonly available negatives. All dates are subject to some variation, since photographers generally used up existing supplies before embracing a new technique.

GLASS

Collodion Also known as wet plate	Thick glass Edges ground Gray coating Produced by individual photographer	1851-c.1880
Gelatin dry plate	Thin glass Uniform thickness Edges sharp Black coating Factory produced	c. 1880- c. 1920

Photographers created their own supply of negatives in the 1850s by coating a piece of glass with a new substance, known as collodion. The light-sensitive silver halides in the collodion captured and preserved the image during the photographic process. Collodion consists of gun cotton dissolved in ether and alcohol. The combination was used for photography for the first time in 1849.

Moving Glass Negatives

If you have glass negatives in your collection, they are probably sitting in a box that is too heavy to lift. Photographers used to store these plates in wooden storage boxes with dividers to protect the

glass from breakage. Since the boxes contained only a few negatives, they could be easily carried.

Here are a few steps to take when you have to move or re-box the glass plates.

1. Make sure each plate has an individual envelope or covering.

2. Pack them snugly in the box to eliminate accidental breakage.

3. Use small boxes that you can comfortably lift.

Special Storage for Glass Negatives

Glass plate negatives, being both heavy and fragile, require special storage care. These plates should be stored vertically on a long edge. Remember that horizontally storing plates could damage the negative on the bottom of the stack. Check the strength of storage materials, even those with reinforced corners. Make sure that the storage shelving units can safely hold the weight. You should only partially fill boxes of glass negatives to ensure that the container will not be overwhelmed by the glass weight. To prevent breakage when moving the boxes, make filler by using a heavy acid free card stock. Negatives larger than 5 x 7 inches need additional reinforcement every five negatives to prevent damage.

Conservators can mend broken glass plate negatives. Washington Monument as it stood for 25 years, c. 1860. *Library of Congress*

Handling Broken Plates

Almost all glass negative collections contain broken plates from mishandling. There are steps you can take to preserve the images rather than throw them away. Sarah S. Wagner, former Senior Photograph Conservator at the National Archives at College Park, suggests storing them flat in a protective mat cut to the same size as the full negative. These sink mats can then be stacked. An alternative to sandwiching the negatives between mats is to place them between two stiff pieces of cardboard and fold a piece of paper securely around all four sides. You can also purchase ready-made four flap paper enclosures from the suppliers listed in the Appendix.[13]

To recreate the glass negative, match the broken pieces. Be sure to wear protective gloves to shield you from the sharp edges. If the image is in multiple small pieces, your restoration attempts may not succeed. If you do succeed, hire a photo lab to make a contact print (same size print) from the negative and then dispose of the pieces. Glass plates can also be mended by conservators.

> **Things to remember when storing glass plates**
> - Store them vertically on the long edge.
> - Make sure shelving and storage containers can support the weight.
> - Use heavy PAT board to create filler for boxes of negatives.
> - Label each box with "Fragile Heavy Glass Negatives!"

Home Conservation for Glass Negatives

If the emulsion of a glass negative is pulling away from the glass, you can remedy the problem by sandwiching it between two pieces of glass. Be careful when trying to piece together broken or cracked glass negatives. There is the risk that the gelatin emulsion will adhere to the glass if it is exposed to high humidity.

1. Buy two pieces of custom-cut glass in the same size as the negative. A glass supplier can cut these pieces for you.

2. Make sure the glass is clean by washing with a gentle detergent and drying with a lint free cloth.

3. Gently place the negative between the two pieces of glass. Wear gloves as protection.

4. Seal them together using special tape such as Filmoplast.

5. Take the negative to a photo lab to have a contact print made.

[13] Sarah S. Wagner, "Approaches to Moving Glass Plate Negatives" Topics in Photographic Preservation (6) 1995: 130-131.

6. Carefully undo the sandwiching before storing in a sinkmat.

7. Store in a protective sleeve in a box with reinforced corners. Remember not to overload the box due to the weight of the negatives.

Warning: The extra glass triples the weight of the negative.

FILM (HANDLE WITH CAUTION)

Eastman American Film-gelatin	Brittle Edges uneven	1884 – c. 1890
Roll Film-clear plastic	Nitrocellulose Thin Curls and wrinkles easily	1889-1903
Roll Film- clear plastic	Coated on both sides with gelatin to prevent curling	1903-1939
Sheet Film- clear plastic	Machine cut sheet Rectangular Edges stamped Eastman	1913-1939
Roll Film-clear plastic	Cellulose acetate Marked safety on the edge	1939-present

Types of Damage

If you haven't looked at your negatives recently, stop right now and pull them out of storage. Just as prints are susceptible to damage, so are negatives. Negatives that are extremely deteriorated may not be printable. It is necessary to take the same preservation precautions with the negatives as the prints. Negatives are easier to identify than nineteenth century prints.

Glass negatives are coated with a binder, like collodion and gelatin, that contains light sensitive silver halides. Over time, and under the wrong circumstances, this emulsion breaks and flakes off the glass. Film negatives are also coated with light sensitive chemicals that become brittle. The emulsion and film base can break into pieces. Both types of negatives can develop mirroring, the silver cast you can see on the emulsion when held at an angle.

Film Based Negatives

According to James Reilly, in the *IPI Storage Guide for Acetate Film* (Rochester, NY:IPI, 1993), all film-based negative deterioration is dependent on exposure to high humidity and

temperature. Once conditions are right for deterioration, chemical changes become cumulative and actually rapidly increase. These chemical changes can be prevented by removing negatives from air-tight containers (film cans or sealed plastic bags) that actually exacerbate the chemical breakdown. Negatives should be stored in well-ventilated locations with stable temperature and humidity levels.

Courtesy of Lynn Betlock

The characteristics of the deterioration vary depending on the type of negative. Of great concern are nitrate negatives that are not only fragile but also dangerous. It is important to know the type of film negative in your possession, in case they are nitrate. This type of negative is chemically unstable and under the right conditions, can spontaneously combust. The nitro-cellulose negatives, popular between 1889 and 1939 may pose a fire hazard. Most museums and archives copy and store these negatives using special techniques. Special warehouses exist to store these potentially dangerous materials. There is no need to be alarmed. The threat to a family collection is not immediate unless you are storing a large quantity of these negatives in an area such as an attic which has temperature fluctuations. The problem really lies with nitrate movie film in canisters. You can read more about nitrate negatives on the National Fire Protection Association website www.nfpa.org in their NFPA 40: Standard for the Storage and Handling of Cellulose Nitrate Film.

An example of a deteriorating nitrate negative. Containers marked "Callender Cable". April 1919. *Collection of the Library of Congress*

If you discover you have nitrate film, have the negatives copied at a reputable photo conservation lab in your area. Federal regulations imposed by the United States Department of Transportation restrict shipping nitrate because it is considered a fire hazard. Once you have the copies, ask your local fire department how to dispose of the negatives. Most communities mention the disposal of nitrate in their fire codes.

How serious is this hazard? Nitrate film can spontaneously combust at 106 degrees F and generates its own oxygen to feed the fire. The gas resulting from this type of fire can be deadly in large quantities.

Nitrate deterioration can damage other photographic materials because it produces chemical by-products. There are several phases to nitrate deterioration according to Cummings:

1. Amber discoloration of film base. Image has faded.

2. Brittle and sticky film base.

Nitrate film can be easily identified by following these steps.

1. Examine the edge of your negatives to see if the word safety appears. If it doesn't, the negative may be nitrate.

2. Using a pair of scissors, snip off a small section of the negative and place it in a non-flammable container such as an ashtray.

3. Try to ignite the section using a match. If it burns quickly, it is nitrate. If it doesn't, your negative is unmarked safety film.

3. Bubbles are apparent in the film base. Negative emits an acrid smell.

4. Film disintegrates into a brown acrid powder.

Health Risks From Deteriorated Negatives

Paul Messier, Conservator of Photographic Materials and Works of Art on Paper, "Preserving Your Collection of Film-Based Photographic Negatives" Conservators of Fine Arts and Material Culture, Rocky Mountain Conservation Center.

http://cool.conservation-us.org/byauth/messier/negrmcc.html

Deteriorated negatives, especially nitrates, can emit a noticeable and noxious odor. Such gasses can cause skin, eye, and respiratory irritations. Allergic sensitivity has also been noted, as has dizziness and lightheadedness. Handle deteriorated negatives in a well-ventilated area. Wear neoprene gloves, remove contact lenses, and limit exposure times. It is also advisable to wear goggles and a respirator with acid/organic vapor filter cartridges.

Safety Film

Cellulose acetate film and nitrate film share some patterns of deterioration, such as brittle quality, bubbles, chemical by-products and an odor. In safety films, the odor is referred to as the "vinegar syndrome". The film base can also shrink, producing waves or "channels" in the emulsion. Unlike nitrate, safety film is not a fire hazard. In extreme circumstances a conservator can strip the emulsion, i.e. the picture, off the damaged acetate base. See Chapter 9 for a case study.

Storage of Film Negative Materials

There are several considerations when storing negatives. First is the environment. Negative deterioration is slowed when the material is stored at a constant temperature and humidity. The life span of negatives stored at 70 degrees and 40% humidity is about 50 years.[14] Lower temperatures and humidity increase longevity, but the options are not usually practical in a home setting. Cold storage conditions, created using a frost-free commercial freezer, further extend the lifespan of these materials. Follow the recommendations for color prints and negatives in Chapter 7 for proper storage in cold environments.

[14] Paul Messier, Conservator of Photographic Materials and Works of Art on Paper, "Preserving Your Collection of Film-Based Photographic Negatives" Conservators of Fine Arts and Material Culture, Rocky Mountain Conservation Center http://cool.conservation-us.org/byauth/messier/negrmcc.html

The second consideration is that negatives range in size from panoramic sheets of several feet in length to 35mm negatives. Each size needs to be stored separately so that the weight is evenly distributed.

As with all photographic material, wear disposable examination gloves when handling the negatives. This will protect you from glass cuts and keep you from depositing oils and dirt on the negatives. Gently brushing the negatives with a soft bristle brush can remove surface dirt prior to placing them in sleeves. Never brush negatives that are deteriorating due to chemical changes or glass negative that are losing their emulsion.

FREQUENTLY ASKED QUESTIONS ABOUT NEGATIVES

Can I store them in the jackets from the lab?

If you are concerned about losing the information from the jackets such as the dates, transfer the negatives and information to buffered sleeves available from suppliers in the Appendix.

This protects your negatives from the acid and plastic in the folders from the lab.

How should I handle negatives?

It's best to wear disposable examination gloves and hold negatives by the edges only. Be very careful of the sharp edges found on glass negatives. Do not wear cotton gloves because the risk of dropping them is much greater.

Storage Recommendations

1. Use buffered envelopes.

2. Lightly brush the negatives with a soft brush to remove surface dirt. Use disposable examination gloves for handling good quality negatives. See the Health Hazards section of this book for handling deteriorated negatives.

3. Place each negative in its own envelope with emulsion side away from the seam.

4. Store negatives upright in boxes. Do not mix sizes.

5. Do not pack them tightly.

6. Use boxes with reinforced corners.

7. When storing glass negatives, make sure the box can hold the weight load.

8. Rolled negatives should be cut into lengths and stored in buffered paper sleeves. Do not store them in polypropylene or polyester sleeves unless they are in cold storage. The plastic sleeves speeds deterioration.

CHAPTER SEVEN: COLOR

Walk into any home and you'll see color photographs on display, either standing in frames or hanging on walls. The photos depict graduations, family vacations and other events of significance to the owner. What might not be immediately noticeable, depending on how long the photographs have been exposed to light, is that they are all likely in various stages of fading. This fading happens so gradually that most people don't notice the change in color quality until they compare the print to a newer color image. If you were to place a photograph that has been displayed in a sunny room with an identical photograph that has been stored in darkness, the change in color would be immediately apparent. However, once we place our images on display, the subtle color changes are overlooked. We often cannot see the dramatic change until we compare an old print to a new print.

Damage to our color photographs is not limited to those we display for public view. Images in storage can also show signs of aging. For instance, slides and instant color images like Polaroid prints deteriorate differently than standard color prints.

Unfortunately, some of our color photographs will incur damage even if we use proper materials and keep them in a temperature and humidity-controlled environment. This deterioration process can be very confusing and disturbing to the family photographer. After all, you have invested time and money to document family milestones. You probably hoped that future generations of your family would appreciate your efforts. The instability of these prints and slides is inherent in the qualities of the color photograph. Color images consist of three basic hues, cyan (blue), magenta (red), yellow, and sometimes black. Each one of these colors fades at different rate in dark storage.

Color shifts occur because of the following: chemical instability of the color process or exposure to light. Different types of color images deteriorate at varying rates, depending on the type of processing and materials. If your parents captured your childhood on film using color processes, then you have probably discovered that those images are now totally destroyed due to their instability. Manufacturers like Kodak, Fuji, and Polaroid issued new products to consumers without revealing that these color images had a limited lifespan. Professional photographers and family photographers bought and used some of the same materials with the identical result.

Pictures faded or discolored as they sat in the family album or on display. The good news is that film companies are responding to their customers' concerns about their color photographs.

BACKGROUND HISTORY

The transition from all black and white photography to commercially available color took close to a century. Daguerre and others tried to invent a color photographic process by experimenting with different chemicals. But they were largely unsuccessful in their quest for permanent color images. In 1850, a New York state Baptist minister, Levi Hill, announced that he'd found a way to reproduce natural color in daguerreotypes, but he refused to reveal his methods. He called his process Heliochromy and his plates were called hillotypes. Many photographers labeled him a fraud. Yet in 2007, researchers working under the auspices of the Smithsonian Museum of American History found that Hill had indeed been able to capture blue and red hues. Other colors had been added by hand. You can view one of these images at the Wikipedia wwww.wikipedia.com entry for Hill

There were many experimenters including the nephew of Daguerre's collaborator, Niepce. A year after Hills' discovery, Frenchman Claude Niepce de Saint-Victor used silver chloride to create a color image and then varnished it for preservation. This image is on display at the Conservatoire National des Arts et Metliers in Paris. Unfortunately, the image wasn't commercially viable. Little more than a decade later, in the 1860s, Frenchman Louis Ducos du Hauron and James Clerk Maxwell in Scotland, unbeknownst to each other, were working on color imaging. Once they discovered their common interest, they collaborated on their explanation of basic color theory: Red, yellow and blue are the components of all other color combinations. Du Hauron designed a camera that produced negatives in the three separate colors.

More than forty years later, Auguste and Louis Lumiere introduced the first color photographic process, the Autochrome, in 1904. Many people have never seen an autochrome. Professional photographers utilized them in their work, but these first color slides are rarely seen in family collections. These one-of-a-kind positive glass images appear primarily in museum collections. They were typically used for landscape photographs and occasionally to photograph individuals. A special viewer, a diascope, was necessary to look at the images.[15] While you're unlikely to own one of these glass images, you can see reproductions of them in National Geographic magazines published between 1914 and 1937. There are also examples available online in The Library of Congress digital collection. You can find them by searching on the term

[15]Sipley, *A Half Century of Color*, 42.

"autochrome" in their digital catalog (lcweb2.loc.gov/pp/pphome.html). You'll be stunned by the clear vibrant pictures. Yet, public acclaim wasn't enough to ensure their longevity. Autochromes required long exposure times and bright lights. Few photographers used the process after 1909.

Family photographers had to wait until 1936 for the first Kodak Kodachrome slides, although 16mm motion picture film appeared a year earlier. [16] Negative film became available from Kodak in 1941. This was the first color still film sold directly to the consumer market. In his book, *The Story of Kodak,* Douglas Collins writes that Kodak experienced its greatest period of economic growth in the 1950s.[17] Annual net earnings doubled in the four years from 1953 to 1957 to $100 million. The company achieved these sales results by investing in research and development that resulted in new consumer products.

To promote camera and film sales, Kodak and other manufacturers taught consumers to appreciate color photography by issuing instruction manuals. After years of taking black and white images, our families needed new picture taking skills. In order to take a good quality photograph, clothing choices became important. The family shutter-bug had to be concerned with color balance as well as background. In order to help their customers adjust, Kodak printed manuals like Ivan Dmitri's *Kodachrome and How to Use It,* published in 1940 (Simon & Shuster, out of print) for family photographers. These manuals had easy-to-use charts to ensure quality. Seemingly overnight, black and white became the artistic medium once color took over. Family albums were now produced in brilliant color. No one in the family had to guess the color of Grandpa Joe's eyes or the color of Aunt Mabel's skirt. [18]

DETERIORATION

Color pictures are composed of two elements: the negative and the image. The negative is the film while the image is printed on different types of paper. Today, most photographs are printed on resin coated (RC) papers. This means that the image is printed on a paper coated with a substance that protects the print surface from abrasion. Over time, these RC papers develop cracking.

Henry Wilhelm, in his voluminous and technical publication, *The Permanence and Care of Color Photographs: Traditional, and Digital color Prints, color Negatives, Slides, and Motion Pictures* (Preservation Publishing Co, download for free www.wilhelm-research.com/book_toc.html), presents evidence on the deterioration of color family photographs.

[16]Sipley, *A Half Century of Color*, 142.
[17] Douglas Collins, *The Story of Kodak* (New York: Harry Abrams, 1990), 277.

His ground breaking exposé is a story of lost pictures, family photographic memories destroyed by the very elements that consumers purchased to preserve them. You can follow his research on photo equipment on his website, Wilhelm Imaging Research www.wilhelm-research.com/

- Kodacolor film used between 1942 and 1953 has one of the worst preservation records. Today, those negatives are irreparably damaged and unprintable. The prints made from those negatives are now almost illegible due to yellow staining.

- Ektachrome slides used from 1959 to 1976 have, by now, experienced fading and color shifting.

- Agfacolor Color Type 4 paper produced and used between 1974-1982 by discount photo processors and commercial studio photographers has also dramatically faded.

These are only three of the color photographic processes used by family photographers.[19] But as disturbing as these three examples are, it is the instant pictures that deteriorate the fastest.

INSTANT COLOR

Until 1947, amateur photographers either sent their rolls of film to a lab for developing or did it themselves in a home darkroom. Edwin Land's patent for "instant" black and white pictures that developed in a minute changed everything. Photographers could shoot a picture, watch it develop, and decide whether to take a new one. This dawn of a new age in family photography presented shutter-bugs with instant gratification. No waiting. You could shoot a picture and place it in your family album in the same day. While black and white film was being used by fewer family photographers, the lure of these instant photos caused millions of folks buy these new cameras and films. In the 1970s Polaroid patented a color film. According to *The Focal Encyclopedia of Photography* (Focal Press, 2007), consumers shot approximately a billion Polaroid prints in 1974. Close to 65% of that number were color images. In order to continue to meeting the needs of their market, Polaroid offered new cameras and films every couple of years. Despite filing for bankruptcy protection in 2008, Polaroid continues to produce cameras, but has discontinued traditional film production as it tries to compete in the new digital photo marketplace. The 600 series of prints are 3 x 3$^{1/8}$ inches in size while standard size prints from 669 film are 4 x 5 inches.

[18] Ivan Dmitri. *Kodachrome and How to Use It*. (New York: Simon & Shuster, MCMXL):11.
[19] Wilhelm 1-60.

In this Polaroid you can see how over time the chemicals have obscured the picture. *Marie Williams*

The problem with these new instant color pictures did not surface for several years. Unfortunately, the life expectancy of a color Polaroid can be limited to only 5 to 10 years if storage conditions include environmental fluctuations. The deterioration of these pictures occurs whether or not the images are stored in the dark. Their very composition causes the problem. The chemicals that form the image are stored between two pieces of plastic. When the picture passes through the rollers of the camera the chemical reaction starts to produce the image. Unfortunately, in a relatively short period of time, that process breaks down and the images begin to deteriorate. While all Polaroid prints deteriorate over a short time, the SX-70, Spectra HD (1991) and the Polaroid 600 experience the most problems.

A friend bought an SX-70 camera as soon as it was introduced and began taking snapshots of his family and friends. He completely abandoned traditional color prints in favor of the convenience of Polaroid's new cameras and films. For twenty-five years, the only camera he has used to document important family events has been a Polaroid. His picture-taking history constitutes a substantial investment in equipment and supplies. Since Polaroid pictures do not fit in pre-cut photo albums, he also purchased the albums specially made by the company for his images. Most of his collection is now in various stages of deterioration such as cracked images and staining. Since Polaroids are a one-of-a-kind image, there is no negative from which to make another print. However, each of these images can be scanned, color-corrected and "fixed" using photo editing software.

SPECIAL CONCERNS OF COLOR PHOTOGRAPHS

Fading

Color photographs and slides are extremely susceptible to light fading. Unfortunately, some of images made on Kodak paper available in the 1950s through 1970s fade regardless of where they are stored. However, to reduce fading of color prints, dark storage at cool temperatures and low humidity is recommended.

Discoloration

In addition to fading, color prints and slides experience discoloration. The shift in color tone varies depending on the type of print. Some prints may look more red and others, more yellow. This can be an all-over color change or just an intensification of certain shades in the print. The discoloration can be reversed using digital restoration.

Cracking

Color prints on Resin-coated (RC) paper can crack under the same conditions as black and white RC prints. Polaroid prints can develop cracks in the emulsion between the plastic layers and destroy the image.

In just a few decades, Polaroid prints can crack through exposure to fluctuations in temperature and humidity. *Lucien Montaro*

Moisture and Temperature

Color prints on coated paper are susceptible to heat and humidity. High heat and humidity will cause prints to stick together. It is best to interleave the prints with acid-free tissue or place them in a recommended album. Damage can be avoided by storing the prints in a proper environment and in individual sleeves.

Fingerprints

Make sure your hands are dry before touching a color print. Damp hands can stick to the print and may also cause an area of discoloration, leaving a lasting reminder that you looked at the image. Fingerprints on color prints can occur because of sweat, oils and salts from your hands. While most color prints are coated, fingerprints can still be left on the image. Polaroid prints often contain fingerprints from individuals who fail to handle the images by their edges during development.

Poor Quality Plastic

Color prints, negatives or slides stored in plastic sleeves that are not polypropylene suffer damage as the plastic breaks down and deposits droplets of plasticizer on the images. When buying plastic pages, stay away from products that exude an odor. The gases given off by these pages will damage the images. Protect your prints and negatives by buying materials from the suppliers listed in the Appendix.

Surface Treatments

Some color prints experience problems from being lacquered after processing. The goal of lacquering is to prevent prints from sticking in framing and surface damage from handling. This treatment also added texture to the surface of the picture. Unfortunately, lacquering also causes discoloration of the image.

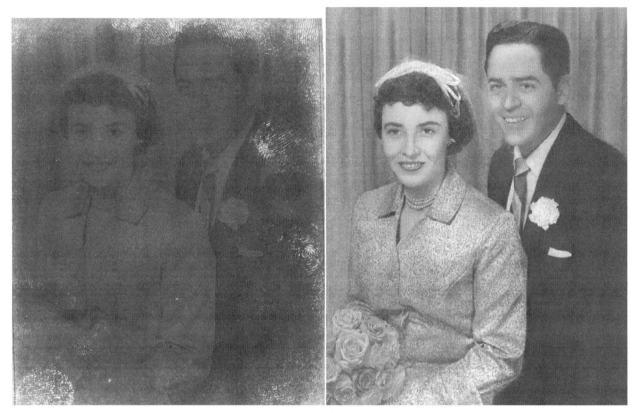

This is an example of digital restoration. The colors shifted destroying the image. The black and white print was the first stage of the restoration. In the final print, color tint was added. Edwin Schuylar Richerson and his bride Eleanor Rita, November 27, 1954. *Photo courtesy of Linda Templeton. Retouching by Lorie www.retouchingbylorie.com*

GENERAL SUGGESTIONS FOR COLOR PRINTS AND NEGATIVES

Color film is inherently unstable, which means that unless steps are taken to safeguard your prints and films, they will fade. By following a few basic principles of caring for them and avoiding special types of damage, you can extend the life of the materials, including Polaroid instant prints, in your family collection. The basic rule of color deterioration is that the amount of light, temperature and humidity affects the rate of deterioration. Therefore, to minimize color deterioration, use these guidelines from libraries and archives.

 1. Do not expose images to sunlight. Any exposure to sunlight fades the images and changes the appearance of the print. If you want to display a photograph, have a copy made from the original negative or photograph and use that. Sunlight accelerates the deterioration process by attacking the dyes in the color film. Fluorescent light can emit high proportions of ultraviolet rays

that can affect the color quality of color photographs. In order to reduce the amount of ultraviolet rays, fluorescent lights should not be used, but if it is unavoidable, purchase special sleeves to mask the bulbs. Most libraries and museums use these sleeves when lighting rooms where their collections are displayed. These sleeves can be purchased from the suppliers listed in the Appendix.

2. **Store images in a dark place with a stable environment.** The standard preservation advice for color is to store images in a cold place at a stable temperature in the range of 30 degrees Fahrenheit. Low temperature and humidity levels slow the deterioration of the image. Maintaining the perfect environment in your house can be difficult, so try to find an area without fluctuating temperature and humidity.

3. **Retain the negatives.** Negatives provide you with insurance. Since prints will become discolored over time, you should retain the negatives to make new prints. Color negatives have special storage needs as well. The best materials consist of individual acid and lignin- free paper sleeves designed for storage purposes and are sold by archival product companies. Negative pages are not recommended since the negatives can adhere to the sleeves over time due to changes in temperature and humidity. If you decide to use pages, stick with those manufactured from polypropylene.

> **What to do with Old Undeveloped Film**
>
> If you own undeveloped film, don't throw it away until you look at the website for Rocky Mountain Film, www.rockymountainfilm.com, a company that specializes in developing older film formats. Keep in mind that this company batch processes film so it can take months or years before you'll see the results. Read the details on their site about the types of film they handle before you send off your package.

COLD STORAGE

Cold storage of color materials has been around for a few decades. The leading authorities on cold storage of color photographic materials are Henry Wilhelm and Carol Brower. They found that cold storage discourages the fading and deterioration of color photographs. Many large museums with extensive color collections such as the John F. Kennedy Library in Boston have extensive cold storage facilities. You may think that cold storage is impractical for family collections, however, several years ago Wilhelm Research tested storing photographs and motion picture film in commercially available non-humidity (frost free) controlled freezer units. These are essentially the same type of unit we use in our homes to store food. If you have a large number of color

pictures, slides and motion picture films, you may want to invest in a small freezer to literally freeze your images to prevent further damage. Set the temperature at 0 degrees and keep the door closed. Each opening of the door causes temperature fluctuations that can damage the pictures.

Cold Storage at Home

What you need for cold storage in your home is a freezer, inert polyester storage bags, disposable examination gloves for handling the images and metal storage boxes. All of these materials are readily available, with the exception of the freezer, from the suppliers listed in the appendix.

Supplies

Freezer (frost free)

Ziploc airtight polypropylene storage bags

Disposable examination gloves

Metal storage boxes

Instructions

1. Purchase a frost-free freezer that can maintain a stable temperature of 0 degrees Fahrenheit.

2. Double-wrap the photographs in PAT-tested materials to protect them from temperature and humidity fluctuations.

3. Place them in freezer bags with zipper closures.

These precautions will dramatically change the rate at which color materials deteriorate.

When removing materials from cold storage be sure to follow the recommendations from the National Archives. [20]

- Remove the items from the freezer to an interim space away from direct heat to allow the materials to gradually warm up.

- Do not remove the photographs from storage bags until they reach room temperature.

- Wipe bags clean of any excess moisture before opening.

Don't want to do this at home? You can rent space from a commercial cold storage facility called Hollywood Vaults at www.hollywoodvaults.com or 800-569-5336. In 1984, the owner of

[20] Sarah S. Wagner, "Cold Storage Handling Guidelines for Photographs" 1991. www.archives.gov accessed 12/3/09.

this company responded to the need in the movie industry for a cold storage warehouse. Hollywood Vaults maintains a state-of-the-art facility for preservation storage, not cold storage for warehousing food. The company's vaults operate at a temperature of 45 degrees and 25 percent humidity. In addition, a filtration system cleans the air so that the materials are not exposed to pollutants. Movie studios, professional still photographers, collectors and museums store materials here.

BASIC DISPLAY GUIDELINES

According to conservator, Paul Messier, color photographs, negatives and slides are just as susceptible to physical, chemical and biological deterioration as black and white materials. However, the chief agent of damage is fading through deterioration of the dyes. For this reason, you should protect your original images by not displaying them. Use the following guidelines to extend the visibility of your copies.

1. Display out of direct sunlight and preferably in rooms that don't receive excessive amounts of sunlight.

2. If you have fluorescent lights in your home consider covering them with ultraviolet filters. See the list of suppliers in the Appendix.

3. Use proper framing techniques outlined in Chapter 11 and include a UV-filtering glass.

4. Display only copy prints or duplicates.

FILM AND GLASS SLIDES

There are basically two types of slides, those on glass and the film slides we have today. Both slide types represent one-of-a-kind original images that should be protected from various types of damage. While copies can be made of both types of slides, the image quality will not be the same as the original because it is a duplicate. If you need to send a slide to anyone, have a duplicate made. You wouldn't want the original slide lost.

Glass slides are a standard size of $3^{1/4}$ x 4 inches. Glass slides are often confused with glass negatives, but two important differences exist. Also called lantern slides, glass slides, are a positive image and a standard size. The positive image on each lantern slide is sandwiched between two pieces of glass. These slides include a paper mount and taped-sealed edges. Glass negatives come in a variety of sizes and are negative images.

The first photographic lantern slides, introduced in 1849, allowed for the projection of photographic images. Earlier versions of glass slides were scenes painted on the surface of the glass and pre-date photography by centuries. William and Frederick Langenheim patented glass slides in 1850 and called their invention a Hyalotype. Their slides became entertainment and the public paid to see these shows. Lantern slides were usually produced on a particular subject and, in addition to entertainment, were used for educational purposes. Individuals could watch a show on ancient antiquities or even scientific pursuits. Early movie theatres projected coming attractions using slides prior to showing the main feature.

Black and white or handcolored slides can be found in libraries and archives on a variety of topics. Early color processes such as the Autochrome became available in slides around 1907. You may even find them in your home. Amateurs could produce their own slides or purchase sets and projectors. My public library recently stumbled on a set of lantern slides that displayed views of the town around 1900 and were part of an illustrated lecture of the history of the town. The slides had been placed in wooden boxes and envelopes and set in a storage area.

The National Museum of Photography, Film and Television in England suggests that owners of lantern slides look for details such as ripped or missing tape, broken glass, and cleanliness. A first inspection may suggest that the slides are in good condition and that the materials are relatively stable. But if the cover glass is cracked or broken and the tape is loose, moisture, dirt and other pollutants can cause damage. [21]

You can repair some of the damage yourself. Broken glass can be replaced as long as you can find glass of similar thickness and reseal the image using PAT tape. Do not, under any circumstances, attempt to clean the image. It is only coated on the surface of the glass. Photographers used a variety of methods to create the transparencies and it is important to hire a professional conservator to make image repairs. The cover glass can be cleaned with a lens tissue or small pieces of cotton. You can store the slides in their original wood boxes to protect them from breakage. If the boxes no longer exist, vertically store the slides with a support placed between every few slides.

Lantern slides remained popular from 1850 until approximately 1950 and these slides are still used today in many academic disciplines. The introduction of inexpensive film slides in the 1950s replaced them. And after color photofinishing became available, color slides were finally

[21] "Conservation--Lantern Slides". National Museum of Photography, Film and Television. www.nationalmediamuseum.org.uk/pdfs/CONSERVATION_LANTERN%20SLIDES.pdf accessed 12/03/09

inexpensive to produce and develop.

Contemporary slides consist of the image and a mount. In 1936, Kodak introduced Kodachrome slide film. The product remained a popular choice until the company discontinued the film in 2009. Lacking a way to mount the slides during processing, Kodak originally sent slides back to consumers to be glass mounted by hand. It was another three years before cardboard mounts were available.

There are three types of mounts currently available. You can glass mount slides yourself by transferring your images from cardboard to glass. This protects the surface from abrasion. Most slide film processed by commercial photofinishers is packaged in cardboard. This acidic paper mount can be replaced by a plastic mount, but the process will be expensive and time consuming. If you take your film to a commercial photo lab frequented by professional photographers, your slides will probably be mounted in plastic. While the quality of the mount will eventually affect the image, the majority of damage to slides occurs through handling and improper environment.

Do not use poor quality plastic sleeves to store your slides. They deteriorate over time.
Collection of the author

GUIDELINES FOR HANDLING SLIDES

Handle by the edges only.

This prevents scratches and fingerprints.

Store Film slides in the dark.

Glass slides are more stable. Both types need proper temperature and humidity to last.

Limit the projection time.

As recommended by Kodak's *Conservation of Photographs*, do not project or use on a light table for more than a minute. A light table is a piece of equipment that sits on the table top and backlights the slides, making projection unnecessary. The combination of heat and light will fade the images. Use copies for projection. Just leaving slides exposed to sunlight will fade the image. Projection times accumulate and cause fading.

Never send originals.

Since these are unique images, once they are lost, they are irreplaceable. Have copies made when you need to send images to someone.

BASIC GUIDELINES FOR SLIDE STORAGE

Use polypropylene pages for storing slides.

Other types of plastic deteriorate with time and will deposit chemicals on the slide surface. Using the pages helps to protect them during handling. Stiff or flexible pages made from polypropylene pages are best for slides. In addition, adequate ventilation between the slides and the storage materials reduces their contact with the sleeves and prevents condensation.

Find a proper environment.

Temperature, humidity and light cause a significant amount of damage to color materials including slides.

Purchase films with a proven storage record.

Protect your slides before you take them by purchasing film that lasts. Kodak Kodachrome slide film is suggested. You can also refer to the charts in Henry Wilhelm's book, *The Permanence and Care of Color Photographs*.

Type of process	Introduced
Autochrome	1904
Lantern Slides	1850
Kodachrome (slides)	1936
Polaroid SX-70	1974
Kodak Color Negatives	1941

MOVIE FILM

While home movies are not technically photographs, they are often part of a family photograph collection. In fact, it would be difficult to find a family without at least one reel of 16mm or 8mm color movie film. Caring for this film is as important as preserving the still images in your collection. The basic rules of preservation apply to home movies. An environment with stable temperature and humidity provides the best protection. Since your still images need the same sort of storage area, it makes sense to keep everything together.

Movie film first became available in the same 35 mm formats used to make early commercial films. If you own any 35mm motion picture film, please contact the National Center for Film and Video Preservation at the American Film Institute at the American Film Institute, 2021 North Western Avenue, Los Angeles, CA 90027, Telephone (323)856-7708. Since nitrate film was produced from 1889 to 1939, most of the early movie film is unstable and should be transferred to safety film.

Another reason to contact a film archive is that you could be holding a copy of a missing film. A list of lost films appears on Wikipedia (en.wikipedia.org/wiki/List_of_lost_films). Each new cache discovered in someone's attic or basement could contain a commercial film valuable to historians studying the history of motion pictures.

All color film, both still and motion picture, fades. You should follow a set of guidelines to slow the deterioration of your home movies. For instance, films for the commercial market such as Ektachrome, Agfa and Ansco tended to fade in less than 10 years. The good news is that Kodachrome movie film sold to consumers since 1940 does not fade as quickly.

Identify your Film

Is the film in your collection black and white or color? Is it marked safety film? Do you have it stored in the original packaging that identifies the brand?

Examine the Film

Does it show any signs of damage? The film base will shrink over time, buckle or become brittle. Projecting the film may have caused sprocket holes to break or scratches. A knowledgeable film conservator can repair tears and perforations. Film can also be copied onto a new base. Before you are tempted to use videotape or DVD disks as a long-term storage medium see Chapter 8

- Rewind the film emulsion side out. Be careful not to wind the film too tightly. Brittle film will break.

- Metal storage cans, available from library suppliers, are suggested for long term storage. These containers can be stacked up to one foot high.

- Label the outside of the can with a permanent marker to ensure that the identification information remains with the film. Transfer any information from the original storage box such as who is in the film, where it was taken, and when.

The amount of color images and the variety of formats in our home collections is dependent on when the family became interested in documenting events and individuals. In some families, there has always been an interest in photography so their collections will be varied and probably contain both still and motion pictures. Economic status is also a factor. In order to take photographs or home movies, you had to purchase equipment, buy film and spend money on expensive processing.

HIRING A PROFESSIONAL PHOTOGRAPHER

There are times in our lives when we hire a professional photographer to document important events like weddings or formal family portraits. But how can you tell if they are following procedures to ensure the longevity of your images? You can start by asking a few simple questions. When hiring a professional photographer to take pictures of special events and family members, interview them about their procedures and final product. As the customer you can request information. Just be aware that special treatment of your prints may incur additional costs.

Questions for professional photographers

What type of photo paper do they use and how long does it last?

Photographic paper fades at different rates. Some papers are better than others. Once you know the type of materials a photographer uses, go to a professional photo store and find out if they have information on the best types of paper. For the most up-to-date information on color permanence, consult Wilhelm Imaging Research online www.wilhelm-research.com/.

Do they water process or chemically process their prints?

Water processing is the better choice because it cleans chemical residue left by the developing process from surface of the prints and negatives.

How long do they store their negatives?

This is important information if you ever need reprints. Under current copyright law, you must go to the photographer who took the photograph to have reprints made. Photo labs will not infringe on this copyright by making duplicate prints from your positive prints. See an explanation of the copyright matter in Chapter 9.

Do they use lacquer to coat the photograph or to create texture?

Ask the photographer if they treat their prints during processing. You may be able to request that your prints not be coated.

Is the photo studio going to frame the prints?

You may be able to make this step optional and take the print to a professional framer to ensure that your print is framed according to methods used in museums.

Are your images going to be presented in an album supplied by the photographer?

You may decide to purchase and supply your own album from one of the suppliers listed in the Appendix. Ask the photographer where they purchase their albums to see if they pass preservation standards.

FREQUENTLY ASKED QUESTIONS

How can I copy my Polaroid pictures?

Since a Polaroid print is a one-of-a-kind image, you need to make duplicate prints. Most photo labs now have the ability to make direct positive prints. This can also be done on a Kodak Picture Maker system. Contact Kodak for a location near you by consulting their website

(www.kodak.com) or calling their customer service department toll-free at 1-800-939-1302.

How can I stop my color prints from fading?

Some color prints fade even when stored in the proper environment, but the best thing you can do is keep color materials in a cool dark place. See storage guidelines earlier in this chapter.

Can I have film developed that has been sitting undeveloped for years?

You can have the film developed but the quality of the prints may not be what you are hoping for. The length of time the film sat undeveloped and the environment in which it was stored both affect the color quality and the degree of fading.

Can I store my slides in carousels or trays?

The preferable way to store slides is in polypropylene pages. Carousel trays give off gases from the plastics they're manufactured from, but also give slides an opportunity to breathe. Storing slides in trays in boxes, to protect from dirt, is better than using poor quality slide pages that deteriorate with time.

How can I make prints from my slides?

Before the days of digital imagery, the only way to make a print from a slide was to first make a negative (called an inter-negative) and then a print. Today, thanks to computers, you can make a good quality print from your slides without making an inter-negative. This process results in a better print. Each time you make a copy from an original, it is called a generation. For instance, the process of making a negative of a slide and then a print is considered two generations. If you were to make another negative from the print it would be an unnecessary third generation. Each generation results in a loss of detail. Now, the whole process can be done in one step by either a photo lab or at home with a scanner and a slide adapter.

CHAPTER EIGHT: THE DIGITAL AGE: THE NEW FAMILY ALBUM

A growing number of individuals feel like the woman in my lecture who insisted that placing her family photographs on compact disc and throwing away the originals is a viable solution to the preservation and space dilemmas posed by our collections. Yet as convenient as this may seem to some, it raises a lot of issues about our family images, not just those taken with a digital camera, but those that bypass the traditional print and are maintained by a photographic web-based company. There are preservation problems, retrieval issues, and the aesthetics of looking at a digital image. Yes, it is easier to share pictures, email copies to relatives and set up family websites. But what is really happening is a changing notion of the nature of a family photographic album.

DIGITAL PHOTOGRAPHY HISTORY

In 1975, an engineer at Eastman Kodak used a camera with image sensor chips that weighed 8 pounds and took 23 seconds to capture the scene. While a digital camera was used at the 1984 Summer Olympics and during the first Gulf War, the first commercially successful digital cameras didn't debut until 1990. The technology has come a long way since then. Now we have cameras small enough to carry in a pocket. You can learn more about the history of digital cameras at www.digicamhistory.com/. If you own an older digital camera, you might be able to help with this online project to identify older cameras.

As fascinating as digital photography is as a photographic medium, the whole process creates preservation problems. There is no doubt that storing photographs on computers is a space saver. It eliminates the problem of photographs piling up around the house. However, the major concerns are retrieval and preservation. According to photographic conservator, Paul Messier, www.paulmessier.com, digital photography has all the traditional issues of preservation—chemical, biological and physical, but electronic files add a new problem—obsolescence. This actually has two components. File format problems occur when the software isn't supported over time. Unless the software company continues to update its product as new operating systems come along, you'll soon be unable to access your photo files.

The second issue is hardware obsolescence. Does anyone remember 8-track tapes, and $5^{1/4}$ inch computer disks, and zip drives? If you do, then you know that there is very little equipment

left that can play the tapes or retrieve the information stored in these formats. The zip drives have been replaced by smaller drives. These same hardware issues are true for digital photography. Think about the rapid progress of this electronic medium in your lifetime and you'll agree that hardware obsolescence is something we're all going to have to deal with.

The solution is to migrate to new formats and hardware. As Messier told me, it's important to move with the pack and use the most up-to-date software and hardware. So how long before your computer is obsolete and you have to move all that information, including your digital images, to a new one? It's sooner than you think. Sure, you can transfer the information from one computer to another, but if the software to read the images changes then you may have a compatibility problem. You have to be sure that the newer system can read the format in which your images are stored.

What happens if you want to donate your family photo archive? Will the facility where you have stored your images be able to read the computer data or would they prefer having hard copies of your images? I bet they would prefer actual photographs over computer data. One archive has collected television news film for the past sixty years. Their collection consists of film in a variety of formats and videotape. It's a wonderful visual history of the last half-century; if they had the equipment to read the videotape and some of the film formats. This is a different type of material than a still photograph, but if you transfer all your images to a digital format, will anyone be able to read them in fifty years?

PHOTO CD/DVDS

Then there is the problem of photo CD/DVDs. Initial testing of the first CDs gave them a life expectancy of only 5-10 years maximum. Today, manufacturers are creating CDs, that according to estimates, will last between 30 to 100 years, or as long as 300 years depending on the type of disk. Companies use accelerated aging tests to predict the stability of their products under certain conditions. What they found is that longevity depends on a few factors--proper storage conditions, careful handling, and limited exposure to light. In addition, the dyes used in the manufacture of the disks can affect their longevity. One manufacturer found that gold disks last longer than silver ones.[22] You can increase the life span of this material by storing your CD/DVDs in the same environment as your photographs. A temperature of no more than 77 degrees Fahrenheit and a

[22] Larry Jordan, "The Life-Span of DVDs" www.larryjordan.biz/articles/lj_dvd_life.html accessed 12/4/2009.

relative humidity of 40% is suggested.

CD/DVDs are quite susceptible to scratching and should be handled by the edges only. Just as light damages the layers in a photograph, it deteriorates one of the CD/DVD components. If you're going to store material on a disk, it should be considered short-term storage. You can purchase Tyvek, an inert polyester sleeve for storage or a special hard plastic case. A U.K. company, Conservation Resources, Ltd. (See Appendix) sells a Corrosion Intercept CD system.

When writing labels on the disk, use a pen that's 100 % solvent free and appropriate for use on CD/DVDs. Some marking pens cause deterioration of the disk itself. Purchase a special marking pen from a library or archival supplier. Don't place stickers on the disks, either. They cause deterioration as well.

The larger issue with CD/DVD technology is the retrieval of the material written on them. Again, the question is whether the equipment will be around to allow you to look at the files in five, ten, or twenty years. Even if the material lasts to the outside date of 300 years, will anyone really be able to look at your photo disks?

If you think this is alarmist, just stop and again consider the history of technology in your lifetime. Whether you are young, old or middle-aged, there are pieces of equipment that have quickly become obsolete in a relatively short period of time such as 45 and 33 RPM records. The public is not fully aware of the ramifications of switching completely over to digital formats. In a recent conversation, a friend laughed when I raised these issues. He said he would just copy all of his data each time the technology changed. However, the costs of this conversion far exceed the inconvenience of having boxes of photographs around the house.

Libraries and archives are very concerned

Planning for Obsolescence

- Plan to upgrade your equipment every few years.

- Transfer your photographs from one media to another when the technology changes.

- Good preservation of digital albums starts with an acknowledgement of the limits of the technology.

- Make additional copies on different media formats such as photo prints, disks and recordable CD/DVDs.

Print out significant photos using the guidelines in Chapter 11.

about digital preservation. The Library of Congress has an informational page (www.digitalpreservation.gov/you/digitalmemories.html) which describes saving everything from email to digital photos. Their advice: create a backup using hard drives (internal or external), label

your digital files with common sense tags so that you can find them later and migrate files to current storage media. They also advise making several different copies and storing them in different places.

EXTERNAL HARD DRIVES AND USB DRIVES

Rather than rely on CDs, more individuals use USB hard drives. Some external hard drives are small enough to fit into the palm of a hand while others are desktop models. Look for formats that can store large quantities of data. While these drives are considered stable, take the Library of Congress advice and maintain at least two different copies of your files, just in case. These small drives can be quite durable. I've washed mine a couple of times after I forgot they were in my pocket.

ONLINE PHOTO COMMUNITY

What is the future of our family photograph collections? At this particular moment, as consumers, we have a wide variety of choices. As a family photographer, it is difficult to track the changes in this exploding market. Each day, there are new digital photography-related sites coming online. At the moment, the digital photographic online world consists of community sites where individuals share images, photofinishers that produce images from digital formats as well as film, and sites that do both. Sites that offer multiple services are trying to incorporate as much new technology as quickly as possible.

PHOTO SUPPLIERS

Most major photo companies have jumped into the digital photography market by offering services via their websites. Kodak offers its customers a choice of services including direct access via its website, access through a Kodak photo processing retailer or photo supplier or processing sites that produce personalized photo gifts or reprints without using a negative.

Each of us may prefer to use a specific option for personal reasons, but be sure to evaluate these sites prior to use. Newer companies offer customers all types of incentives such as free film processing, scanning your images to place them online, free downloads and storage space. It is difficult to estimate which of these photo processing sites will be long term survivors. Whether you use traditional film or digital formats, here are a few questions to help you evaluate the various offerings:

1. How do they process your film and make images accessible online?

2. Can you download images from their site?

3. How long do they store the images?

COMMUNITY SITES

Sharing your family photographs online is another facet of the rapidly expanding digital photography industry. Most sites offer you the ability to edit your images, organize them into albums, add captions, send copies via email, print them and even password protect your site. Before deciding to use these features for all of your family images, evaluate the site and the company.

Read the Fine Print

Before you quickly click the "I Agree" button regarding their terms and conditions, take a few minutes to read them over. By posting images on their website are you giving them the right to use your images without contacting you?

How Long Have They Been in Business?

Since the digital format is a fairly new medium for family images, most of these businesses are fairly new. However, they may be financial backed by an older more established company. While this does not guarantee longevity and economic stability, the financial support is an indication that the company has been deemed worthy of investment. You can also research their business model. Find out how they support their product.

What happens to your electronic files if the company ceases to exist?

Site reviewers often do not address this topic, but it it is one that will have growing importance. There will be winners and losers in these e-commerce ventures, so before posting valuable family images on a site, why not ask if they can transfer your images to another site of your choosing. Of course, you probably can download your images to a disk or CD yourself. Keep in mind that if you have used an online company for the photo processing, you may not have negatives to make prints from in the future.

Does the company offer photo editing tools?

Some websites offer a variety of editing options that allow you to create your own scrapbook pages and family websites or to simply crop and rotate images. Make a list of the features you want to use and see if the site offers them. Be sure to check back regularly because the number of options generally increases the longer a company is in business. If your online service doesn't offer the editing features you're looking for, download your images and use a

photo editing program or another website for editing.

How easy is it to look at your images?

If you don't have fast Internet access, you may have trouble using your files. Photos are often large files and download time is important to consider. Try a few of these companies prior to signing up for the service. Most have demos online for potential customers. If you don't see a demo or trial service feature, contact the customer service department for access.

Are you limited to a specific number of files?

Space limitation becomes important if you are going to upload a large number of images. You'll want to know if the company limits the number and size of the images that you can post. Ask companies to elaborate on any "free" offers as these may have a finite definition.

Is there a maximum size at which you can display or print?

Can you upload all formats of images including large tiff format files or are you limited to the jpeg file format. If the site compresses your digital images or only lets you upload small files, the outcome can be affected when you print or use the images in a photo book or other product.

Are your albums completely private or open to the public?

Some people don't mind if everyone sees their family photographs and has access to them. For most us, images are private, to be shared only with relatives and friends. Before you decide to make your genealogical information and photographs public property, consider the privacy issues presented in this chapter.

How long do they maintain your images?

The business model for these sites is to provide basic services for free, initially. Others charge monthly or yearly fees. In many cases, a limited amount of storage space is available for free but once you exceed that limit, you'll need to upgrade your account for a fee.

Do they re-size your images?

If you shoot all your images with a digital camera, do you want the site to re-size and compress your images? This may not affect your ability to view them on the web, but these edits will change the image appearance when you request copies.

Can you disable right-click copying?

Watch for right-click copying. You can copy all kinds of things on the web by right-clicking with your mouse (control-clicking on a Mac) including photos you've uploaded to photo sites. I

use a photo site that allows me to turn off the right-click option. You also can put a watermark on images to discourage reuse. Watermarking is an available option in many types of photo editing software and is practiced by many photo stock houses.

Of course, the best way to determine if a site suits your needs is to try it out. You can often use online demo versions on most websites. Some companies even offer to send you a starter kit to introduce you to their services.

Preservation Issues

Image retrieval difficulties because of unavailability of equipment or incompatible software are only two problems for the digital medium. Of growing concern are the websites that offer to host your images, acting as a family photo archive online. While it is possible to place your images on one of these websites, there are a couple of issues to consider. First, while these sites are initially free to new users, there is eventually a cost to store images or make prints. A more serious issue concerns which of these companies will survive in the rapidly expanding e-commerce world. In the worst case, you would store your images online, the company would fold and you could lose all of those images. A professional who works in the industry claims that many of these new small start-ups will be absorbed to form larger companies and the digital archives transferred. If this expert is wrong, you won't have the actual photographs to look at with or without technology. Simply stated-most photographs are more permanent than digital storage mediums.

Concerns

Archival has different meanings in the digital realm. Instead of acid and lignin-free storage, digital media preservation is about durability and formats. For instance:

Durability: How long will the format you select last? Have you researched the preservation aspects of your choice? No digital storage media currently available will outlive a nineteenth century print on a stable medium.

Reliability: Prints that you can hold are reliable. Can you say the same for your computer?

Accident Proof: How many times have you accidentally written over a computer disk full of information? Make sure whatever medium you select can be write-protected to prevent that from happening.

There are plenty of positive aspects to the digital album. You can share images, make copies, store large quantities of images compactly, display them without handling originals and restore them. Just don't expect your digital albums to be viewable by your great-grandchildren unless you take the steps to make that happen.

What is the future of family photography?

My only advice is to have fun with your family photographs and not worry about the technological future. Pay attention to preservation, but let the companies finish collaborating without you. If you treat your images well, they should last at least one lifetime regardless of the format. As you experiment, just remember to document important moments using a technology with some longevity so that future generations can enjoy your family's history. Otherwise, our descendants may have more photographs of family members from 1890, when photographs were relatively stable, than they will of us from 1990. In the meantime, I'm going to try to invest wisely in photographic technology and keep reading the current consumer journals to follow the trends.

FREQUENTLY ASKED QUESTIONS

Can I have traditional photographic prints made from digitized images?

Yes. Most photo labs and online vendors can produce prints of your digital images on regular photographic paper.

What about the videotapes I have in my collection?

Videotape consists of metal oxides placed on a clear polyester tape. Images are recorded on the magnetic metal oxide and the VCR plays it back. This is a fragile medium. The surface area is subject to abrasion. Repeated playing wears away the metal oxides and degrades the images. Dirt that builds up on the VCR can also scratch the tape. Videotapes are a temporary storage medium and most are unplayable before they are ten years old. Less expensive tapes have even lower life expectancies. The only way to preserve the image is to copy the tape before damage becomes noticeable. In general, conservationists recommend not storing the tapes near any magnetic source that will erase the material on the tape. Videotape is not suggested as a preservation storage medium. Blocking, (where the tape sticks together), dropout (when pieces of magnetic material are missing), and deterioration of the magnetic base are a few of the common types of damage suffered by videotapes.

In general, buy brand name tape, check it once a year for damage, make a preservation copy, and clean your VCR regularly. In addition, you should rewind and check the preservation copy yearly to anticipate when you will have to make a new copy. Have your videotapes transferred to a digital medium whenever possible so that you have a backup.

CHAPTER NINE: DUPLICATING PHOTOGRAPHS

One way to preserve your photographs is to use copies for display and when you create albums. Just a few years ago, before scanners and digital copiers became available, there was only one way to make copies of photographs--you had to make a copy negative and then a print. That has all changed. You can now walk into virtually any photo store and use an on-site photo kiosk to scan and print photos. You can even email images to family members or transfer them to a CD/DVD. Digitizing images allows you to crop, enlarge, reduce red eye, and even add creative borders to your pictures. Photo kiosk services may be too expensive to use for all of your images, but they are perfect for a select few. These stand-alone systems make prints, ranging from small wallet size photographs to 8 x 12 inch portraits. These machines also allow you to change the size of the original in seconds. You can even work with a variety of photographic formats including prints, Photo CDs, and some digital photographic equipment. Downloading the image onto a disk and printing it at home as also an option.

If you have a lot of pictures, purchase your own scanner. It's worth the investment. This equipment works very well for scanning images or flat art. If you have a large number of slides, you might want to purchase a special slide scanner. They are slightly more expensive, but worth the investment if the majority of your photographs are transparencies and slides. Before purchasing any piece of equipment, research the quality of the product. Reviews appear in *Consumer Reports* and computer magazines like *PC Computing* and *PC World*. This information is also available online.

PHOTOGRAPHIC COPIES

In order to make copies the traditional way, you have to use a piece of equipment called a copy stand and make either negatives or slides of the pictures. This process can be completed in a professional photo studio or at home. A copy stand consists of two 500 Watt tungsten light bulbs, spaced evenly apart and an adjustable rod attached to the base where you attach the camera. Conservators recommend using strobe lights instead due to the heat and strong light of the tungsten. If you choose to use tungsten, turn off the lights to cool them down. The bulbs uniformly light the object being photographed. I prefer this method because I am taking a

negative of the print from which additional copies can be made. The print quality is also a little better than the newer direct positive methods.

These stands can be made very simply at home by mimicking the more professional models. Instructions to build your own copy stand are available online at http://www.gedpage.com/copystand.html.

SCANNING

Scanners are affordable for the home user. You can purchase an inexpensive model for less than $100. These models are fine for most family photograph projects and are an excellent way to copy your images. If you have a wide variety of family photographs to scan, from daguerreotypes to glass negatives and slides, investigate the capabilities of each machine very carefully. Not all scanners can handle historical photographs such as cased images. And you may need to invest in a more expensive model to handle your needs. While you wouldn't want to repeatedly scan your images and expose them to heat and light, a single scan for preservation purposes outweighs the risk.

Learning the language of scanning is like being tossed into an alphabet soup. There are several different picture formats: RAW, TIFF, GIF, and JPEG. These various formats can be a little confusing at first. After all, what do those letters mean? In order to understand the basics of scanning, you need to become familiar with a few acronyms for terminology.

DPI-Dots per inch. The more dots per inch contained in an image, the better the resolution quality.

RAW - This format contains all the data related to an image. It must be converted to be viewed. There are many different RAW formats currently in use. Some are proprietary to specific companies.

TIFF - Files saved in this format are uncompressed. This is a preservation standard at a high resolution, i.e. more than 600 dpi.

GIF - This format is a web standard for graphic files.

JPEG - Images in this format are compressed to save file space.

Factors to consider when choosing a format:

Compression: Does the format compress the image? If so, then choose another format for images you are going to edit, manipulate or restore later.

Image Quality: Some compression methods affect image quality. This can affect editing.

Printing: If you want to print an image, then you'll want to have an uncompressed file of at least 300 dpi. This will allow you flexibility to print large or small prints. 72 dpi jpeg files for

instance, are just for the web. You can't get a good quality picture from this low resolution.

Color Depth: Does the format have a full range of color or is it limited?

Special Features: Can you add watermark your images or add copyright information?

I prefer to use the TIFF format with no compression for saving scans even though these scans take up a lot of storage space. TIFF retains all the qualities of the original image, while JPEG, including the JPEG option under TIFF, drops out some features during compression. Unfortunately, not all photo editing software supports TIFF. JPEG is a great format for sharing images online because of the compression. GIF is another option, but is limited in its ability to record color. Use GIF for graphics, not photographs. The best way to see the differences between these formats is to experiment with them.

A scanner uses sensors to measure the amount of light reflected off the image. The size of these sensors determines the resolution or clarity of the picture. The DPI rating of your scanner correlates to the number of sensors per inch of scanning width. A good-quality scanner allows you to adjust the scanning resolution of your picture. The DPI rating of the scanner influences the picture quality of the image. Other factors affect the DPI. For instance, you need to know the range of your scanner and the printer when considering DPI. You can scan the image at a higher resolution for printing even if your printer can't duplicate the same DPI. At some point, you will upgrade your printer and not have to rescan the image. In the case of printing an image on the web, the DPI correlates to the amount of time it takes your computer to download the image. Many websites use images scanned at 72 DPI. This results in a readable image and one that can be quickly downloaded.

> Online and print product reviews
>
> PC World: www.PCWorld.com
>
> Consumer Reports: www.consumerreports.org

Reviews of scanners usually mention features like color accuracy, optical resolution, connectors (USB, cable or wireless), software and type of photo multi-function. Don't buy a text-only scanner to preserve your photos. You'll be disappointed. The low resolution of text-only scanners is suitable for photos. If you can afford it, buy a dedicated flat-bed scanner rather than a multi-purpose model that combines scanning, printing, and copying features. If you want to scan cased images, slides or negatives, visit a store and ask to try the product. It is possible to buy slide-only scanners for less than $100. If you have a sizeable collection, this investment makes sense.

Color accuracy or color balance in the image is an important factor when considering a scanner purchase. This component captures an image in realistic color. Scanners with more bits

offer more accurate color representations of your image. The majority of the scanners now have at least 48 bits. Remember that all color is composed of three primary colors, red, green and blue. A scanner with poor color balance will not show a true white. You don't want to see other colors present in the scanned image of a white dress. You want to see an accurate copy of the image you are scanning.

A good scanner also provides detail in the image. This is commonly referred to as image resolution. This translates into the DPI rating mentioned above. The higher the DPI the most detail in the viewable image. This doesn't mean that you have the capability to print an image in the same amount of detail. That depends on the DPI rating of your printer. Watch the numbers. These are expressed in product specifications dpi resolution. In general, purchase a scanner with the highest resolution that you can afford.

Software usually accompanies the scanner. Make sure this software is TWAIN compatible. TWAIN stands for technology without an interesting name. This software program helps the equipment scan the image onto your computer.

The software also leads you through the step-by-step process of scanning an image. You will need to identify what you are copying such as line art, halftones, black and white photographs or color. Based on your selection, the software will assign specific qualities to that image. Scanners come with

Features

Flat Bed Scanner

A flat surface is essential to scanning photographs safely and accurately. While handheld and sheet-fed scanners exist, you will damage the image you are trying to scan and probably won't obtain a good image. If you're going to scan cased images, bring one to the store and try the scanner. Some "read" the glass rather than the image, resulting in a blurry image.

Digital ICE

This technology automatically corrects minor surface defects. Before purchasing, see if you can turn off the Digital ICE to scan the original as is and then make the corrections using photo-editing software. Look for a professional mode on your scanner.

DPI (dots per inch)

The higher the DPI rating, the more detail will be present in your viewable photograph on the computer monitor. Images on the web work best at 72 dpi. For printing purposes, make sure that your printer can support the dpi of the scanner.

Software

If you intend to improve the quality of the scanned images, you will need software that allows you to crop, rotate, change the scale of the image, fix the contrast, and remove red-eye. The program should also allow you to undo errors.

some photo editing software, but you may want to purchase more sophisticated software if you plan to manipulate the size, color, and features of the image. One of the most popular software choices is Adobe PhotoShop Elements. You could also use free (and upgradeable) photo editing websites such as Picnik.com. Basic features of these programs include rotating the image (especially important for large images), cropping, increasing or decreasing the contrast, straightening crooked images, changing the size of the image and removing red-eye. The best programs allow you unlimited opportunities to undo any number of changes before closing the program. When you first begin trying to manipulate your digitized images, you will want to reverse your mistakes. More sophisticated restoration techniques are available in the professional versions of popular photo editing software.

Once you've narrowed down your scanner options, go to a store and try out the product. Make sure it fits in your workspace, doesn't make a lot of noise and is easy to operate. Look over the product specifications to see how long it takes to scan an image. If you're going to take the scanner with you when you meet with family, see if it will fit into a carrying case or small suitcase.

Scanning the Images

This introduction to scanning covers the three basic steps to digitizing family photographs: scan levels, formats and storage. The first step in the process is selecting a scan level. This is the dpi or scan resolution combined with the number of colors or color depth. Then select a format. The suggested format for archiving images is TIFF with no compression. Note that for sharing scanned images, JPEG is the preferred format because the smaller file sizes increase the speed of transmission. The third concern when digitizing your images is selecting a storage medium that is "archival." You can print your digitized images r keep them on CD/DVD or external hard drive. Unfortunately, the debate continues on what constitutes the best digital "archival" storage method. In the future, the best retrieval methods will also allow for data migration, the transfer to another newer medium. When scanning any type of photograph for long-term use, scan at a high resolution (at least 600 dpi) and use an uncompressed TIFF format.

Printing Digital Images

There are three ways to make prints of your digitized images. You can use an online photo website, a stand-alone kiosk in a local store or purchase a good quality inkjet printer. In the first two cases, you'll want to receive prints on regular photo paper, while at home you can use "archival" paper and inks available from special suppliers. Bear in mind that not use photo paper

some print on thermal paper. Consult research on the longevity of kiosk prints on the Wilhelm Imaging Research website www.wilhelm-research.com. Use the search box at the top of the site to find the literature. According to Henry Wilhem of Wilhelm Imaging Research Inc., it wasn't until 1994 that the first desktop printers had the capability to print photos.[23]

While it is relatively easy to produce photographic prints on your home inkjet printer, there are preservation issues that are unique to these prints. The permanence and fading qualities of both the ink and the paper need to be considered separately. The companies that supply inks are not the same manufacturers that produce paper. In the inkjet-produced print, both ingredients (ink and paper) have different rates of "permanence." Archival in terms of printer inks and papers means that the manufacturer only intended for the product to last for a "reasonable" period. [24]

Prints generated by using the best quality inks and papers are still subject to fading, bleeding ink, yellowing, and damage from high humidity. Wilhelm Imaging Research continues to investigate industry claims and conducts accelerated aging tests to see which products last the longest. Henry Wilhelm's research, available online, is the best source of current data. The choices you make regarding the two components of the home-produced print influences the stability of your image. The key to printing at home is to use an ink and a paper from the same manufacturer such as Epson DuraBrite ink and Epson paper. They are manufactured to work together. Don't use one company's ink with another type of paper.

The pictures you print yourself can last a long time if you purchase products that have been tested. Standard paper and ink will fade in under a year, while special inks and paper can possibly last as long as 50-100 years. In order to increase the longevity of these prints, apply the same basic rules of preservation storage that you use for the rest of your collection.

> **Suppliers of archival inks and paper**
>
> Lyson LTD www.lyson.com
> MIS INKS www.missupply.com
> For current information on inks and papers, see Wilhelm Imaging Research, Inc. www.wilhelm-research.com. This site also contains a list of suppliers for mentioned products.

Digital Information Online

In the digital realm, it is difficult to track the latest changes. That's why having readily accessible reviews and product information from websites is invaluable. Use these sites to follow

[23] Henry Wilhelm, "The Intimate Relationships of Inks and Papers: You Can't Talk About the Permanence of One Without Considering the Other." www.wilhelm-research.com accessed 12/08/09.

news, obtain feedback from actual users of cameras and scanners, and learn new techniques to make your equipment work for you. According to *Digital Camera Magazine*, there is a lot of digiphoto material available online, but it is user beware. The following three sites received top ratings from them.

Steve's Digicams www.steves-digicams.com

Photography Review www.photographyreview.com

Image-Acquire.com www.image-acquire.com

SPECIAL CONSIDERATIONS: KNOW THE LAW BEFORE YOU COPY

When I called a photo store to inquire about certain equipment for copying photographs, the sales person made me promise to talk about copyright infringement and family photographs. Not that I needed reminding. As a former picture researcher, copyright considerations were part of the everyday business of selecting images for print publication. But how does this law affect genealogists? Copyright refers to an intricate set of Intellectual property laws put in place to protect the interests of the "author." In general, the author is the person, persons, or corporation that creates an original work. The United States Copyright Office (USCO), under Title 17 of Federal Law, is the government office that oversees the use and abuse of copyright protection. These laws can be found online on the Library of Congress website, lcweb.loc.gov/copyright, or at most large public libraries. The USCO also processes and registers copyrights.

Under the law, rules of usage and infringement are the same whether you are creating a family genealogy, a family website, or copying images to distribute to relatives. Genealogists need to be familiar with the basics of copyright law before attempting to publish any images in their collection in a book or on a website. An understanding of terminology will help you determine whether or not the photograph you wish to copy or publish is under copyright. For the purposes of this book, a copyright is the legal right of the "author," in this case, photographer, to resell the images they created. Thus, if you took the picture, you are considered the author. However, if you or a relative went to a professional photographer for a portrait, the photographer owns the copyright. In order to reproduce that image, you must obtain their permission. It doesn't matter that you paid the photographer for the family photograph, you must still approach the photographer for permission to publish. This law also pertains to copies. Either the photographer will make the copies at your expense or sign a waiver allowing you to have copies made elsewhere. Publication of some images will be subject to an additional usage fee known as a

royalty. In this case, you have to tell the photographer where the image will be used and why.

Some items are strictly regulated by law and should never be copied. This includes: money, Federal Reserve Notes, citizenship certificates, passports, postage stamps, revenue stamps, checks, bonds, securities, and government identification documents.

How does this law concern you?

Let's say that you have a photographic portrait in your collection taken by a photographer who is still in business. According to a ruling made by the U.S. Supreme Court in 1978, the photographer holds the copyright for that image. In order to make copies of the picture or loan it out for display or publication, you must first approach the photographer for the right to do so. You also need to request additional copies from the photographer.

Are there any exceptions?

There is another clause of the law that covers "fair use." Four criteria determine whether use of a photograph can be considered fair use. "Work" refers to a photograph.

1. Is this a commercial or non-commercial usage? (Are you going to make a profit from its use?)

2. What is the nature of the usage? (How will you use it and where will it appear?)

3. How much of the work are you using?

4. Does this affect the value of the work?

Simply defined, "Fair use" means that you can use the image for personal or educational use without monetary gain. While one of the factors pertains to the percentage of the work being reproduced, this was primarily intended for authors of written works. Contact the photographer whenever any portion of their image is going to be published or posted on the Internet. Using a copyrighted photograph on your website without permission is a copyright infringement.

Does a photographer have the right to use my image without permission?

Professional photographers that sell their work to advertisers and publications usually obtain a signed release from the individuals in those photographs. Reprints of model releases and an explanation of your rights are published in the *ASMP Guide to Professional Practices in Photography*.

What about alterations?

Any alteration of the image must also be approved by the copyright holder, which means that if you want to use a section of a copyrighted image on your website, you need permission to do so. As computer-enhanced images become more common, it is increasingly popular to manipulate an image to add information. This is easily done with digitized images. Photo restorers can show you examples of altered photographs, cases where the owner asked to have a person taken out or added in. You may view alterations as a handy way to remove the visual evidence of unsavory relatives or to change history by including a deceased family member in a group portrait. Two famous cases involve alteration of the dust jacket of the book *A Day in the Life of America* and a photograph from the movie *Rain Man*. In the first case, a moon was added to the photograph. In the second, the picture that appeared in *Newsweek* magazine accompanying a story on the movie *Rain Man* showing Dustin Hoffman and Tom Cruise standing together was a composite of two different images. [25] While you may not consider this a problem, think about what would happen to the future interpretation of these altered photographs. Are you changing history by altering images?

If you think that copyright laws don't affect you, see what happens when you take a contemporary family photograph to a photo studio to be copied. In most cases, the studio will request a waiver from the photographer before making reproductions. Professional photographers and photo studios basically agree to uphold the law. Therefore, they can refuse to make copies of images covered by the law. Several professional organizations including the Professional Photographers of America have agreed to adhere to a set of copyright guidelines outlined by the Photo Marketing Association International. You can find a complete set of the responsibilities of the consumer and professional photographers on the Kodak website, www.kodak.com/global/en/consumer/doingMore/copyright.shtml.

When locating images to add to your collection, copyright issues are even more important. Images published in books, magazines, and on the web also fall under the parameters of the law. For genealogists, it is best to be cautious about reprinting images you find elsewhere. Historical photographs taken prior to 1923 are no longer covered by copyright protection. But do not assume that historical images you find in museum collections are in the public domain. These are documents owned by the museum. To verify the parameters of the law, use the chart provided, or

[25] Andrew D. Epstein, "Photography and the Law," in Richard C. Allen et al, *Lawyering for the Arts* (Boston: Massachusetts Continuing Legal Education Inc., 1991) II 7.

follow the advice given in the Consult the Experts section.

If you think you would like to protect some of your images by applying for a copyright, follow these three easy steps. Go to the Library of Congress website for copyright information www.copyright.gov or write to the United States Copyright Office, Library of Congress, Washington, D.C. 20559 to obtain the appropriate form. The USCO also has a twenty-four hour hotline to handle form requests at (202) 707-2000. You need to submit two copies of the published image or one copy of an unpublished photograph.

> **Terminology**
> *Author*: Creator of the item being copyrighted.
> *Copyright Infringement*: Using an item under copyright without permission.
> *Publication*: Public distribution of copies.
> *Fair Use*: Use of a copyrighted work for educational or personal purposes.
> *Public Domain*: Works no longer covered by copyright.

Check the website for a list of fees and details on electronic filing and submit your form and payment. Holding a copyright entitles you to exclusive rights to make copies, sell and market the picture, display it and allow others to duplicate it as long as you have the proper releases.

Once you publish your images on a website, they can be copied easily by other individuals. One way to see if anyone is using your pictures without permission is to enter the image file name including the extension, for example, myimage.jpg, into an image search engine such as Google.com. The displayed list of results will indicate where your image appears on the web.

> **A copyright notice should contain the following:**
> The symbol ©, the word copyright, or the abbreviation Copr.
> Year of first publication (creation).
> Name of the copyright holder.
> Example: © 2010 Maureen Taylor
> **This notice should appear on the item.**

Copyright law is a complicated issue, subject to constant debate. Genealogists need to pay attention to the law when copying or publishing photographs that might be under copyright protection. Before publishing any photographs make, sure that you have taken care of any copyright issues.

REGISTERING A PHOTOGRAPH

1. Submit Form VA.

2. Two copies of the work to be registered for non-returnable deposit. Unpublished images need one copy, a photocopy or contact sheets.

3. Non-refundable filing fee. Check website for current fees. http://www.copyright.gov /docs/fees.html (Check or money order payable to Register of Copyrights)

4. Send package to Register of Copyrights, Library of Congress, Washington, D.C. 20559

Websites

United States Copyright Office, www.copyright.gov

Find forms and information about Title 17.

Basic Guidelines

Pre 1923: In the public domain.

1923 - 1963: Works published with a copyright notice, but not renewed, are in the public domain. If the copyright was renewed, protection extends another 67 years from renewal date.

Published 1964 - 1977: Copyright protection is in effect 28 years from date of first publication. Automatic extension of 67 years from renewal date. (United States Copyright Code 304a & b).

After January 1, 1978: Copyright protection is in effect for the life of the author plus 70 years (United States Copyright Code 304a). In the case of joint authors, copyright protection is in effect until 70 years past the date of death of the last-surviving author.

For additional information consult:

Copyright Table compiled by ProGenealogists.com, Cottrill & Associates www.progenealogists.com/copyright_table.htm

Who Owns Genealogy? By Gary B. Hoffman, www.genealogy.com/genealogy/14_cpyrt.html

CHAPTER TEN: PROFESSIONAL HELP: CONSERVATION AND RESTORATION

Unless you are extremely fortunate to have a collection in mint condition, at least a few of your family photographs will need to be professionally restored or conserved. There is a lot of confusion about these two processes. Companies that actually claim to conserve your images may be misrepresenting their services. Digital restoration is not conservation. The two terms are not interchangeable. Restoring an image is the process of re-creating the appearance of the object. Conservation includes several steps such as object examination, scientific analysis, research, and evaluation of the object's condition. All conservation work involves treatment to prevent future deterioration. Both conservation and restoration are time-consuming processes. Unless you are a trained chemist with a background in photographic conservation or a specialist in photographic restoration, you will want to hire a professional. A professionally-trained photographic conservator should handle your conservation work. Your attempts to remove damage could destroy your images.

Photographic conservators are specially-trained individuals. Their backgrounds include working with all the mediums that have appeared in the history of photography such as glass, metal, wood, paper prints, albums and plastics.

WHY YOU NEED A PROFESSIONAL

There may be tarnished daguerreotypes in your collections or prints covered with stains. Stains due to acid storage materials or mold can gradually affect your pictures. A conservator can reverse some damage in these cases.

In other situations, where photographs have been exposed to catastrophic events such as floods or fires, a conservator can assist in the recovery of your valuable photographs. Water-logged images and those exposed to smoke will require special treatment.

It is necessary to find a properly trained photographic conservator to work with your images. Since no laws regulate this profession, find someone affiliated with a professional organization. One such group is the American Institute for Conservation of Historic and Artistic Works (AIC), www.conservation-us.org/. Members of this organization must adhere to the AIC's

Code of Ethics and Standards of Practice. They require their members to produce work at a high level of professionalism. One of their sub-groups is the Photographic Materials Group (PMG). The AIC also operates a Conservation Services Referral System. Contact them to obtain a list of their members in your area. Since they represent conservators from a variety of backgrounds, be sure to ask specifically for photographic conservators. There is no charge for this service.

Within the AIC, there are various levels of membership (Fellow, Professional Associate, or Associate). Fellows and Professional Associates have agreed to follow the ethics outlined by the organization and have passed a peer review.

Many museums have small conservation labs to work with their in-house collections. They may be willing to refer you to a conservator. However, it is important to follow certain guidelines for choosing a conservator.

Choosing a Conservator

According to the AIC, there are specific questions you should ask before hiring a conservator. As a potential client you have the right to ask questions and expect answers. After all, this is an important decision. You will be turning over irreplaceable family photographs to their care. This is not the time to be shy about the interview process. You need to find out about their training, experience, professional activities, and availability. Ask for references and be sure to contact them to see if they are satisfied with the work.

Evaluating a Conservator

1. What is their training for photographic conservation?

You want to learn more about their professional background. Did they study in a formal program or learn through participating in an apprenticeship? Are they specifically trained in photographic conservation? Do they regularly attend conferences to keep up to date with new developments?

2. Ask for a list of references and call them.

Conservators that actively accept clients will have a list of individuals they have recently done work for. Calling these references is a necessary part of the hiring process. It can save you time and money later.

3. How long they have been involved in photographic conservation?

Someone who has many years of conservation experience will be able to use that history to anticipate treatment problems. They have also developed a network of other professionals that they can call on if necessary.

4. Is conservation their primary activity?

You need to find out if conservation is their business or just a hobby. This distinction can make the difference between a well-conserved item and project that has gone awry.

5. Do they have experience working with the type of image you have? Ask for examples.

There is a wide variety of photographic materials in family collections. You want to make sure that the person you hire is familiar with the item you are trying to have conserved.

6. What is their availability?

Good conservators usually have a backlog of clients. The project you want to undertake may not be complicated, but because there are other clients, work may not begin immediately.

What you should expect?

1. The conservator will examine the item before advising a treatment.

2. They will supply you with a written preliminary report that contains a description of the treatment, results and estimated cost.

3. Ask for an explanation of the charges. Do they charge separately for examination? Are these charges deductible or separate from the future contract?

4. The conservator should be able to explain risks, insurance, payment schedule, and shipping.

5. If the work is more involved that originally projected, you will be notified.

6. When the work is completed, some conservators provide a treatment report, while others require the client to request a copy. The report contains a list of treatments and materials as well as both written and photographic documentation.

What can a conservator accomplish?

These examples illustrate the different approaches involved in conserving different

types of material. In all cases, the hard work and expertise recovered these "lost images." Before you throw out the damaged materials in your own collection, consider obtaining the advice of a professional conservator.

DAMAGED DAGUERREOTYPE RECOVERED

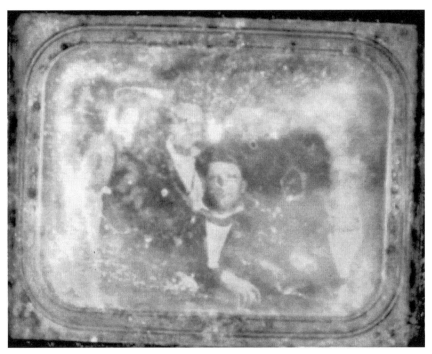

Here are the before and after conservation photographs of a daguerreotype found in a time capsule in a church cornerstone in LaGrange, Georgia. Cleaning the image allowed for identification of the men. *Courtesy of the Troup County Archives and NEDCC.*

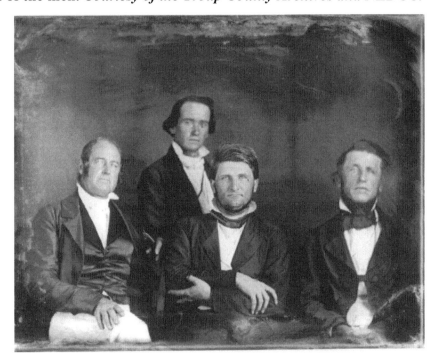

The First Baptist Church in LaGrange, Georgia discovered a daguerreotype in a time capsule in the 1856 cornerstone during demolition of the building. When found the image was completely tarnished. Not a single one of the four sitters was visible.

The Church Archives Committee, with the guidance of the Troup County Archives, decided to send the daguerreotype to the Northeast Document Conservation Center for treatment. For well over a century, it had been exposed to high humidity, fluctuating temperatures, and probably water. All parts of the daguerreotype package had deteriorated. The brass mat and preserver were corroded brown with a few green spots. The glass cover was intact, but was very dirty and had mold growth on it. The plate, itself, had mold deterioration (greenish spots), water lines across the image, and some uneven brown and blue tarnish. The paper on the reverse of the plate was completely disintegrated.

The Northeast Document Conservation Centerwas given the daguerreotype to treat. A senior paper conservator reduced the surface soil using dry cleaning techniques and cleaned the plate electrolytically in a strong ammonium hydroxide solution. The image of four men became clearly visible.

The brass mat and preserver were cleaned in ammonium hydroxide, and then washed and varnished in shellac. The daguerreotype package was resealed using a new cover glass and Filmoplast P90 tape.

Since NEDCC's treatment of the daguerreotype, the staff of the Troup County Archives identified the man on the left as Phillip Hunter Green, a noted local builder, and the man in the center as Reverend Elder B. Teague, minister of the church. The other two men are still unidentified.

Church leaders had anticipated retrieving a capsule in the 1922 cornerstone, placed when the church was renovated, but were unaware of the capsule in the 1856 cornerstone, placed when the church was built. In the earlier stone in an opening chiseled out of the granite a cardboard shoe box was found. Gary Sheets, building superintendent, said, "I was nervous as a long-tailed cat in a room full of rocking chairs when we were taking out the box." Unlike the contents of the 1922 stone, the articles found in the older stone were in poor condition. They included the daguerreotype treated at NEDCC, a small bible, a small wooden box which may have originally housed the daguerreotype, some remnants of a tapestry-like fabric, and some unidentifiable deteriorated "crumbs".

When the new First Baptist Church is built, it will include another time capsule in its cornerstone. Inside that time capsule will be a photographic copy of the daguerreotype.

Reprinted with permission from NEDCC, 100 Brickstone Square, Andover, MA, 01810. <nedcc.org> NEDCC News, Winter 1997. Vol. 7 No. 1.

NEGATIVE DETERIORATION

The Chicago Albumen Works specializes in salvaging damaged negatives. Shown here are before and after views of a negative of Clark Gable and Margaret Mitchell at the premiere of Gone With the Wind. The image is shown as a positive to illustrate the damage. *Courtesy of the Atlanta History Center*

The method employed by the Chicago Albumen Works to salvage these deteriorating negative involves three steps. First, the emulsion is chemically removed from the di-acetate base. The Pellicle (the removed emulsion) is then set in a carefully controlled solution which allows its folds and furrows to relax. Finally, the flattened pellicle is duplicated with our standard duplication procedures, producing an archival film interpositive and an accurate duplicate negative. The pellicle itself can also be returned to the collection.

Reprinted with permission of the Chicago Albumen Works, Front St., Housatonic, Massachusetts, 01236. Telephone: (413) 274-6901. www.albumenworks.com/

The Chicago Albumen Works offers negative conservation for individuals and institutions.

Interview with a Conservator Paul Messier of Boston Art Conservation www.paulmessier.com Professional Associate of the American Institute for Conservation.

What is the basic component of any conservation work?

A conservator stabilizes a photograph.

When should a photograph be considered for conservation work?

Like any other artistic or cultural object, photographs require conservation treatment to address active deterioration. Active deterioration typically falls under three broad categories: chemical, physical and biological. Some examples: Chemical deterioration can relate to the presence of acidic enclosure or adhesives. Such materials can cause progressive staining and/ or fading of photographic images. Perhaps the most significant cause of chemical deterioration is long-term exposure to elevated relative humidity which can cause deterioration to photographic binders (the image such as gelatin) the paper base and the silver-based imaging materials. Physical deterioration usually takes the form of tears, crease and overall embrittlement, making handling and displaying the piece risky. Biological deterioration typically takes the form of mold and insect activity that can cause staining. These are all manifestations of active deterioration which require conservation treatment in order to stabilize the condition of the piece.

How long does the process take?

Usually a conservation treatment will have two major phases: The first phase typically deals with addressing the various forms of active deterioration in order to stabilize the object. Once the piece is stabilized, then treatment might shift to compensating for areas of loss or doing other restoration work. The first phase can often be achieved after 1-5 hours. Depending on the amount of restoration needed, the second phase can take minutes to any number of hours.

What can a conservator accomplish?

It varies depending on the type of photograph and the type and amount of damage.

Tintypes

For instance, there is not much a conservator can do to repair abrasive damage to a tintype. If the tintype is rusting, conservation treatments can stabilize the chemical deterioration of the image. It can be consolidated to help prevent lifting off of the image.

Ambrotypes

When the backing of an ambrotype is flaking away, consolidation treatments can re-adhere it into place.

Paper Prints

A conservator can repair physical deterioration by mending tears with Japanese paper and wheat paste. When the damage is severe, the entire print can be removed from its original mount, lined and remounted on Japanese paper or a sturdier mounting board. This protects the photograph from further tears.

When the damage is the result of chemical deterioration such staining or silver mirroring, a variety of treatments can help. Silver mirroring gives the print a silver or iridescent appearance when held at a particular angle. The silver mirroring may be removed from the surface or coated by saturation of the mirroring. In both cases, the mirroring can be significantly reduced.

Stains due to biological damage can be reduced by washing in de-ionized water or bleached using light. This is a challenge for certain types of prints depending on their sensitivity to water.

Missing pieces of emulsion due to abrasion, cracks, tears, or insect damage can be compensated for with a technique called Inpainting. First, the area of image loss is consolidated using a substance. Then, the inpainting medium such as watercolor, pastel, or colored pencils is applied. The goal is to make the area of image loss as minimally distracting as possible. In all cases, the inpainting should be reversible.

If you could give one piece of advice about caring for photographs in a home, what would it be?

I think long-term exposure to elevated relative humidity and poor quality housing materials are the most significant factors that cause deterioration of most collections. Avoiding these conditions is critical for the preservation of photographs, whether in a public institution or in the home.

How expensive is conservation work?

If someone has a photograph of sentimental value in their collection, they should not be discouraged from approaching a conservator. Stabilization can be done in a few hours of treatment. Often, it is the cosmetic work such as inpainting that becomes expensive. If need be, a person can have a conservator stabilize the print from future damage and have the cosmetic work done at a later time.

Conservation on a Paper Print

These before and after photographs of a damaged portrait illustrate what a conservator can accomplish. The sample report provides you with an example of what a client can expect.

SAMPLE CONDITION AND TREATMENT REPORT

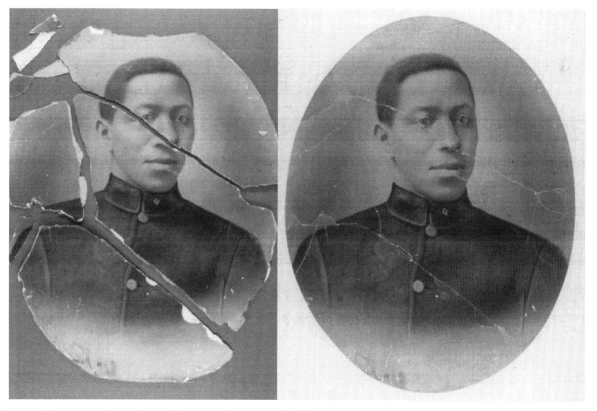

PAUL**MESSIER**
Conservation of Photographs & Works on Paper

103 Brooks Street Boston, MA 02135 // www.paulmessier.com // Tel 617.782.7110 Fax 617.782.7414

These photographs of a damaged portrait illustrate the conservation process. Reports courtesy of Paul Messier. Photograph courtesy of Keith Washington

Condition Report & Treatment Proposal

File #: 99414

Type: Crayon enlargement

Title/description: Portrait of a Man

Artist/origin/date: Unknown maker

Inscriptions: none

Dimensions: approximately 19 x 16 oval

Owner: Jean M. Washington

Examined by: Paul Messier**Report date:** December 4, 2009

Condition:

The photograph is in poor condition. It is split into four major pieces, and several smaller fragments. The pieces are adhered to an acidic, paperboard, mount. There are losses, punctures, tears, and staining.

There are several losses to the photograph, all located along the outer edges. The largest losses are as follows: 4 ½ x 4 ½ x 2 ½ inches, triangular, located to the left of the sitter's head; 2 ½ x 2 ½ x 1 inches, triangular, located near the sitter's left shoulder; 1 ½ x 3 x 3 inches, tirangular, located above the sitter's right shoulder; 1 x 1 ½ x 2 inches, triangular, located at the upper edge.

There are three punctures in the photograph. They each measure approximately one inch in diameter and are located above the sitter's left eye, at the lower left edge, and 2 ½ inches from the lower right edge.

There are several tears throughout the photograph. The largest of these are as follows: 3 inches vertical, located at the right shoulder; 2 ½ inches vertical, located at the lower edge; 4 inches, diagonal, located to the left of the ear. The photograph appears to have suffered some minor water damage. There are dark brown stains at the lower edge. There is minor media loss near the sitter's mouth.

Proposed treatment:

The photograph will be split from its acidic mount mechanically with metal and Teflon spatulas. Remaining paper will be removed from the reverse of the photograph with poultices of methylcellulose. Western paper fills will be made from paper toned with acrylic paints to compensate for the lost fragments. The fragments will be assembled together and adhered on the reverse with Japanese paper and wheat starch paste. The photograph will be lined overall to a sheet of Japanese paper with wheat starch paste. It will then be placed between blotters and under weights to dry. Once dry, the photograph will be mounted to a 2-ply board with Lascaux 360 HV, an acrylic adhesive and dried between blotters under weights. Losses to the image areas will be inpainted with pastels, colored pencils, and watercolors.

Treatment:

The photograph was split from its acidic mount mechanically with metal and Teflon spatulas. Remaining paper fragments from the mount were removed from the reverse of the photograph with poultices of methylcellulose. Western paper fills were made from paper toned with acrylic paints to compensate for the lost fragments. The fragments were assembled together and adhered on the reverse with Japanese paper and wheat starch paste. The photograph was lined overall to a sheet of Japanese paper with wheat starch paste. It was placed between blotters and under weights to dry. Once dry, the photograph was mounted to a 2-ply board with Lascaux 360 HV, an acrylic adhesive, and dried between blotters under weights. Losses to the image areas were inpainted with pastels, colored pencils, and watercolors.

TINTYPE CONSERVATION

Political double-sided badge, 1860, tintypes in brass frame, diameter 2 ½ cm. Before treatment.

Badge after treatment

TREATMENT OF AN AMERICAN POLITICAL TINTYPE BADGE by Karina Beeman of www.paulmessier.com This is a excerpt of an article that appeared in *Topics in Photographic Preservation*, Volume Thirteen, 2009.

The tintype bears the image of Abraham Lincoln on one side and his vice-presidential running-mate, Hannibal Hamlin, on the other. The tintype was in very poor physical condition and

required stabilization through immediate conservation treatment. The combination of different materials used to fabricate the badge (a metal die, iron plate, collodion, asphaltum, and varnish), the small scale and limited resources in the conservation and historical photography literature on the process, provided challenges.

The portrait of Abraham Lincoln, used as a master copy for production of the badge, is a reproduction of the famous "Cooper Union Portrait," by Matthew Brady made on the morning of February 27, 1860. This was the first photograph made of Lincoln in New York City and one of the few full-length photographs of him before he became president.

The Lincoln tintype was the most severely damaged and unstable. It had two losses of the collodion binder. In addition, the collodion on the Lincoln side had numerous, significant, cracks, with loose particles lying on the surface.

These are not unique needs for political badges and tintypes in general. Quite often, they have cracking in the collodion that leads to image losses. Such damage diminishes and devalues the object. Left untreated, additional image loss will occur owing to the effects of advancing iron-based corrosion and through mishandling. Because the object was very fragile due to insecurities in the collodion and the diminutive scale, a custom box was created for safe handling, storage, and physical protection

All procedures were performed under the microscope.

- Consolidation of the loose collodion particles. Adhesive was carefully applied on the area of losses and cracking with fine sable brush.

- Surface cleaning

- A wax and resin mixture was applied to the surface to cover losses. All work was performed under the stereomicroscope due to the small size of the losses. The fill was built up gradually, dot by dot.

- The fill was covered using silicone release Mylar™.

- The final treatment step was an application of an overall coating.

DISASTER PREPAREDNESS: WHAT TO DO WHEN THE UNEXPECTED HAPPENS

For many of us, living in certain areas of the country means exposure to natural disasters such as hurricanes, tornados and earthquakes. While there is some predictability to weather fluctuations, it

is the unexpected events such as fires and floods that change our lives. These disasters usually affect our belongings, including our photograph collections. Several individuals have even experienced damage to their photograph collections during heavy rainstorms while their house was being renovated.

So what can be done to prepare your collections for potentially damaging disasters? In the words of a salvage expert, there are four parts to a disaster planning process: prevention, preparedness, response and recovery.[26] Most museums, libraries and archives have disaster plans in place just in case the unexpected occurs. Many others are creating them. You can, too. Good planning means that when the next natural disaster strikes, you will know how to save your valuable collection from destruction and who to call on for assistance.

Follow the example of the professionals who think the best way to prepare for disaster is to take steps to prevent or minimize damage. This simply means storing your collection in an area of your home or in a facility that will limit certain types of damage. In other words, in addition to looking for an area with stable temperature and humidity levels, store your photographs in an area away from water pipes, chemicals and electrical wires. Accidents have a tendency to happen when we least expect them and that water pipe may end up bursting and flooding your collection.

Preparation is the next step in disaster planning. First, do you know who to call if your photograph collection is damaged due to flood or fire? Obviously there will be other things that need attention before you get to your photographs, but eventually you may need to contact a professional experienced in dealing with damaged materials. You can obtain a list of conservators in your area by contacting the American Institute for Conservation of Historic and Artistic Works, 1156 15th St., NW, Suite 320, Washington, D.C. 20005 www.conservation-us.org/.This list is a free service of the organization. Conservators will charge for their services. Before assuming that this individual will be able to assist you, call and ask if they work with home collections. If they don't, ask them for a reference.

Prepare a simple checklist of items to complete when faced with a disaster. Include items such as knowing the location of the main water shut-off to your residence, the number for the fire department and of course, the number of a local conservator.

[26] Betty Walsh, "Salvage Operations for Water Damaged Archival Collections: A Second Glance" WAAC Newsletter 19 No. 2 (May 1997), 1 http://cool.conservation-us.org/waac/wn/wn19/wn19-2/wn19-206.html

PREPARING FOR DISASTER

Finding a good storage space for photos, family documents and heirlooms can be tough. Basements, attics and garages expose keepsakes to fluctuating temperatures and humidity levels as well as pests and chemical fumes. The best storage place in your house is a windowless interior closet away from water pipes. Just remember that even these spaces might not be safe during a disaster. Water damage from a storm or broken water pipe can happen anywhere in your house.

Preparation

Museums and libraries have disaster plans that you should consider implementing in your household. Here are some steps you can take just in case:

- Note where the water, gas and electrical shutoffs for your house are located.

- Jot down the phone number for your local fire department, as well as a conservator in the area. You can find a conservator by using the American Institute for Conservation of Historic & Artistic Works online referral service, www.conservation-us.org/. These professionals have different specializations, so find one who can care for the materials in your collection.

- Many preservation companies have emergency contact numbers for individuals and institutions. The Northeast Document Conservation Center at 978-470-1010 or www.nedcc.org maintains a 24-hour emergency hotline for your use when disaster strikes. You can access the free pamphlet on disaster planning on their website.

- Keep an emergency kit of distilled water, blotting paper and unprinted newsprint (from an art-supply store) in a waterproof container.

- Keep a few waterproof containers on hand for short-term storage of photographs.

Response

When keepsakes are damaged by water, take these actions immediately:

- Clean up the excess water after you've shut off the electrical supply to the house.

- Assess the damage. Are the materials partially dry, damp or wet? What type of water damage has occurred - clean water from a broken pipe or dirty flood water? Was the water contaminated with chemicals? If so, can you identify the chemicals? Has mold started to grow on the materials? Were the materials wet for more than 48 hours before you salvaged them?

- Set up a drying area.

Recovery

Salvage materials as quickly as you can to prevent further damage then follow these steps:

- Control the environment by either reducing the heat or using a de-humidifier to lock out moisture. Fans work to circulate the air.

- Contact the experts. Before attempting any major recovery operations, ask a conservator for advice.

- Rinse wet ambrotypes, daguerreotypes, tintypes and black-and-white prints in clean, distilled water. (Consult a conservator about the right process for color prints and negatives.) Dry each image/negative separately in a single layer on a clean, dry surface. Dry prints face up so they don't stick together. They will curl and will need conservation after being water damaged. Blotting paper or unprinted newsprint will help absorb excess moisture. Remember to handle images by the edges only. Since all images are susceptible to fingerprints when wet, handle them using disposable examination gloves.

- Do not attempt to pry apart any materials which are stuck together. Contact a conservator for help with those items.

Knowing how to respond to an unexpected disaster will minimize the damage to your photographic materials. Each type of damage requires specific responses and an assessment of the problem.

WATER DAMAGE

You can minimize the loss of images if you know how to respond to water damage beforehand. I know several people who decided that their photographs were not salvageable because they were immersed in water. This is not always the case. It depends on the length of time the materials were submerged, the condition of the water and the type of material. Remember that most photographic developing involves water, so you may still be able to save your collection. You will need three things to save parts of your collection: time, space for drying and a few supplies.

1. Clean up Water

In order to assess the damage, you will have to clean up the water. Make sure that the electrical supply to your residence is shut off before attempting to stand in the water, just in case there are any electrical wires. Use whatever method you can to empty the area of excess water such as pumps and special wet vacuums.

2. Assess the Damage

At this point you need to answer a few questions.

- What type of water damage (broken pipe, or dirty flood water)?

- Are the materials partially dry, damp or wet?

- Was the water dirty or contaminated with chemicals? If so, what type?

- Has mold started to grow on the materials?

- Were they wet more than 48 hours before you salvage them?

The answers to each of the questions guide your next steps. If the material was contaminated by more than just water, you need to call a conservator for advice. Wet photographs that remain in humid warm conditions encourage mold growth in just a few days. It is important to prevent mold by controlling the environment.

3. Control the Environment

As quickly as possible, you need to reduce the humidity level and temperature in the area that sustained water damage. Failure to do so will result in mold and mildew growth. You can dry out the environment by lowering the heat (in winter) and by using dehumidifiers to reduce the amount of moisture in the air. A few strategically placed fans to circulate the air will speed up the process.

4. Contact the Experts

Before you attempt to salvage any photographic material, you should know which items benefit from air-drying and which require cold storage until professionally conserved. Some materials will need to be frozen until conservation can take place. The initial air drying or freezing should not be done without the advice of a professional. All packing of materials should be done under the guidance of a conservation expert. This is when you call the local conservator on your checklist or contact one of the labs listed in the Appendix.

In general, the following photographic materials should be air dried immediately:

ambrotypes, daguerrotypes, tintypes and prints. You can safely rinse off dirt in clean distilled water. Some negative materials and color items have components that dissolve in water so consult a professional. When in doubt, consult a conservator.

Find a large clean dry work area to begin your salvage operation. Air drying is accomplished by placing the images face up on blotting paper or unprinted newsprint to absorb the moisture. Negatives should be set emulsion side up. Glass negatives should dry vertically. Cased images that contain water should be taken apart gently. Be careful not to lose the identifying information. Set small weights on the corners of any prints that start to curl when drying.

Materials should be salvaged in a particular order to increase recovery rate. The materials affected most by water such as daguerreotypes, ambrotypes, tintypes and collodion negatives should be dried first. Other materials can be dried in the following order: color prints, black and white prints, negatives and transparencies. Wear disposable plastic gloves when working with the images. Only handle the images and negatives by their edges. The emulsion is soft and susceptible to damage from improper handling.

Materials that have already dried and stuck together should be re-immersed in water before you try to separate them. Trying to pull them apart stuck images will damage the emulsion.

Types of Material	Drying Method[27]
Cased Images	Face up if water and debris inside. Contact a conservator for disassembly. Do not blot dry.
Glass Negatives	Emulsion side up if cracked or emulsion is peeling. Dry vertically if in good condition.
Acetate Negatives	Emulsion side up.
Prints	Face up on blotters.
Slides	Remove from mount. Dry emulsion side up.
Sheet Film and Negatives	Gently hang to dry.

[27] Betty Walsh, "Salvage Operations for Water Damaged Archival Collections: A Second Glance" WAAC Newsletter 19 No. 2 May 1997 p. 1. http://cool.conservation-us.org/waac/wn/wn19/wn19-2/wn19-206.html

Preparation for Drying

1. Set up a clean work area.

2. Gently rinse dirt and debris off the items using clean distilled water.

3. Wear disposable plastic gloves for handling materials.

4. Handle images by the outside edges only. Never touch the emulsion.

5. Layout images in a single layer. They will stick together if dried as a clump.

What to Save in Case of Disaster

The hardest part of a disaster plan is deciding what to save if you only have a few moments. I'd grab my negatives and the small box of historical photographs. I can make prints from the negatives and the historical images are irreplaceable. In order to be able to grab and run, I need to put them in an easily accessible spot. But how do you make that decision if you have a large group of material?

Consider a digital solution. Some individuals advocate digitizing your photograph collection as a type of insurance. Since digital media stores large numbers of images in a compact format, you can easily grab the CD and reprint the images later. A part of the disaster plan for every computer department includes storing backup tapes and disks off-site. Why not double your insurance by making a copy of the CD or by moving copies of your files to an external hard drive and placing it in a safe deposit box. You could also leave the copy with a good friend. This way, if you have to leave the scene of a disaster without your original images, you will be able to make copies.

Another solution is to publish your family history and illustrate it with pictures from your collection. You can do this by including copies in a typescript and donating it to a local historical society, formally publishing the material in book form, or by creating a family website with extensive graphics. There is a solution for every budget.

> **Family Photograph Disaster Plan**
>
> - Make a list of emergency numbers: fire, police, conservation lab, names of friends who can help.
> - Know how to shut off the main switches for water, gas and electricity.
> - Prepare an emergency supplies kit.
> - Have a disaster plan.

> **Emergency Supply Kit**
>
> Blotter paper or un-printed newsprint
> Disposable plastic gloves
> Distilled water
> Fans
> Dehumidifier
> Clothesline
> Plastic clips
> Plastic bags
> Sponges

RESTORATION

As with photo conservation, a professional organization also monitors photographic restoration experts. The Professional Photographers of America, established in 1880, offers certification for individuals.

Flip through any genealogical magazine and you will find companies that advertise restoration services. Unbeknownst to the most consumers, there are a wide variety of services that fall under restoration from airbrushing to digital manipulation. You want to be sure that your expectations match their expertise. After all, you are entrusting this company or individual with a photograph that has sentimental if not monetary value. Evaluate the company before you engage them. Ask questions about their training and equipment. You want to be an informed consumer. Find out the full range of their services. If they define photographic restoration as digital manipulation, but your image needs to be recreated by creating a duplicate and airbrushing, then this is not a good match. Don't be afraid to ask for references and to see samples of the type of work they've done for other clients.

EVALUATING A RESTORATION EXPERT

1. What is their training?

Do they have a background in photography or computer science? Have they taken classes to enhance their skills? Restoration is an expensive process so you won't want to hire an inexperienced person. The Professional Photographers of America (PPA) maintains a free referral service on their website to help you find a certified Art Tech professional in your area. Go to the Find a Photographer option, select Art Tech and supply your zip code in order to obtain a list of qualified professionals. Ask if the person you are considering hiring is a member. The PPA http://www.ppa.com/PPA_F.htm offers its members an opportunity to attend events and sponsors continuing educational opportunities.

2. Ask for a list of references and call them.

All professional companies maintain lists of clients. Ask the restorer whether they have a reference list. Then call these individuals. In addition to speaking with their references, ask to see before and after examples of their work.

3. How long have they been involved with photographic restoration?

Photographic restoration is not a new business. Digital techniques have just made it more

accessible to the public. If a particular company only does digital restoration, you probably want to look elsewhere. Simple digital restoration can be done at home with a scanner, a computer and a software package. If you have a large number of pictures, it may be worthwhile to invest time and money to learn this process. A professional restoration expert has experience manipulating prints digitally and enhancing them with photographic techniques and airbrushing.

4. Is restoration their primary business?

Ask about their other services. In order to get the best quality restoration, hire a person who makes restoration their primary business rather than a sideline.

5. Do they have experience working with the type of image you have?

If they show you examples of restoration work on nineteenth century prints, but you have a daguerreotype, ask whether they also have experience working with your type of image. Restoration is only part of the process. They need to know the proper way to handle your original when it is in their possession.

6. Ask about their availability?

Reputable experienced restorers may have a waiting list of clients. If you need something in a hurry, it is best to ask up front about the wait.

What you should expect?

1. The restorer will examine the object prior to suggesting a restoration method.

2. You will receive a written estimate prior to the start of work.

3. They should be able to explain risks, insurance, payment and shipping.

4. They will handle your photograph with extreme care.

5. You will be notified if the job exceeds the original estimate.

What can a restoration expert accomplish?

The strategy used to restore an image depends on the amount of damage apparent in the image. Each photograph survives a different set of environmental hazards and amount of handling. Therefore, the condition of each image is unique. A typical restoration has several phases. The first step documents the original condition of the print by making a copy negative or a scan. Second, a new print is made so that airbrushing and other embellishments can take place. In the end, the new print will be restored using a variety of methods. The original photograph is

never directly worked on. Upon completion of the work, the original is returned to the owner. You should also be given a copy negative of the restored print and the print itself. You can make additional prints from the negative without having to touch the original.

COMMON TERMINOLOGY DEFINED BY DAVID MISHKIN OF JUST BLACK AND WHITE.

Restoration

There are two types of restoration--digital and airbrushing.

Digital Restoration

Digital restoration involves using a computer as the tool to fix or repair a damaged photograph. The restorer scans the image and recreates detail with the help of photo editing software. This process produces computer files that can be printed on different mediums such as paper, photographic films, or digital files.

Airbrush Restorations

In airbrush restorations, a pressurized (usually from an air compressor) paint brush is the tool. The airbrush is filled with pigment. Either a fine or coarse stream is sprayed onto a copy print to cover up the defects you are trying to eliminate. The final product is a work-print that can be used as is or copied.

Photographic Enhancements

The contrast in a **faded** print can be improved using special film, filters and chemistry. A very faded image can be brought back to original clarity using this technique.

INTERVIEW WITH DAVID MISHKIN OF JUST BLACK AND WHITE IN PORTLAND, MAINE

When should a photograph be considered a candidate for restoration work?

It is purely subjective. Because of the expense involved, you need to determine the sentimental value or strong historical value of an image prior to making the financial commitment.

How long does the process take?

It usually takes three to four weeks depending on several factors such as the amount of restoration work needed and my work load.

Are there different types of restoration work?

You can have a photographic enhancement (which is not considered a restoration) digitally restore an image or use airbrushing.

Why is a restoration so expensive?

The production of a real and professional-looking restoration requires the skill of an artist. Whether using airbrush or digital tools, the person doing the work must be highly skilled in the medium. Individuals with these skills charge rates based on their training and expertise, sometimes in excess of $50.00 per hour.

When is a photographic enhancement appropriate?

When an image is extremely faded, manipulation of filters, film and chemicals can bring back some of the original detail.

Are there any faded photographs that can't be enhanced?

Most faded photographs are pre-1900 and are usually salt or albumen prints. Insufficient washing at the time they were produced can cause the image to fade. There are also photos that appear faded, but were either printed too light or were taken with a camera that had light leaks. If an image is faded (generally pre-1900 pictures), it might benefit from photographic enhancement. This is where we take a faded photograph and enhance it using photographic methods. There are instances where an image is too faded to be enhanced such as underexposed prints or those that experienced light leaks.

Is there any type of damage that doesn't benefit from restoration?

If you can't see a person's face, you can't do a restoration. In a digital restoration, we are recreating detail from what is already present in the image. For one client, the eyes and nose of the person in the tintype were too scratched to be able to recreate. In these cases, it is an artist's guess as to the appearance of the original features.

What about airbrushing?

Airbrushing is when we create a duplicate print of a damaged image and using artists' techniques to apply paint to the surface of the duplicate in an attempt to recreate detail or eliminate damage. Airbrushing is good for filling in cracks and missing pieces, making new backgrounds, and eliminating things. This is the most expensive form of restoration and usually costs a few hundred dollars.

If you could give one piece of advice about caring for photographs in a home what would it be?

The best thing you can do is to have a copy negative and an archival processed print made of valuable photographs.

What else should a person do?

After a high-quality copy negative is made, store the original in a place like a safe deposit box because it has all the elements of proper environment. Most safe deposit vaults maintain a stable temperature of 68 degrees Fahrenheit and 50 percent relative humidity. In addition, the box allows you to store the collection in a dark and secure place. Safe deposit boxes are also an economical storage solution.

What about digital prints rather than photographic copies?

The quality is there in a digital reprint, but it requires expensive computers and materials. I think it will be at least ten years before digital methods match the copy negative. Many companies provide their customers with either a digital reprint or the print plus the file. The caution with digital mediums is that technological changes may make those files unreadable.

What do you consider the most important ways to keep a photograph safe for future generations?

We already mentioned two. 1. Have a copy negative made of significant photographs. Make sure the negative is archival processed. 2. Store photographs in a safe deposit box for environment, safety and economy. 3. Place the images in protective sleeves made of acid and lignin-free paper, polypropylene or polyester. This will protect them from handling and abrasion.

In your experience, what is the most common form of damage that you restore?

Scratches and folds. People keep photographs in wallets. They get lots of cracks and scratches.

What about oversize pictures?

If someone gives us a panoramic picture, we digitize it, make a copy negative, and then an enlargement print. Since the new print is another generation, it loses some focus. In this case, it is best to provide the client a large digital output (at least 36 inches) instead of a photograph and a copy negative. We give them the image as a digital file (zip file). Another option is to skip the digital process and create a copy negative. We use airbrushing for the restoration and then make a new print of the airbrushed result.

Do you have anything else you'd like to add?

The most important thing we do is give someone an archivally processed negative of an image so that they can have copies made.

AIRBRUSH RESTORATION

Daguerreotype

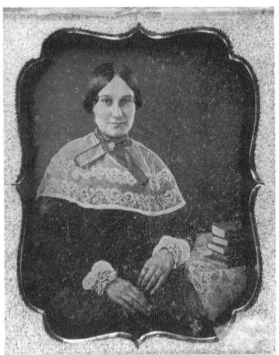 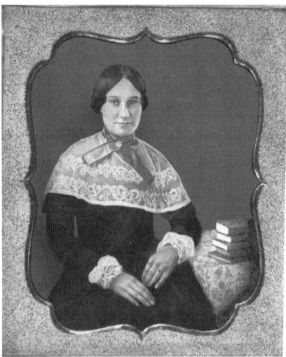

This is an airbrush restoration of a daguerreotype showing decomposition of the glass.
David Mishkin, Just Black and White

This daguerreotype of a woman from 1845-1850 is showing some damage on the surface glass due to decomposition of the glass. The costume details date this image. The woman is wearing her hair looped over the ears in the style introduced in 1845. Her cape collar is called pelerine. The white collar and cuffs would be changed daily. The addition of costly neck ribbon finishes the costume and establishes that she is not lacking financial resources.

Airbrushing removed the distracting marks from the image. There were several steps to the process. First, a photographic copy print was made of the daguerreotype in its original mat. Then, an artist used airbrushing to apply paint to the surface of the copy print. The final result has a new background and is free from lint. Great care was taken not to disturb the informational content of the image so that the costume details remain intact. The client received a new copy negative of the restored daguerreotype, a photograph, and the original daguerreotype. No work is done to an original print or object using airbrushing. Copy prints are always made first to protect the condition of the original.

DIGITAL RESTORATIONS

Tintype

Digital restoration can dramatically enhance a damaged tintype. *David Mishkin, Just Black and White*

These two examples are both tintypes with different types of damage. In both cases, a professional artist used digital photo-enhancing software to eliminate all traces of age and decay.

In the first set of tintypes, the costume detail on the elderly man is clear. He is wearing a striped shirt without a collar and a type of jacket known as a sack coat. The coat appears to have braided trim. These garment details date the image to the mid-1860s. The placement of his hands is interesting. He may be hiding one due to an injury.

His tintype has a few notable features. The clipped corners and halo image suggests that this

What can be accomplished digitally?
Damage disappears or is diminished
Color balance can be restored
Negatives can be scanned and printed as positive images free from damage

tintype was originally in case. Over the years, pieces of the emulsion came off the iron plate and those areas rusted. There is also some scratching of the image due to abrasion. The most puzzling piece of the damage is the hole in the upper right side of the image. In the tintype of the younger man, the plate is so damaged that the costume is almost completely illegible. It is difficult to date an image is this condition. The younger man is wearing a small pointed collar with his shirt and no tie. The lapels of his jacket are not visible although he is wearing either a loose jacket buttoned at the top or with a vest. More detail must be visible to make a definite identification. The surface of this tintype is pitted due to contact with an unknown substance.

In the elderly man's portrait, the artist recreated all the detail such as the missing pieces of shirt. The halo effect was emphasized to give the photograph the appearance of a painted portrait. The problems with the background such as the hole and the abrasion are gone. The artist had to recreate or enhance all the detail in the image to restore the tintype.

The tintype of the younger man required the artist to recreate the entire look of the photograph based on the little remaining undamaged detail. The restored version is a digital portrait with the appearance of a painting.

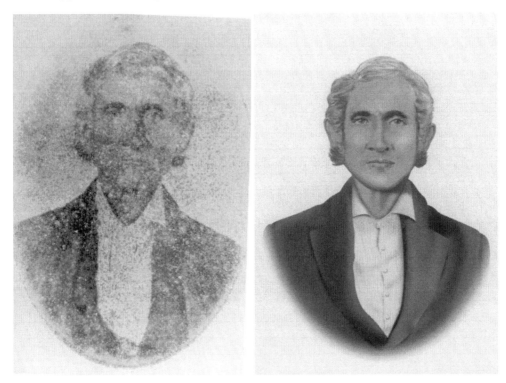

In this tintype, the image is barely visible. Look at the effect after digital restoration. *David Mishkin, Just Black and White*

PAPER PRINT

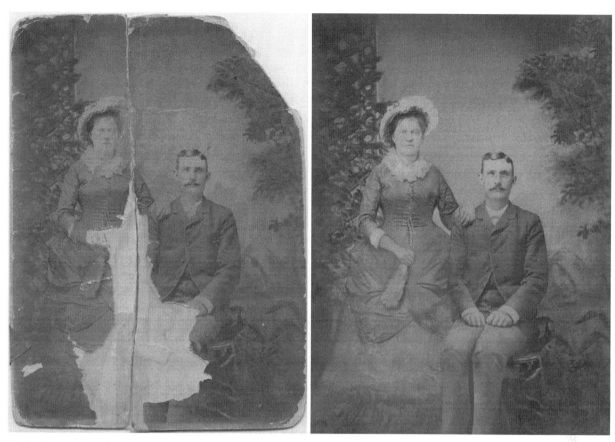

Digital restoration can fill in missing details from a scan of a damaged print. Unidentified couple, 1880s. *David Mishkin, Just Black and White*

Photographic Enhancements of Faded Prints

In each of the following examples, the original photographs exhibit varying amounts of fading. If you were to take a faded print to have copies made, the prints would look like the first view of the faded examples presented here. By selecting a photo lab experienced in photographic enhancement, you can make clear new prints of the faded originals. Photographic enhancement uses a combination of filters, film and chemicals based on the condition of the originals to recreate the images. The techniques vary based on type of a print and amount of fading.

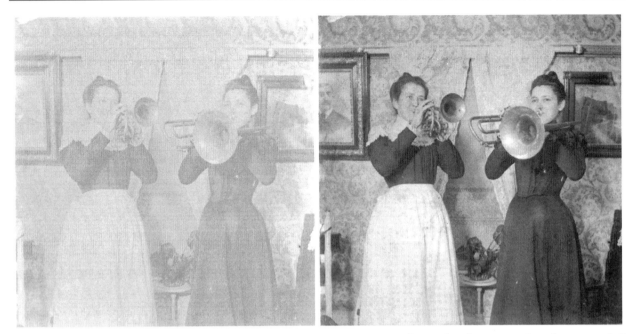

The contrast in faded photographic prints can also sometimes be improved using special filters, film and chemistry. *David Mishkin, Just Black and White*

The prints of the women musicians date to the late nineteenth century. The photographic method used to create them is not known. Fading occurred as a result of light exposure, fluctuations in temperature and humidity, or instability in the photographic process. Whatever the reason, the enhancements were successful. Each client received a new print that made the scene visible.

The print of the young girl from the mid-twentieth century has faded probably due to improper processing of the original print. Once again, the right combination of skill, and photographic techniques accomplished the end result--a beautiful print!

Digital Restoration You Can Do At Home

Not all digital restoration work must be done by a professional. The whole process can be cost prohibitive, so there are a few things you can accomplish at home with a minimal financial investment. But, you may have to spend more time and money if you have a file of images that are damaged. However, the results might not be as dramatic as the examples presented here.

Everyone has photographs that need restoration or improvement. The photo editing programs available for amateur use have improved, so you are only limited by your imagination.

Digital image manipulation helps you turn a poorly composed photograph into a keeper for

the family album. Be patient. It will take some time to learn how to restore images. A certain amount of time is necessary to learn the new techniques. In this case, you will be exposed to terminology and techniques with which you will be unfamiliar. The good news is that you can find tutorials online or find a book on the topic to guide you through the initial steps.

You can enhance and repair historical images in your family collection with a few basic maneuvers. For example, you can change the exposure of a photograph by adding or deleting highlights and shadows. Do you wish that you could drop out that distracting background in the image of your aunt? Most programs allow you to change the focus of different elements of the picture or even delete whole sections. I find the most valuable tool in photo editing software is the ability to repair damaged images. With digital restoration, you can remove cracks, fill in missing persons, enhance faded images and even change history by removing people from pictures. You can also take out the X over someone's head and replace missing parts of emulsion. These programs are powerful enough to allow you to change the visual history of your family by adding or subtracting people from your images. I don't advise it, but if you must, then label each image appropriately.

For simple at-home digital restoration, you can use the software that comes with your scanner. Professional-quality restoration packages are expensive, but offer more options. In general, the more expensive the program the more features and control you will have over complex changes.

- Save each picture as a new file so that you don't change the original scan.

- Use a photo editor that allows for unlimited undo's.

- Choose a package that has the option of looking at two views of the same image at once.

- Can you blow up a specific detail to work on it?

Tools and how to use them

Clone: Allows you to copy texture/colors from other areas.

Lasso: Identify an area Then you can enhance, copy and move it to another place.

Auto Repair: Will enhance the contrast, brightness, and color (if color photo) of a faded original.

Blur: Allows you to soften harsh images (i.e. remove crosshatch pattern from scanned newspapers.)

Eyedropper: Picks up color from the image to fill in another area.

Painting: Using artistic tools to digitally paint areas.

Airbrush: Models an actual airbrush.

Smear: Smooth or blur edges from painting tool.

Lighten/Darken: Enhance small areas.

Copy: Replicate area within a specified area or mask.

Color Mapping: Contrast and brightness.

Sharpening: Makes edges more distinct.

What you need to do this at home

Flat bed scanner

Computer

Ink Jet printer

Photo-editing software

Steps involved

1. Select the image
2. Scan the image at a high resolution (1,000 dpi) to pick up the details.
3. Save it as two separate files. Work on one, while the other is an archive copy.
4. Re-save the image.

Digital manipulation you can do yourself

Improve contrast.

Sharpen the image

Correct color balance.

Fill in small areas.

Rotate.

Eliminate distracting background spots.

When to Stop

While photo restoration can do many things, it can't bring the picture back to its original unblemished condition. There is only so much manipulation that can be done digitally. Everyone who uses digital manipulation has to accept this reality before beginning to work on an image. The limits are set by the condition of the image prior to scanning. You will be able to improve or eliminate certain problems, but at some point you will realize that you've reached a conclusion.

BECOMING A PROFESSIONAL

If you decide you want to train to be a professional conservator or restorer, there are programs and organizations to help you pursue that dream. Both professions are technical in nature and require that you enroll in formal programs. After obtaining your degree, you'll need to take classes, attend workshops and maintain membership in a number of organizations to stay current with changes in your chosen field.

Becoming a conservator is a time consuming and challenging choice. The American Institute for Conservation (AIC) has a couple of brochures for potential students. One outlines undergraduate prerequisites for admission to a training program and the other lists all the conservation programs in the United States along with financial aid information and a bibliography.

Since conservators conduct scientific and technical work when restoring an image, a background in science is important. Typically, undergraduate coursework in both general and organic chemistry is necessary. Some programs also require studies in other sciences, physics and mathematics. Most programs also expect degree candidates to have a background in the humanities, art and to be able to read at least one foreign language. Applicants should have exposure to the profession by working in a conservation lab as an intern, volunteer or paid employee.

Still interested? Conservators are highly trained professionals who work with irreplaceable materials so the graduate degree programs are demanding. According to the AIC, programs require four to six semesters, summer work projects and a year-long full-time internship outside the classroom. Students specialize in a particular type of conservation. This internship enables them to work with professionals in their specialty.

The requirements for degrees in retouching and restoration are not as difficult to meet. Undergraduate and graduate programs in photography usually offer the option of learning some of techniques employed in photographic restoration. However, the Professional Photographers Association of America www.ppa.org sets standards for anyone who wants to apply for certification and maintains a website to explain the process. www.certifiedphotographer.com. You must pass a written test as well as demonstrate general knowledge of photography and retouching. You have three years from the time you submit your application to pass the test and submit a photographic sample. In addition, you must provide both personal and business references. A member panel examines a sample of your work to see if it meets professional standards. If so,

then the panel awards certification for five years. In order to maintain that certification, you must meet continuing education requirements by attending educational programs offered or approved by PPA. This includes class work and hours of hands-on instruction. You can take classes from a PPA affiliate school that offers special classes one to two weeks a year and earn continuing education points. For a complete list of conferences and educational opportunities, consult the Education pages on the PPA website.

CHAPTER ELEVEN: SHARING AND DISPLAYING PHOTOGRAPHS

You've reached the end of your photographic journey. If you have followed the advice in this book and in *Uncovering Your Ancestry through Family Photographs,* you now have a perfectly organized, restored and fully identified family photograph collection. No, I'm not crazy. You **will** get there if you gradually invest time and money, but while you are doing that, don't forget to enjoy your family pictures. In our work-driven society, we need to remember to appreciate the small things in life. Our photographs are definitely one of those things. Why not use them for a little stress reduction session by spending some time looking at all your pictures of past vacations? My favorite activity is showing old images to children. They are able to express the joy that we've forgotten. My children love to mimic the expressions and poses from the pictures. I stock up on disposable cameras when they go on sale so that they can record their own memories of the events in which they participate. You'll gain a whole new perspective of the world by viewing it through their eyes.

USING YOUR PHOTOGRAPHS IN A FAMILY HISTORY

In the first chapter of *Alice's Adventure in Wonderland* by Lewis Carroll, Alice asks, "What is the use of a book without pictures or conversation?" The same is true when applied to a genealogical book. Yet, the majority of genealogies published in the last 100 years make inadequate use of visual aids. There is usually the obligatory map and a frontispiece portrait of the founding member of the family. But genealogies written around the mid-nineteenth century use illustration and photographs in ways later compilers seem to have forgotten. While the technology didn't exist to make reproductions of actual photographs, these genealogists hired engravers to make prints based on original photographs. In several instances, these books contain original cartes de visite images. It was less expensive to include the originals in a limited edition than commission engravings. A notable example is the *Bolling Family Genealogy* printed in a limited edition of fifty copies in 1868. A review of the book in the *New England Historical Genealogical Register* stated, "The chief value of the book is in the numerous photographs and portraits."[28]

By using family photographs and documents you can add life and interest to the family history you create. A well-chosen and placed image draws a reader into the text by piquing their

[28] "Review of A Memoir of a Portion of the Bolling Family in England and Virginia", *NEHGR* 24 (January 1870), 95.

curiosity. The caption should be no more than a couple of sentences, and in a genealogy, should feature the name of the individuals in the picture, their life dates and a brief statement about the subject of the photograph. So how can you utilize the photographs you have in your collection?

USING PHOTOGRAPHS AS ILLUSTRATIONS

1. Make notes on the manuscript pages about who you have pictures of and what documents are available. If you are using a genealogical computer program, enter these images as attachments to the family group sheet.

2. Select images that are in focus, in good condition (original or restored), and are well composed. If an image doesn't fit those criteria, don't use it even if it is your only picture of an important family member. You want your genealogy to look professional. Including poor quality images will not project that impression. Try not to select more than one image of the same person. Are the images copyrighted? See Chapter 9 for a review of copyright issues and family photographs.

3. Write clear captions that explain who is in the picture and why you are using it. Be brief. A few sentences are enough.

4. Lack the photographs or documents you need to illustrate the text? Try contacting other relatives to see what they have in their collections. Try including images of places your ancestors lived or activities they pursued.

5. Don't send originals to printers. Have copies made by following the suggestions offered in Chapter 2.

DISPLAYING FAMILY PHOTOGRAPHS

You don't have to create a family history to show off your images. Some people create a wall of honor in their homes. Taking care of your images doesn't mean you can't put them on display as long as you take a few precautions. If you have historical photographs in your possession that are already framed, remove them from those frames before further damage occurs. A fairly typical nineteenth century frame has the image flush against the glass and the backing materials are either cardboard or wood. In these cases, the photograph is exposed to acid from the backing and is in danger of contact with condensation on the glass. What can you do if this is a special family image that you want to continue to display? There are a few easy and relatively inexpensive ways to keep that image on public view.

USE COPIES

My historical photographs are too valuable to expose them to the dangers inherent in framing and displaying. It is so easy to make copies. Most camera stores can produce same size duplicates of your images. Since nineteenth and early twentieth century photographs come in a variety of colors, you will want to use a color copying process so that your photographs retain their qualities. However, if you want a historic feel to the picture, ask the lab to use sepia tone. The image will appear slightly brown and have the appearance of being old. This service is usually available for an additional fee.

If you have double prints of a particular image, you can display a duplicate without risking the original. This is especially true of the photographs taken today. You can easily order second copies when you have the film developed or when you have the negative. Before you copy contemporary photographs taken by a professional photographer, make sure that you are not infringing on someone's copyright.

FRAMING MATERIALS

Special materials can help you retain the quality of the image you want framed. You can request museum-quality materials when you take your image to be framed. The glass will offer protection from sunlight and the backing will be lignin and acid-free. The basic parts of any frame are the glass, frame and backing. Most professional frame shops carry UV protection glass or acrylic that filters out the harmful rays of the sun. These ultraviolet rays are the same ones that cause skin cancer. They also cause images to fade or discolor. When selecting a frame, choose baked enamel on metal or aluminum rather than wood. The wood gives off gases and acids that cause staining. The final element of a framed piece is the backing. Ask for acid and lignin-free materials. If the framer doesn't have the necessary supplies, you can order them from one of the vendors listed in the Appendix.

> **Framing checklist**
>
> Use materials that have passed the PAT.
>
> 1. Select a frame that is baked enamel or aluminum.
> 2. Make sure to mat the image.
> 3. Find a framer with experience in museum-quality framing.

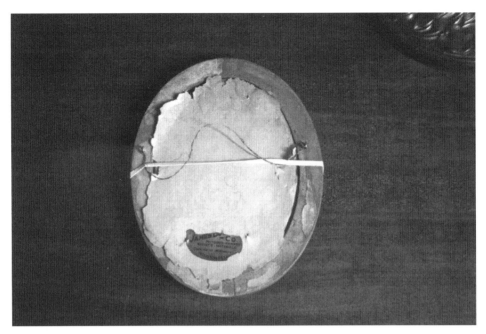

Make sure you use PAT materials for framing so your pictures don't end up looking like this. The acid paper and wood frame may damage your photographs.

Here are a few other considerations. First, do not dry mount the photograph to the backing. Small strips of adhesive polypropylene or photo corners will work just as well and are reversible. Acceptable adhesives include wheat starch and rice starch paste. Second, place the photograph in a mat. This is an acid and lignin-free card stock with an opening for the photograph. The mat prevents the image from resting on the glass and provides for some air circulation. This prevents condensation, which forms as a result of temperaturate and humidity fluctuations, from damaging the image and keeps the image from sticking to the glass.

WHERE TO DISPLAY

Unless you don't mind replacing your images every few years, you should display them in a place that will extend their life span. Find an area out of direct sunlight so that light and heat won't damage the print. Keep in mind that fireplaces and other heat sources like radiators generate temperature fluctuations that cause deterioration of the print. Choose an area that has a low light level. Sunlight and fluorescent light expose the images to ultraviolet rays.

> If you want to frame items yourself, the instructions provided in *The Life of a Photograph* by Laurence E. Keefe and Dennis Inch explain the process. The authors cover all topics from matting an image to creating a frame.

> **Selecting a Frame Shop**
>
> 1. Ask if the framed item will be of museum quality?
>
> 2. Do they use PAT approved materials?
>
> 3. Ask for references. For instance, do they work with museums and libraries?

Being careful with your photographs does not mean that you need to keep them completely out of sight. As long as you are preservation aware and follow museum-quality framing methods, you can enjoy your family photographs and show them off to visitors.

Family Pages, Blogs, and Extended Family Sites

A natural extension of the photo sharing website is a family website or a blog that shares both images and genealogical and general information. So, you are anxious to join the vast numbers of people creating family websites, but what do you need to know before you begin and how do you get started? Sure, there are sites that offer you space for free, but before signing up evaluate the site and determine what type of site or blog you are going to create.

Professional web designers refer to a site's information architecture, the how and why a site is constructed. With any site, you need to outline your goals and objectives. I'm going to use "site" to refer to both a webpage and a blog post. It's becoming increasingly common to use a blog format to create and maintain a website.

DESIGN CONSIDERATIONS

1. Why are you creating the site?

You can develop a site that contains just genealogical information and images, or one that acts as a great family meeting place online. Take a look at other sites to see how other families use their sites. Having a website is a great way to share your family research and photographs. If you want to hear from others about their research, list an email address on your site.

2. What type of equipment do you have?

Some of your decisions will be based on the type of equipment you have. If your computer is not current and lacks a fast modem you are probably going to need to upgrade your equipment. All you really need is a computer (with a modem), access to the Internet via phone line, cable or DSL (Digital Subscriber Line) and a good quality printer. The faster the modem, the quicker you can download pages. To add photographs to your site, you will either need a scanner, a digital

camera, or you'll post your pictures on one of the photo sharing sites (see earlier section) and upload them to the site. Most computers come loaded with software for viewing the web and receiving email. Even with this software, you will need to sign up for Internet service with an ISP (Internet Service Provider). You can find one in your local area by using your phone book or by searching online. Ask friends how satisfied they are with their service before committing to one.

3. Are you designing it yourself

One of the primary issues is the design of the site. Before you start working with web design, look at pages already on the Internet to get ideas. This is simple to do. Use a standard search engine such as Google and type "family website" into the search field. You will uncover all types and styles of family sites along with articles on how to create them. Keep in mind that web pages are subject to copyright laws so you can't copy the pages exactly, but looking at them will help you decide how to organize your information and photographs. Some web hosting services offer hints on creating a site and provide tools and templates to help you with the process. You can also enlist family members. Teenagers are, in most cases, quite familiar with the Internet and would welcome an opportunity to design a web page.

4. Updating your site

Once you have posted your information on the site, it is time to start thinking about the next phase of the project. In order to keep your site up to date, you will want to make regular changes. Will that be your responsibility or are there other family members who can help with the task? The best sites are those that are updated regularly. This takes time, but if you want to have a well-respected site, it is worth the effort.

Once you have decided on the purpose of your site and have a general idea of what you want it to look like, you will need to find a hosting service. There are many options ranging from those that offer free hosting to those that bill monthly through your Internet Service Provider.

Evaluating a hosting service for your family site

1. Is it free or is there a fee?

When you first see an advertisement for a free web service, make sure that it really is no-cost. One advantage to paying your ISP for space is that you'll be able to name your own site and have a unique URL with an email account.

2. Are there space limitations?

Some free services limit you to a certain amount of storage space and then bill you for

additional space.

Can you Design Your Own?

Does the site provide you with a template you must use or are you able to use your own design?

3. Do they provide design software or can you use your own?

Some sites provide you with web design software while others let you use your own program.

4. What are their privacy conditions?

Privacy is an important concern. You want to make sure that you can password protect your family information so that it isn't available to everyone. If you don't see their privacy statement, email the company for a copy before you sign up.

Creating the Site

Whenever you create a website, remember to include basic components such as a title, a background, and an email address. Use consistent fonts to make your text easier to read. For visual interest, add graphics. Don't be afraid to add video or audio to your site if your hosting service allows you to include multi-media. Add a copyright notice (copyright [date] and [your name]) at the bottom of the page. If you're creating blog postings, consider signing up for a Creative Commons License (www.creativecommons.org) to cover reuse. Your page is an online publication and you should treat it as such. Keep your site user friendly and attractive.

Common Sense Image Use

Images and blogs/websites are a natural partnership. A picture illustrates a point or becomes the focal piece of a column or adds to the attractiveness of your site. It advertises who you are. No doubt about it, images enhance the ability of your blog/website to connect with your readers. There are some common sense image usage tips to keep in mind before you start placing pictures everywhere.

- **Condition**. First and foremost, use pictures that are easy to see and in good condition. Take advantage of photo editing tools to remove marks and sharpen the image. If you want to draw attention to a detail, crop the image and then include both the full size picture and the cropped version. If you're deliberately showcasing a picture with problems, it's a good idea to tell folks exactly why you're using a less than perfect photo. Similarly, if you've enhanced an image mention that as well.

- **Size**. The larger the image, i.e. resolution and size, the longer it takes to download and for folks to see it. There is a high annoyance factor here. Remember that not everyone has a newer model computer and that some users still rely on dial-up Internet access. The other problem with image size is the storage limits. If you post a lot of images, you'll eventually need to expand your storage space.

- **Resolution**. Don't put high-resolution images online. Resize your images before posting by compressing images in tiff format to jpg format. The best dpi for the web is 72. You really don't need anything larger. If you use a higher resolution image, there may be unexpected or unauthorized usage later on. This doesn't prevent online copying, but at higher resolutions, print quality is poor.

- **Copying**. Watch for right-click copying. You can copy all kinds of items on the web by right-clicking with your mouse (control-clicking on a Mac). Should you? No. It's an ethical issue. I use a photo site that allows me to turn off the right-click option. You also can put a watermark on your images to discourage reuse. Unfortunately, I don't currently know of any blog or website software that allows you to turn off right-click copying.

- **Permission**. If you find an image on the web that you'd like to use, see if you can find the owner. Ask permission before adding their image to your blog.

- **Living Persons**. Don't use pictures of living people, unless they give their permission. Generally, don't post any photograph less than twenty-five years old without written consent. Professional photographers obtain signed releases in order to use images. If you need sample forms, consult the book issued by the American Society of Media Photographers, *the ASMP Professional Business Practices in Photography* (New York, NY: Allworth Press, 1997, 5th edition).

- **Select Photographs Carefully.** You wouldn't want to cause anyone discomfort or embarrassment with your choice of images. Let photographic jokes remain private.

- **Protect Identities**. If you want to publish photos of an event, either have folks sign a model release that states how and where you'll publish those images, or don't show faces. I recently used a photo of a group of kids at one of my workshops. I focused the camera on their artwork instead of their faces. Each child held up their poster board so that their faces were completely covered. Use photo editing tools to erase excessive identifying information from the images. While it is acceptable to state someone's occupation as schoolteacher, is it within reason to exclude the name of the school in a photograph? When writing a caption for the image, be

careful not to include too much identifying information on living persons.

If you doubt the importance of this issue, ask yourself the following questions:

- How would you feel if someone used your photograph without your permission?

- How would you feel if it was copied by an unknown person and posted on a non-family related site?

- How would you feel if pictures and information on your children were posted elsewhere? It can happen.

Before you post any genealogical information to accompany family images, remove data on living persons from your GEDCOM file. Several filtering programs can do this for you. GEDClean32, GEDLiving and GEDPrivy all clean your files of genealogical information on living persons.

> **Filtering Programs**
> GEDClean32
> www.raynorshyn.com/gedclean
> GEDLiving
> www.rootsweb.com/~gumby/ged.html
> GEDPrivy
> hometown.aol.com/gedprivy/index.html
> Res Privata
> www.ozemail.com.au/~naibor/rpriv.html

A good general rule to follow is to exclude information on individuals who are less than 100 years old. For instance, WorldConnect at Rootsweb eliminates data outside that cut off unless you ask to override it.

Before you willingly share information and photographs of living persons with "relatives", be a little skeptical. Don't provide this data in emails and GEDCOM files without first establishing their right to know. After all, if they are researching family history, do they really need to know all about your immediate family? Even if you trust these individuals, how do you know they won't pass this material on to another researcher without consulting you or submit it for inclusion on a CD or website? Using one of the more powerful search engines such as Google.com, search for your name. Find any hits? Do the same with the large commercial genealogy sites. You might be surprised to see your private family information listed in a public place.

Ten years ago, the National Genealogical Society composed a set of guidelines for web pages that are still useful today.

GUIDELINES FOR PUBLISHING WEB PAGES ON THE INTERNET

Recommended by the National Genealogical Society, May 2000

Appreciating that publishing information through Internet web sites and web pages shares many similarities with print publishing, considerate family historians—

- apply a single title to an entire web site, as they would to a book, placing it both in the <TITLE> HTML tag that appears at the top of the web browser window for each web page to be viewed, and also in te body of the web document, on the opening home, title or index page.

- explain the purposes and objectives of their web sites, placing the explanation near the top of the title page or including a link from that page to a special page about the reason for the site.

- display a footer at the bottom of each web page which contains the web site title, page title, author's name, author's contact information, date of last revision and a copyright statement.

- provide complete contact information, including at a minimum, a name and e-mail address, and preferably some means for long-term contact, like a postal address.

- assist visitors by providing on each page, navigational links that lead visitors to other important pages on the web site, or return them to the home page.

- adhere to the NGS "Standards for Sharing Information with Others" regarding copyright, attribution, privacy, and the sharing of sensitive information.

- include unambiguous source citations for the research data provided on the site, and if not complete descriptions, offering full citations upon request.

- label photographic and scanned images within the graphic itself, with fuller explanation if required in text adjacent to the graphic.

- identify transcribed, extracted or abstracted data as such, and provide appropriate source citations.

- include identifying dates and locations when providing information about specific surnames or individuals.

- respect the rights of others who do not wish information about themselves to be published, referenced or linked on a web site.

- provide web site access to all potential visitors by avoiding enhanced technical capabilities that may not be available to all users, remembering that not all computers are created equal.

- avoid using features that distract from the productive use of the web site, like ones that reduce legibility, strain the eyes, dazzle the vision, or otherwise detract from the visitor's ability to easily read, study, comprehend or print the online publication.

- maintain their online publications at frequent intervals, changing the content to keep the information current, the links valid, and the web site in good working order.

- preserve and archive for future researchers their online publications and communications that have lasting value, using both electronic and paper duplication.

©2000,2001 by National Genealogical Society. Permission is granted to copy or publish this material provided it is reproduced in its entirety, including this notice.

The digital family album offers possibilities that our ancestors couldn't even imagine. We share photographs, communicate with several family members simultaneously on extended family sites and reach out to forgotten relatives. Use the technology wisely with regard to historic family photographs and do not throw the originals away. Think of digital albums as another way of using your family images, not a replacement for the traditional family image.

CHAPTER TWELVE: SAFE SCRAPBOOKING

In certain parts of the country, creating albums or scrapbooks of family photographs and memorabilia is extraordinarily popular. The scrapbook phenomenon is sweeping the country as more people become interested in tracing their family history. If you don't believe me, ask a bookstore information desk for publications on scrapbooks. The number of titles available on this topic will surprise you. Search a little further and you will find magazines and websites that relate to this relatively new hobby.

Souzzan Y.H. Carroll, author of *A Lasting Legacy: Scrapbooks and Photo Albums That Touch the Heart*, attributes the beginning of contemporary scrapbooks to Marielen and Anthony Christensen.[29] These two people displayed their albums in 1980 at the World Conference on Records in Salt Lake City, Utah. Interest in creating these albums gradually grew until 1987 when the first commercially-produced items appeared from Creative Memories. Using a simple concept of marketing to consumers who sign up for classes with thousands of consultants in the United States, United Kingdom, Taiwan, Canada and New Zealand, Creative Memories is one of the most well-established scrapbook companies in the industry.

Creating albums of family photographs is not new. Thomas Jefferson and Mark Twain, along with scores of grandmothers, used their spare moments to lay out images in albums. Some of the more elaborate examples resemble contemporary scrapbooks in their use of clippings and related artwork. Unfortunately, the techniques employed by our ancestors and by many of today's scrapbook enthusiasts are beautiful pictorial narratives of family history and a preservation nightmare.

Unknown to most people is that techniques recommended in some of the books on scrapbooking will keep photo conservationists busy for centuries, if the scrapbooks last that long. All of the materials inherent to creating scrapbooks, such as albums, papers, inks, and glues, add up to a mess. For example, the glue used to paste the images into the albums can seep through the pictures and make it impossible to remove the photographs from the pages. This doesn't need to be the case. Let's avoid the mistakes of past generations by applying a little common sense and a

[29] Souzann Y.H. Carroll, *A Lasting Legacy: Scrapbooks and Photo Albums That Touch the Heart* (Bountiful: Living Vision Press, 1998), 9.

few basic rules. By using PAT-approved products and avoiding certain behaviors, you can preserve these albums for the enjoyment of future generations. But how do you know if the techniques in the books and magazines are safe for your family photographs?

There are major misconceptions in most scrapbooking manuals. Acid-free is not always archival. This terminology is overused. Archival generally refers to material that will not cause additional damage to your family heirlooms; however, there is no industry standard for the term. Rather than rely on terminology such as acid-free and archival, make sure all your supplies passed the PAT. Read the labels and ask manufacturers for information about your supplies. One company, Creating Keepsakes, is dedicated to preserving family memories. They use an advisory committee of preservationists to insure that products bearing their CK OK stamp of approval really are safe to use. In response to the preservation standards advocated by industry leaders, many manufacturers advertise and sell special products specifically for scrapbook enthusiasts. This means that genealogists can create durable, safe and attractive scrapbooks if they use the right materials.

ALBUMS

In the late 1970s, I created a series of albums using the wrong materials. At the time, I was unaware of the dangers of acidic paper and adhesives. Today, those albums are in terrible shape. The acid and the glue in the magnetic album stained the images while the plastic overleaf disintegrated and stuck to the pictures. All this damage could have been avoided if museum-quality photograph albums were available.

> There is a misunderstanding of the word archival. In fact, there are no archival standards. Instead look for specific materials that passed the PAT and are certified safe for use with images. Using these materials appropriately will protect your photographs.

Anyone desiring to create a family photo album has a wide variety of choices. The best albums can be purchased from the suppliers listed in the Appendix. While these albums cost more than those commonly available in discount stores, they are worth the investment. The basic features of a preservation quality album are PAT-approved paper and boards. Make sure that the adhesive and the covering that holds the album together has passed the PAT. In general, stay away from vinyl Naugahyde because the resulting hydrogen chloride gas will destroy your images. [30] Preservationists recommend selecting an album that comes with a slipcase to protect your images from light and dust.

[30] Jeanne English and Al Thelin, *SOS: Saving Our Scrapbooks*. (Orem, Utah: Creating Keepsakes, 1999), 44.

PAPER

Scrapbook paper and card stock come in a variety of colors and textures. Be sure that the dye used in the paper is not water soluble. Another consideration is whether the paper is lignin-free. Naturally found in tree and plants, lignin is the substance that causes paper to yellow with age. While the acid added to paper during the production process to break down the wood chips causes staining, it is the lignin that helps to create the aged look that paper acquires when left in the sun.

When creating your scrapbook, look for paper that is acid-free, lignin-free, buffered and doesn't bleed color. Construction paper is particularly poor quality—it's acidic, contains lignin and bleeds color when wet. The best way to preserve your albums is to use materials that fit the PAT standards. Quality papers suitable for use in scrapbooks are labeled acid and lignin-free. Creating Keepsakes is one company that works with a group of preservationists to guarantee the preservation qualities of its products.

It is easy to check the acid content of paper, but keep in mind that many materials can be rendered acid-free temporarily. You can purchase a pH testing pen from the suppliers listed in the Appendix. If the line you draw on the paper with the testing pen turns purple, the paper is acid-free and has a neutral pH (6.5-7.5) or is higher than 7.0. The presence of other colors indicates that acid is present. Be sure to use a pH testing strip and distilled water on darker paper. In general, you should use neutral pH papers with color photographs, which are pH sensitive, while other items suffer no damage with a pH of 8.0. Using these pH testing devices is not a foolproof way to select preservation supplies. Rely on the PAT for guidance.

Since the dyes in some paper bleeds when exposed to water or high humidity, you need to test highly colored papers for stability. This is done by dropping a small dot of water on the paper or by placing a small piece of the paper in a cup of water. If the color comes off, the paper is not approved for use in preservation quality scrapbooks. For this reason, some preservationists suggest using papers and cutouts of a neutral color. Fortunately, these papers are available from library suppliers and most scrapbook stores.

Buffered paper helps prevent acid from migrating to other items in your album because it contains a chemical, probably calcium carbonate. Eventually, all paper is affected by the acid it absorbs. Buffering merely slows down the process.

Paper Recommendations from Creating Keepsakes[31]

- Neutral pH (6.5 -7.5) for use with color photos; pH of 7.0 -8.0 for other uses

- Buffered with two percent minimum calcium carbonate

- Lignin free (one percent maximum lignin content)

- Free of fugitive (bleeding) dye

ADHESIVES

Even if you use PAT-approved albums, the techniques you employ to create the scrapbook may cause your project to fall apart or damage the images. Many books suggest that scrapbooking actually preserves your images and then tell you to use glue, paint and other harmful materials as part of your project.

People often show me older photo albums with the images glued to black paper and express dismay over their inability to remove the pictures from the pages. In addition, the adhesive used to stick the images to the page stained the images or caused them to ripple from contact with the glue. I've seen all types of damage caused by adhesives and advocate that scrapbook hobbyists use PAT-approved photo corners rather than any type of glue, including those advertised as safe and archival.

Photo corners range from clear polyester to decorative paper. Either corner type is fine for use in albums as long as the materials are safe according to the PAT. Clear corners can be made of the two types of plastics approved for use with images: polyester or polypropylene. When a manufacturer states their corners are made out of plastic, you need to verify the type. If in doubt, ask the supplier. Be aware that the glue in these corners can change with time and ooze on the image or cause the pages to stick together. As the adhesive in the corners ages it will be less effective. Unfortunately there are no perfect solutions to this problem.

[31] Humpherys. "Pulp Fact, Not Fiction," *Creating Keepsakes* (November 1999), 59-61

Don't cut original photographs to create a scrapbook, use copies instead. Unidentified photos, c. 1900. *Collection of the author*

All photo corners use an adhesive that doesn't come in contact with the images or documents but you should make sure that it is reversible, colorless, odorless, solid and acid-free. In general, I never put adhesive on a document or photograph. Many scrapbook manuals show beautiful layouts with cutouts and stickers placed on the images and documents. Unless you are using copies of all your images, it is best to refrain from placing cutouts and stickers on your images, no matter how safe the manufacturer claims they are.

Another option is to purchase a special paper punch that allows you to create slits in your pages to hold the photographs by their corners. This eliminates the need for special supplies and concerns about adhesives.

If you need to remove adhesive from the back of photographs, you can use un-du Adhesive Remover by Doumar Products, You can reach this company at (800) buy-undu or www.undo.com The Rochester Institute of Technology, Duke University and Creating Keepsakes have all rated this product as safe. This non-abrasive substance removes most adhesives by neutralizing them. Place a few drops on the problem area and use a clean soft lint free cloth to gently wipe away the adhesive. Work from the middle to the edges. This work pattern will prevent you from bending

the image. Be careful that the solution doesn't end up dissolving the adhesive and migrating to the picture. This could cause staining and long term damage. Un-du is quick drying. [32] Sticky glue from pressure sensitive tape, labels or corners can be removed with a vinyl eraser or rubber cement pick-up eraser. Both are available in art supply stores. It's advisable to try the eraser before using a solution.

INKS

Labeling your images is an important part of creating any type of scrapbook. After all, you wouldn't want to spend the time to create the album and have a future generation be unable to identify the individuals. In general, all photographs should be labeled by placing information underneath or alongside your pictures. A basic caption includes the name of the person (with life dates), information about the event, where the picture was taken and when. Scrapbook magazines can supply examples of creative labeling. For example, you may want to have a single image on a page with a story surrounding it.

Before you begin, take a few precautions. First, never write on the front of the image. Second, never ever use ballpoint or a felt tip marker. The ballpoint smudges and makes indentations in the image while felt-tip marker water-soluble ink can be absorbed by the image. You **can** use a soft graphite pencil on the back while the image is face down on a hard clean surface. But, never use anything on the picture area. Even if you are using copies, it is not a good idea to write on an image. The pressure of the pencil will leave indentations on the image surface. Contemporary photographs are coated with resin that makes it difficult to write on. In this case, most of the pens appropriate for this purpose use ink that takes about half a minute to dry. Look for a pen with a soft tip and waterproof ink if you want to label the back of the resin- coated images. Just be sure to give the ink enough time to dry or you will end up with ink where you didn't intend. You can also label your photographs by writing the identification on the outside of a sheet protector.

There are a few new pens that can be used in scrapbooks available from the "archival" suppliers. These are the only types of ink and pens approved for album use. Even inexperienced genealogists have seen examples of what happens to ink when exposed to water or high humidity levels. If you have never seen this type of damage, it will only take a few minutes to find an

[32] "Questions and Answers," *Creating Keepsakes*. (March 2000), 26.

example by visiting a local library or archive.

Always test the solubility of the ink you want to use by writing on a piece of paper and submersing it in water. If it runs, don't use it. A safe pen for scrapbooks is one that passes the non-toxicity standards of the Arts and Creative Materials Institute. They recommend that the ink be waterproof, fade resistant, permanent, odorless (when dry) and quick drying. Don't be concerned about the smell of the ink when wet. Pens that dry rapidly often contain alcohol that dissipates when dry. You wouldn't want to spend hours composing an entry only to have it smudge or run. Most pens commonly available in stationery stores such as ball points, roller-balls and markers do not meet these standards. Before purchasing a pen, try it out to see if it passes the test.

In general, permanent black ink is the best choice for captioning since colored inks can fade. While scrapbook manuals advise using color for decorative features, make sure they pass the criteria for scrapbook-safe ink. Conservationists do not recommend metallic inks.

Glues and ink are not necessarily safe for use with photographs. If you want to follow the directions provided in most publications on creating memory albums and scrapbooks, use copies and never originals. Place the originals in storage so that future generations can appreciate them unblemished.

> **Basic Labels**
> Full name, date, location. Additional information can be listed beside the image on your scrapbook page.

RUBBER STAMPING

Decorating pages with all types of graphic elements including rubber-stamped designs is part of what makes a scrapbook attractive. But is it safe? Catherine Scott decided to find out by interviewing preservation experts. The experts noted that while the inks and materials are safe, no one knows if the stamps will fade and change color. [33]

As a precaution, Scott and the experts suggest using inks are safe for scrapbooks, but be sure to test the ink's water solubility. Embossing powders which raise the stamped image, can be used as long as they don't come into contact with your images. In fact, the experts advised embossing every stamp to seal the ink and protect your images from the chemicals in the ink. Full instructions and safe products appear in Scott's article. [34]

[33] Catherine Scott, "The Ins and Outs of Rubber Stamping" *Creating Keepsakes* (February 2000), 65-67.
[34] Scott, "The Ins and Outs of Rubber Stamping" *Creating Keepsakes* (February 2000), 65-67.

SHEET PROTECTORS

You have the option of protecting your scrapbook pages by slipping them into sheet protectors. This step eliminates any abrasive damage that can occur when the pages rub together. Just as it is important to consider the chemicals in paper, you should be aware of the best type of sheet protector. You wouldn't want to spend time and money buying PAT products only to undo your efforts with poor quality plastics.

Sheet protectors come in a variety of designs. Some are top loading, while others have pockets or fold over edges. You can forgo scrapbook papers in favor of using specially-sized protectors. A list of suppliers appears in the Appendix.

Regardless of the type of protector you select, make sure that they are either inert polyester or polypropylene. These types of plastic do not deteriorate with time and they do not deposit chemicals on your scrapbook pages. Conservators suggest avoiding pages made from polyethylene because they contain an unstable chemical that is added during the manufacturing process. This "slip agent" helps the sheets move smoothly through production, but over time, it rises to the surface of the pages and can cause smudging. [35]

There are other factors to consider before purchase. Since your scrapbook pages are heavier than regular photographs, you should purchase durable protectors that are labeled heavyweight. This product will add to the bulk in your album so you should try several different types of heavyweight and medium-weight sheets to see which suits your purposes. Another issue is whether to use non-glare or clear pages. Again, there is a preservation concern. Non-glare pages sometimes contain substances to give pages a specific appearance. I find that non-glare pages do not give you a clear view of photographs.

STICKERS

Stickers are fun and add to the visual interest of the scrapbook you are creating. Use them freely in your album, but make sure that they are PAT approved. As long as you don't place stickers directly on documents and images, you can use them safely.

FAMILY MEMORABILIA

Part of the process of creating a scrapbook is including the memorabilia that adds meaning to the events and people you are documenting. Unfortunately, the types of items you place in the album

can adversely affect all the steps you've taken to protect your photographs. Documents transfer acid to the images, ink in fabric and yarns can bleed if the materials aren't colorfast, and flowers will stain. So what materials can be included and how?

Documents and newspaper clippings add another dimension to the story you are trying to tell. However, since the paper is acidic, you want to be careful they don't come into contact with your images. Preservationists recommend de-acidification before placing clippings in scrapbooks. Seek the advice of an expert before attempting to use any of the de-acidification sprays on the market or immersing the documents in a special solution. Parts of the document could be damaged by the solution. Spraying entire documents with one of these solutions can cause bleeding dyes and result in long-term chemical damage. Another option is to make copies on PAT papers.

There is a common myth that won't die. Many people wrongly believe that laminating their documents will help preserve them. Initially, lamination was thought to protect items. Unfortunately, after an item is encased in laminate, damage begins to occur almost at once. The acid sealed inside and the plastic covering both start to deteriorate documents and photographs. Indeed, the entire process is harmful and irreversible. In addition, exposing items to heat during the lamination process ages the material.

This lovely page was created using a copy of an original photograph. It commemorates a family event. *Diane Haddad*

[35] Gayle Humpherys. "The Skinny on Sheet Protectors," *Creating Keepsakes*, (September/October 1999), 63-66.

Fortunately, another method both protects and preserves precious family documents. It involves encapsulating the material in two protective sheets of polyester sealed with double sided tape. Just like the photo corners, this tape can experience problems over time. Just in case, make sure your item isn't close to the tape. This method is used in most libraries and archives. Encapsulation is safe and reversible, exactly the opposite of lamination. Before encapsulating any document, make sure it has been de-acidified using special solutions. This process can be used for items too large for ready-made envelopes and sleeves.

We all have items we would like to include in the story of our lives. These items may be made out of wood or plastic or may contain flowers, rocks or ceramics. Leather is treated with tannic acid, which will leach onto your images and pages. You know what I mean. The little trinkets you pick up while you are on vacation or that your children bring home. Unfortunately, natural objects transfer lignin and acid to your scrapbook pages. Plastics give off gases and rock and ceramics are abrasive. Money is also unsuitable for inclusion until it has been cleaned and placed in a protective covering. However, there is hope. Include memorabilia by using specially made polypropylene envelopes that contain the same adhesive as the corners. These envelopes are available in a variety of sizes from scrapbook suppliers. Some scrapbook suppliers have products that offer creative solutions such storage compartments and decorative frames. Check with the manufacturer to be sure that the plastics are made from are either polypropylene or inert polyester. [36]

Materials that you can safely put in your album include most fabrics and yarns as long as they are acid-free, non-abrasive and colorfast. However, wool is not safe for photos because it contains sulfur. When in doubt about whether an object or item is safe, place it in a protective covering to be sure you are not inadvertently causing damage.

CREATING THE SCRAPBOOK

Now that you know what supplies are safe to use, it is time to create the scrapbook. Since one of the goals of creating a scrapbook is to tell a story, you first need to select what items will be included. Scrapbooks become a family artifact. They can be used to tell a particular family story or to create a biography of a single family member. Once you decide on a theme, you can focus on completely telling that story. Your theme can be as specific as a single event or perhaps cover a broader topic that includes an entire year of family photographs.

[36] Deanna Lambson. "Can You Keep It?" *Creating Keepsakes* (March 2000), 55-62.

There are three basic steps to creating a scrapbook after you decide on a focus.

1. Set up a clean work area where you can lay out your photographs and store your materials. Be sure to wash your hands and wear clean disposable examination gloves before handling your images.

2. Purchase materials. Be sure to use only PAT-approved materials to create your album.

3. Lay out the items. Deciding what to include in your album can be a daunting task when you are faced with boxes and notebooks full of materials. Choose photographs that relate to your theme and are of good quality. If you have difficulty taking usable photographs, see the suggestions in the Appendix.

Consider using copies

Many of the cutting and pasting techniques illustrated in popular magazines will cause irreparable damage. When you use copies and duplicate prints, you eliminate the danger of destroying irreplaceable images. Rather than crop original images and obscure identifying information, use a duplicate and place the original in storage.

Decorate your pages using stickers of Acid-free paper and adhesive or use cutouts that follow safe scrapbook guidelines. As long as you don't place your images in danger through exposure to harmful substances and chemicals, be as creative as possible. Just don't let your excitement allow you to make preservation mistakes.

DIGITAL SCRAPBOOKS

Digital imaging offers you an alternative to traditional scrapbooking. Genealogy programs, scrapbook software and web tools have features that allow you to create a digital scrapbook. This format allows you to create a safe scrapbook without making copies and buying supplies. One popular software package used by experienced digital scrapbookers is Adobe Photoshop. Most dedicated scrapbook software includes tools to help you create scrapbook pages to print out or post on the web. Usually, you select the type of page and format from a list of projects and then digitally insert your photographs. If you decide to print the pages, follow the guidelines for printing digital images in Chapter 9.

CONSULT THE EXPERTS

If you need advice, look no further than the web or in the pages of popular magazines such as *Creating Keepsakes*. If you don't know where to buy supplies or attend classes in your area, consult the directories in the back of every issue.

To keep track of current trends and new products, consider becoming a member of The International Scrapbook Trade Association (ISTA). Members receive a bimonthly newsletter.

Basic Rules of Scrapbooking

Golden Rule: Don't cause any permanent damage to your irreplaceable images.

Do's

1. **Use scrapbook safe materials.**

2. **Use copy photos, placing originals in storage.**

3. **Enhance the value of your album by labeling the images.**

4. **Use photographs that are of good quality.**

5. **Do create a lasting artifact that future generations can enjoy.**

Don'ts

1. **Don't use magnetic albums with adhesive pages.**

2. **Never crop original photographs.**

3. **Never write on the front of images.**

4. **Don't include images that are of poor quality or in disrepair.**

5. **Don't place adhesive directly on an image or attach cutouts.**

RULES FOR SAFE SCRAPBOOKING

1. If you are going to use the methods and techniques presented in many of the more popular books, your first rule is to make copies. The originals should be preserved for future generations by being stored in a proper environment. Once you have decided to use duplicate prints or copies, you can be as creative as you like without being concerned about the lasting quality of your scrapbook.

2. If you decide to lay out original photographs in an album, use materials that are acid-

free and PAT-approved. Avoid inks or paints. Colored papers are not recommended.

3. Don't crop or mat original images. You are irreversibly destroying the image by cutting the photograph or gluing a mat over the image.

4. Do not laminate or handcolor vintage images. Make a copy and use that instead. Laminate contains chemicals that destroy the images over time.

5. Identify the images. Some suppliers offer suggestions on how to identify the images without causing damage.

FREQUENTLY ASKED QUESTIONS

How can I remove photographs from old photographic albums such as those with the magnetic pages?

You have a couple of different options. First, you can use a piece of very thin dental floss and carefully run the floss underneath the photograph very gradually so as to not damage the image. A microspatula can be used to gently remove photos from albums. You can also try a product such as Un-Du, an adhesive remover, or a vinyl eraser, to gently dissolve the glue. However, I don't recommend removing photos from albums unless they are the magnetic type, because the photo album tells a story. Someone placed those images in a specific order for a reason. Try scanning the photo you'd like to use, rather than taking it out of the original album.

GLOSSARY

Throughout this book, I have used **technical terms** that may be unfamiliar to individuals who are new to working with family photographs. In addition to the list provided here, two encyclopedias that deal specifically with photographic terminology may be helpful. They are Gloria S. Mc Darrah, Fred W. McDarrah, and Timothy S. McDarrah's *The Photography Encyclopedia* and *The Focal Encyclopedia of Photography* (third edition) edited by Leslie Stroebel and Richard Zakia (Boston: Focal Press, 1993). For nineteenth-century terminology, consult *Cassell's Cyclopedia of Photography*, edited by Bernard E. Jones. (New York: Cassell and Company, 1911, reprinted by Arno Press, 1973)

Let's start with the basics. The number one misunderstood word—archival! You'll see it everywhere from albums to pens. But, what does it really mean? The word "archival" is based on "archives", which to us is a place where items are cared for. Therefore, archival usually refers to the types of special storage materials used in an archive. But there's a problem. There are no industry standards for "archival." While it's generally understood that the term refers to material or conditions that extend the longevity of the stored objects, use caution when purchasing items to create art or in which to keep your treasures. Don't take the word archival at face value. For instance, when a photo album is labeled "archival" does that refer to the outside, the pages or the plastic overlays? Manufacturers usually follow the word archival with a list of other terms so you'll need to read the fine print to see what you're really buying. There is more exact terminology and standards that increase the likelihood that you'll preserve your creation. Here's a glossary of common words and tools to help you make choices for the long term.

Abrasion

A type of damage that occurs when prints are rubbed against an object or each other. In certain prints, this rubbing will cause image loss and scratches.

Acid-Free

Think back to that high school chemistry class. Do you remember a discussion of pH as a way to measure the acidity or alkalinity of objects like paper? This measurement provides an indication of whether the product is suitable for storage. Acid-free refers to a paper with a pH higher than 7.1. Ideally, the paper has been chemically purified and treated with a buffering agent to neutralize any lingering acid.

Acid

Paper having a pH lower than 7.1.

Airbrushing

Technique used for retouching photographs by applying paint with a tool called an air gun. This technique can be used to eliminate damage from a copy print.

Albumen print

Photographs made by coating paper with a combination of egg white and silver nitrate.

Ambrotype

A piece of glass coated with light-sensitive chemicals, introduced in the mid-1850s.

Archival

Materials or conditions that extend the longevity of the objects stored in them. An example is acid-and lignin-free storage box with a pH exceeding 7.1.

Autochrome

Image created by coating grains of potato starch dyed red, green, and blue-violet onto a sheet of glass. These images became commercially available in 1907 and were primarily used by professional photographers.

Cabinet card

A type of card photograph that measures $4^{1/2}$ inches x $6^{1/2}$ inches.

Calotype

The first paper negative. Invented by William Fox Talbot.

Candid Photography

Photographs that lack the formality of studio portraits. It generally refers to pictures taken by amateur photographers after Kodak camera became available.

Carte de visite

A small card photograph introduced to the United States in 1859. It measures $4^{1/4}$ inches x $2^{1/2}$ inches.

Collodion

A combination of ether, pyroxyline, and alcohol that was used to make prints and wet-plate negatives. It was also used on wounds during the Civil War.

Conservation

Professional treatments by specially trained conservators to stabilize a deteriorating object. A free list of conservators in your area is available from the American Institute for Conservation of Historic & Artistic Work, Inc. (AIC), Conservation Services Referral System, 1156 15th St., NW, Suite 320, Washington, D.C. 20005 Telephone: (202) 452-9545. Web: www.conservation-us.org/

Contact print

A way of making photographs without enlarging the image. Until the invention of a way to enlarge images became available, all photographs were contact prints.

Copy stand

Special equipment either made at home or commercially manufactuered to allow photographers to copy images.

Copyright

Legal right of ownership to an image or text.

Crayon portrait

Photograph enhanced by the use of artists' materials and techniques.

Cropping

Eliminating distracting elements from a photograph. Editors usually crop images prior to publication to improve their quality and to fit a particular space.

Daguerreotype

A one-of-a kind photograph made on a highly polished silver plate. Introduced in 1839 by Louis Daguerre.

Developing Out Paper

Photographs developed through the use of chemicals rather than those that appear during exposure to lights. See *printing-out paper*.

Deacidify

This refers to the process of removing acid from items. There are a variety of chemicals on the market for deacidifying documents. Before using them, test on a small corner of the document first. Do not use on photographs.

Direct Positive

Production of a copy print without the use of a negative.

DPI

Also known as dots per inch. The term refers to the number of sensors per inch of scanning width. The greater the DPI, the clearer the image.

Dry-plate negative

Glass plate coated with light-sensitive chemicals and gelatin used when dry.

Emulsion

The light-sensitive part of a negative or paper.

Encapsulation

Encapsulation is a safe and reversible method of preserving a document or photograph. It involves sealing an object or item between two protective sheets of polyester. There are also small polyester sleeves and boxes for objects.

Ferrotype

See *tintype.*

Foxing

Reddish-brown spots that appear on photographs as a result of a chemical reaction due to high humidity.

Generation

Copies of an original print not made with an original negative. It is usually associated with a loss of detail.

Hyalotype

Type of glass slide patented in 1850 by the Langenheim Brothers.

Hygrometer

A device that measures and monitors the temperature and humidity in an area.

Image resolution

Refers to the amount of detail in an electronic image.

Improper Processing

Photographic processing that fails to wash off residual chemicals.

Lantern Slides

Positive images on glass that could be projected. They were popular for more than one hundred years.

Lignin-Free

Leave a newspaper in the sunlight for a little while and see what happens. Guaranteed it will turn yellow and become brittle. You've just witnessed what lignin does. It is a naturally occurring substance in wood. When paper products contain lignin, they will yellow and become fragile. Look for products that are both acid and lignin-free.

Lightfast

Pens and other types of inks labeled lightfast mean they contain dyes and pigments that resist fading when exposed to light. Different types of inks fade at varying rates. Make sure that inks are both lightfast and waterproof.

Magnetic Album

A poor quality album with adhesive on the pages to keep photos in place.

Mylar

An inert plastic approved for the storage of negatives and photographs.

Negative

Reverse light and dark areas. In a color negative, the colors are reversed as well.

Nitrate

Nitrocellulose. This substance was used to create negatives between 1889 and 1939. These negatives are highly unstable and are a fire hazard.

Off-gases

Fumes given off by substances such as plastic containers and carpets can deteriorate materials stored in or near them. These gases can damage photographs. Use inert plastics like polypropylene, polyester or Mylar for long term storage.

PAT

The Photographic Activity Test is an internationally recognized standard for museum-quality storage that tests the reactivity of photographs to substances in manufacturers' products. The Image Permanence Institute (IPI) (www.imagepermanenceinstitute.org/), a non-profit research lab sponsored by the Rochester Institute of Technology and the Society for Imaging Science and

Technology, tests paper and plastic as well as "adhesives, inks, paints, labels, and tapes" for four to six weeks. The PAT is used internationally, so look for evidence that products have passed this rigorous standard before buying.

Polyethylene

A type of plastic once thought safe for use with photographs and negatives. Conservators now caution against using it.

Polypropylene and polyester plastics

A type of plastic approved for storing images and negatives. Neither of these plastics deteriorates with time nor deposits chemicals on materials stored in them. While non-glare plastics are available, they can be treated with chemicals, so don't use them.

Printing-out paper

Photograph that develops during exposure to light. See *developing-out paper.*

Relative Humidity

The average amount of moisture measured in the air. Most archives maintain a relative humidity of 30 to 50 percent.

Reinforced Corners

Acid and lignin-free storage boxes should have extra supports on the corner exteriors. Some manufacturers double the weight of the storage material while others reinforce the corners with metal.

Restoration

The process of re-creating the appearance of an image.

RC Paper

Photographic paper coated with resin, a type of plastic that became available in the 1960s.

Scanning

The process of converting an image to an electronic format.

Stereograph

Creating the appearance of a 3-D image by photographing the same object from a similar angle. The images are mounted beside each other and viewed with a stereoscope.

Tintype

A type of photograph, also known as a ferrotype, that consisted of a piece of thin iron coated with light-sensitive chemicals.

Toning

Coating prints with a solution of gold or platinum to change their color and improve stability.

Transference

When two platinum prints are placed together, front to back, and the image from one transfers onto the back of the first image over time.

Transparency

Another name for a color slide or film positive.

Ultraviolet Light

UV does more than damage our skin. It can deteriorate our belongings. UV is found in sunlight and fluorescent bulbs so protect your original materials from its effects by storing them only in indirect light. Color photographs should be kept in a cool dark place to slow deterioration.

Union case

A case invented by Samuel Peck in 1852 to hold photographs. The cases were manufactured from a combination of gum shellac and fiber but are mistakenly thought to be made from a type of plastic.

Waterproof

Whether or not a product responds to water and high humidity can influence how long your scrapbook stays in pristine condition. If you use an ink or paper containing water soluble dyes, certain conditions such as high humidity can cause color to leach out of paper or ink could run.

Wet plate

Glass negative made with light-sensitive chemicals and collodion that was used while wet. Photographers made their own negatives immediately prior to using them.

BIBLIOGRAPHY

Baldwin, G. *Looking at Photographs: A Guide to Technical Terms*. Santa Monica, Calif.: J. Paul Getty Museum in Association with British Museum Press, 1991.

Capa, Cornell, Ed. *International Center of Photography Encyclopedia of Photography*. New York: Crow Publishers, Inc., 1994.

Coe, Brian. Kodak Cameras: *The First Hundred Years*. Hove: Hove Foto, 1988.

Coe, Brian and Mark Haworth-Booth. *A Guide to Early Photographic Processes*. London: The Victoria and Albert Museum in Association with Hurtwood Press, 1983.

Collins, Douglas. *The Story of Kodak*. New York: Harry N. Abrams, Inc., 1990.

"Conservation-Lantern Slides." National Media Museum. www.nationalmediamuseum.org.uk. Accessed 12/08/2009.

Crawford, William. *The Keepers of Light: A History and Working Guide to Early Photographic Processes*. Dobbs Ferry, N.Y.: Morgan and Morgan, 1979.

Dunkelman, Mark. "An Interview with Michael J. Winey, Curator at the U.S. Army Military History Institute." Military Images (November/December 1993): 9–16.

Edmondson, Brad. "Polaroid Snaps the Customer." American Demographics 9 (February 1987): 23.

Eskind, Andrew H. and Greg Drake, eds. *Index to American Photographic Collections*. 3d enlarged ed. New York: G.K. Hall & Co., 1996.

Farber, Richard. *Historic Photographic Processes*. New York: Allworth Press, 1998.

Foresta, Merry A. *American Photographs: The First Century*. Washington, D.C.: Smithsonian Institution Press, 1997.

Frizot, Michel, ed. *A New History of Photography*. English ed. Cologne, Germany: Konemann, 1998. French edition. Paris: Bordas, 1994.

Gernsheim, Helmut and Alison Gernsheim. *The History of Photography From the Camera Obscura to the Beginning of the Modern Era*. New York: McGraw Hill, 1969.

Johnson, William S. ed. *International Photography Index*. Annual. 1979, 1980, 1981. Boston: G.K. Hall & Co., 1983-.

Nineteenth Century Photography: An Annotated Bibliography. 1839–1879. Boston: G.K. Hall & Co., 1990.

Lavedrine, Bertrand. *A Guide to the Preventive Conservation of Photograph Collections*. Los Angeles: The Getty Conservation Institute, 2003.

Mace, O. Henry. *Collector's Guide to Early Photographs*. 2d ed. Iola, Wis.: Krause Publications, 1999.

McDarrah, Gloria S. Fed W. McDarrah and Timothy S. McDarrah. *The Photography Encyclopedia*. New York: Schirmer Books, 1999.

Newhall, Beaumont. *The History of Photography*. New York: The Museum of Modern Art, 1982.

Palmquist, Peter E., Ed. Photographers: *A Sourcebook for Historical Research*. Brownsville, Calif.: Carl Mautz Publishing, 1991.

Public Record Office. *An Introduction to Nineteenth and Early Twentieth Century Photographic Processes*. Public Record Office Series: Introduction to Archival Materials. London: Public Record Office, 1996.

Sandweiss, Martha A., ed. *Photography in Nineteenth-Century America*. Fort Worth, Tex.: Amon Carter Museum, 1991.

Color

Dmitri, Ivan. *Kodachrome and How to Use It*. New York: Simon and Schuster, 1940.

Dresser, A.R. *Lantern Slides and How to Make Them*. 1892.

Elmendorf, Dwight Lathorp. *Lantern Slides: How to Make and Color Them*. New York: E &H.T. Anthony & Co., 1895.

Henisch, Heniz and Bridget A. Henisch. *The Painted Photograph*, 1839–1914: Origins, Techniques, Aspirations. University Park: Pennsylvania State University Press, 1996.

Krause, Peter. "How Long Will Your Color Prints Last?" *Popular Photography* (April 1999): 76–94.

Polaroid Corporation. *Storing, Handling, and Preserving Polaroid Photographs: A Guide*. Cambridge, Mass: Polaroid Corporation, 1983.

Sapwater, E. Kirsten Mortensen and Helen Johnston. "Images on Ice: Cold Storage Freezes Time for Photographic Film and Prints." PEI (April 1999): 36–44.

Sipley, Louis Walton. *A Half Century of Color*. New York: Macmillan Co., 1951.

Wilhelm, Henry, and Carol Brower. *The Permanence and Care of Color Photographs: Traditional and Digital Color Prints, Color Negatives, Slides and Motion Pictures*. Grinnell, Iowa: Preservation Publishing Co.,1993.

Wood, John, ed. *The Art of the Autochrome*. Iowa City: University of Iowa Press, 1993.

Conservation of Photographs

Bernier, Brenda M. "A Study of Poly (Vinyl Chloride) Erasers Used in the Surface Cleaning of Photographs." Topic in *Photographic Preservation 7* (1997): 10–18.

Caring for Photographs: Display, Storage, Restoration. Life Library of Photography. New York: Time-Line, Books, 1972.

Derby, Deborah, with assistance from M. Susan Barger, Norah Kennedy, and Carol Turchan. "Caring for Your Ohotographs." Washington, D.C.: American Institute of Conservation, 1997.

Hendriks, Klaus B. and Rudiger Krall. "Fingerprints on Photographs." *Topics in Photographic Preservation* 5: 8–13.

Keefe, Laurence E., and Dennis Inch. *The Life of a Photograph.* Boston: Focal Press, 1990.

Kolonia, Peter. "How to Preserve Your Prints." *Popular Photography* (October 1993): 47.

Lavedrine, Bertrand. *A Guide to the Preventive Conservation of Photograph Collections.* Los Angeles: The Getty Conservation Institute, 2003.

McComb, Robert E. "Taking Care of Your Photographs." *Petersen's Photographic* 26 (March 1998): 26–28.

"Photo Preservation: How to Care for Your Photographs." http://www.ajmorris.com/a06/photopres.htm. Accessed 12/18/2009.

Seefeldt, Paula A. "How to Preserve Your Photographs." *Good Housekeeping* 210 (March 1990): 243.

Wagner, Sarah S. "Approaches to Moving Glass Plate Negatives." *Topics in Photographic Preservation* 6 (1995): 130–31.

"Some Recent Photographic Preservation Activities at the Library of Congress." *Topics in Photographic Preservation* 4 (1993): 140–42.

Walsh, Betty. "Salvage Operations for Water Damaged Archival Collections: A Second Glance." *WAAC Newsletter* 19, no. 2 (May 1997) http://cool.conservation-us.org/waac/wn/wn19/wn19-2/wn19-206.html. Accessed 12/18/2009.

Wilson, Bonnie. "Ask an Expert: Preserving Your Photographs: Windows to the Past." Minnesota Historical Society www.mnhs.org/preserve/conservation/reports/photoqanda.pdf. Accessed 12/18/2009.

Copyright

Allen, Richard C., et al. *Lawyering for the Arts.* Boston: Massachusetts Continuing Legal Educations, 1991.

ASMP Professional Business Practices in Photography, 5th ed. New York: Allworth Press, 1997.

"Copyright, Photography and the Web." (7 March 1997) http://frankmcmahon.com/photoweb/copyrite.htm. Accessed 12/18/2009.

Cottrill and Associates/ "Copyright Table" http://www.progenealogists.com/copyright_table.htm. Accessed 12/18/2009.

Elias, Stephen. *Patent, Copyright, and Trademark.* 3d ed. Berkeley, Calif: Nolo Press, 1999.

Epstein, Andres D. "Photography and the Law." In *Lawyering for the Arts,* edited by Richard C. Allen, et al., 7.

Everyone's Guide to Copyrights, Trademarks, and Patents. Philadelphia: Running Press, 1990.

Hoffman, Gary B. "Who Owns Genealogy?" http://genealogy.com/genealogy/14_cpyrt.html. Accessed 12/18/09.

Strong, William S. *the Copyright Book: A Practical Guide.* 4th ed, Cambridge, Mass: MIT Press, 1993.

"When U.S. Works Pass Into the Public Domain" http://www.unc.edu/~unclng/public-d.htm. Accessed 12/18/09.

Daguerreotypes

Barger, Susan M., and William B. White. *The Daguerreotype: Nineteenth Century Technology and Modern Science.* Washington, D.C.: Smithsonian Institution Press, 1991.

Berg, Paul. *Nineteenth Century Photographic Cases and Wall Frames.* Huntington beach, Calif.: Huntington Valley Press, 1995.

The Daguerreian Annual. Pittsburgh: The Daguerreian Society.

Field, Richard S. and Robine Jaffee Frank. *American Daguerreotypes From the Matthew R. Isenburg Collection.* New Haven, Conn.: Yale University 1989.

Foresta, Merry A., and John Wood. *Secrets of the Dark Chamber: The Art of the American Daguerreotype.* Washington, D.C.: Smithsonian Institution Press, 1995.

Krainik, Clifford, and Michele Krainik, with Carl Walvoord. *Union Cases : A Collector's Guide to the Art of America's First Plastic.* Grantsburg, Wis.: Centennial Photo Services, 1988.

Newhall, Beaumont. *The Daguerreotype in America.* New York: Duell, Sloan & Pearce, 1961. Reprint. New York: Dover Publications, Inc., 1976.

"Preservation of the Daguerreotype Collection" http://lcweb2.loc.gov/ammem/daghtml/dagprsv.html. Accessed 12/18/09/.

Rinhart, Floyd, and Marion Rinhart. *American Miniature Case Art.* New York: A.S. Barnes & Co., 1969.

American Daguerrean Art. New YorkL Clarkson N. Potter, 1967.

The American Daguerreotype. Athens: University of Georgia Press, 1981.

Rudisill, Richard. *Mirror Image: The Influence of the Daguerreotype on American Society.* Alburuerque: University of New Mexico Press, 1971.

Wood, John. ed. *America and the Daguerreotype.* Iowa City: University of Iowa Press, 1991.

The Scenic Daguerreotype: Romanticism and Early Photography. Iowa City: University of Iowa Press, 1995.

Digital

Bleich, Arthur H. "Pioneer Websteads (and Other Great Online Resources on the PhotoDigital Frontier," *Digital Camera* (April 2000): 17–20.

Eggers, Ron. "An Introduction to Digital Imaging." *Petersen's Photographic* (April 1998): D3–4.

"The Art of Scanning." *Petersen's Photographic* (April 1999): 18–19, 21.

Freeman, Angela. "From Snapshots to Web Sites." *PC World* (December 1997): 347–50.

Gormley, Myra Vanderpool. "Adventures in Cyberspace," http://www.ancestry.com/columns/myra/Shaking_Family_Tree07-09-98.htm/. Accessed 12/18/09.

Johnston, Peter. "Image Archiving Aids Digital Service." *Graphics Arts Monthly* 67 (February 1995).: 72.

King, Julie Adair. *Digital Photography for Dummies*. 3d ed. New York: IDG Books, 2000.

Kolonia, Peter. "Digital Saves the Day: Pro Photographers Are Turning Rejects Into Winners–Digitally." *Popular Photography* 61 (April 1997): 30–36.

Film

Gordon, Paul L., ed. *The Book of Film Care.* Rochester, N.Y.: Eastman Kodak Co., 1992.

Slide, Anthony. *Nitrate Won't Wait: A History of Film Preservation in the United States.* Jefferson, N.C.: McFarland, 1992.

Negatives

Patti, Tony. "Historically Speaking. Discovery of the Collodion Process in Photography." *PSA Journal* 60 (January 1994): 7.

Photographic Technique

Bearnson, Lisa, and Siobhan McGowan. *Mom's Little Book of Photo Tips.* Orem, Utah: Creating Keepsakes Books, 1999.

Hart, Russell. *Photography for Dummies.* Foster City, Calif.: IDG Books, 1998.

Hughes, Jerry. *How to Take Great Photographs With Any Camera.* Dallas: Phillips Lane, 1999.

Myers, Allison. "Ten Common Photo Mistakes: Learn How to Avoid Them." *Creating Keepsakes* (November 1999): 101–5.

Shull, Wilma Sadler. *Photographing Your Heritage.* Rev. ed. Orem, Utah: Ancestry, 1988.

"Twenty-five Handy Pro Tips: Tricks of the Trade You Can Use Too." *Petersen's Photographic* (October 1999): 28–33.

Zuckerman, Jim. "Five Instant Techniques to Improve Your Photography." *Petersen's*

Photographic (March 1999): 33–35.

Preservation

Albright, Gary. "Which Envelope? Selecting Storage Enclosures for Photographs." *Picturescope* 31, no. 4 (1985):111–13.

Burgess, Helen D., and Carolyn G. Leckie. "Evaluation of Paper Products: With Special Rederence to Use With Photographic Materials." *Topics in Photographic Preservation* 4 (1991): 96–105.

Hendriks, Klaus B., and B. Lesser. "Disaster Preparedness and Recovery: Photographic Materials." *American Archivist* 46 (Winter 1983): 52–68.

Messier, Paul. "Preserving Your Collection of Film-Based Photographic Negatives." Conservators of Fine Arts and Material Culture, Rocky Mountain Conservation Center http://cool.conservation-us.org/byauth/messier/negrmcc.html. Accessed 12/18/09.

Norris, Debbie Hess. "the Proper Storage and Display of a Photographic Collection." *Picturescope* 30 (Spring 1982): 34–37.

Romer, Grant B. "Can We Afford to Exhibit Our Valued Photographs?" *Picturescope* 32 (1987: 136–37.

Topics in Photographic Preservation. American Institute for Conservation. Photographic Materials Group. Issued biannually. 1987–1997.

Walsh, Betty. "Salvage Operations for Water Damaged Archival Collections: A Second Glance." *WAAC Newsletter* 19, no. 2 (May 1997) http://cool.conservation-us.org/waac/wn/wn19/wn19-2/wn19-206.html. Accessed 12/18/2009.

Wilbur, Anne. "How Stable is a Photograph?" *Memory Makers* (Spring 1998): 10.

Prints

Darrah, William C. *Cartes de Visite in Nineteenth Century Photography.* Gettysburg, Pa.: W.C. Darrah, 1981.

Gagel, Diane VanSkiver. "Card and Paper Photographs, 1854–1900." *Ancestry* 15 (September/October 1997): 13–17.

Reilly, James M. *Care and Identification of Nineteenth Century Photographic Prints.* Rochester, N.Y.: Eastman Kodak Co., 1986.

Restoration

Benedetti, Wendell. "How to Restore Your Damaged Treasures." *Petersen's Photographic* (April 1998): D8.

Scanning

Fulton, Wayne. "A Few Scanning Tips" http://www.scantips.com. Accessed 12/18/09.

Ledden, Larry. *Complete Guide to Scanning.* New York: Family Technologies, 1998.

Scrapbooking

Braun, Bev Kirschner. *Crafting Your Own Heritage Album.* Cincinnati: Betterway Books, 2000.

Carroll, Souzzann Y.H. *A Lasting Legacy: Scrapbooks and Photo Albums That Touch the Heart.* Bountiful, Utah: Living Vision Press, 1998.

Coombs, Patti. "The Lowdown on Labeling Photographs." *Creating Keepsakes* (May June 1999): 58–60.

English, Jeanne, and Al Thelin. *SOS: Saving Our Scrapbooks.* Orem, Utah: creating Keepsakes Books, 1999.

"Heritage Albums: Saving the Past for the Future," *Memory Makers* (Spring 1998): 21–25, 59.

Heritage Scrapbooks. Escondido, Calif.: Porch Swing Publishing, 1999.

Humpherys, Gayle. "Pulp Fact, Not Fiction." *Creating Keepsakes* (November 1999): 59–61.

"The Skinny on Sheet Protectors." *Creating Keepsakes* (September/October 1999): 59–61.

Lambson, Deanna. "Can You Keep It?" *Creating Keepsakes* (March 2000): 55–62.

Scott, Catherine. "The Ins and Outs of Rubber Stamping." *Creating Keepsakes* (February 2000). 65–67.

Wilbur, Anne. "Preserving a Legacy." *Memory Makers* (January/February 2000): 108–09.

Stereographs

Bennett, Mary, and Paul C. Juhl. *Iowa Stereographs: Three-Dimensional Visions of the Past.* Iowa City: University of Iowa Press, 1997.

Darrah, William C. *Stereo Views: A History of Stereographs in America and Their Collection.* Gettysburg, Pa.: Times and News Publishing Co., 1964.

The World of Sterographs. Gettysburg, Pa.: W.C. Darrah, 1977.

Waldsmith, John. *Stereoviews, An Illustrated History and Price Guide.* Raonor, Ohio: Wallace-Homestead Book Co., 1991.

Terminology

Bellardo, Lewis J., and Lynn Lady Bellardo. *A Glossary for Archivists, Manuscript Curators, and Records Managers.* Chicago: Society of American Archivists, 1992.

Daniels, Maygene F. "Introduction to Archival Terminology." ALIC. http://www.archives.gov/research/alic/reference/archives-resources/terminology.html. First published in *A Modern Archives Reader: Basic Readings on Archival Theory and Practice.* 1984. Accessed 12/18/09.

Tintypes

Burns, Stanley B. *Forgotten Marriage: The Painted Tintype and the Decorative Frame 1860–1910: A Lost Chapter in American Portraiture.* New York: The Burns Collection, Ltd., 1995.

Lindgren, C.E. "Caring for Tintypes and Creating New Ones." *PSA Journal* 59 (January 1993): 17–18.

Rinhart, Floyd, Marion Rinhart, and Robert W. Wagner. *The American Tintype.* Columbus, Ohio: Ohio State University Press, 1999.

APPENDIX

Archival Products
P.O. Box 1413
Des Moines, IA 50305-1413
www.archival.com

Bags Unlimited
7 Canal St.
Rochester, NY 14608
www.bagsunlimited.com

Clear File, Inc.
800-423-0274
www.clearfile.com

Conservation By Design Limited.
Timecare Works
5 Singer Way
Kempston
Bedford
MK42 7AW
www.timecare.co.uk

Conservation Resources International, LLC
5532 Port Royal Road
Springfield, VA 22151
800-634-6932
www.conservationresources.com

Hollinger Metal Edge Corporation
6340 Bandini Blvd.
Commerce, CA 90040
800-862-2228
www.hollingermetaledge.com/

Light Impressions
P.O. Box 2100
Santa Fe Springs, CA 90670
800-828-6216
www.lightimpressionsdirect.com

University Products
517 Main Street
Holyoke, MA 01040
www.archivalsuppliers.com/
800-628-1912

Conservation Help

American Institute for Conservation of Historic & Artistic Work, Inc. (AIC)
www.conservation-us.org/

Archival Storage Facilities

Iron Mountain
745 Atlantic Ave.
Boston, MA 02111
617-535-4766
www.ironmountain.com

Made in the USA
San Bernardino, CA
16 April 2013